CW00508057

EDINBURGH
EDUCATION AND SOCIETY
SERIES

General Editor: Colin Bell

BRITANNICA's TYPESETTERS

Women Compositors in Edwardian Edinburgh

Siân Reynolds

EDINBURGH UNIVERSITY PRESS

© Siân Reynolds 1989

Edinburgh University Press
22 George Square, Edinburgh

Set in Linotron Palatino
and printed in Great Britain by
Redwood Burn Limited,
Trowbridge, Wilts

British Library Cataloguing
in Publication Data
Reynolds, Siân
Britannica's typesetters:
women compositors in
Edwardian Edinburgh.
1. Scotland. Women printers.
History
I. Title
686.2'092'2

ISBN 0 85224 634 X

CONTENTS

 A generation 89
 Family, childhood, upbringing, schooling 94
 Daily experience 99
 The Great War 104
 Marriage, children, responsibilities 105
 A dwindling band 111

7. IN THE UNION AT LAST: THE EDINBURGH WOMEN'S BRANCH 114
 The 'Female Section': creation and early recruitment 114
 'Giving the girls control of their own business':
 getting started 116
 Relations with the men's section and with the STA 121
 Defending women's issues: the grit in the machine 125

CONCLUSION 136
 The work process: when is a skill not a skill? 136
 The rewards of labour: why not equal pay? 138
 Class identity and solidarity *vs* women's rights 139
 Gender and history 141

 Notes 144
 Index 165
 Illustrations between pages 66–7

ACKNOWLEDGEMENTS

For permission to quote from the records held at the National Library of Scotland, I am grateful to Dr T. I. Rae, Keeper of Manuscripts and to the various holders of copyright: the Scottish Branch of SOGAT 82 (archives of the Edinburgh Typographical Society); the receivers of Clark Constable (1982) (archives of R. & R. Clark and T. & A. Constable); and the Longman Group UK (archives of Oliver & Boyd). For permission to consult and draw on material from the registration records, I thank Mr G. P. Mackenzie, Departmental Records Officer at the General Register Office for Scotland. Table 1 is reproduced by permission from Robert Gray, *The Labour Aristocracy in Victorian Edinburgh* (OUP, Oxford, 1976). Illustrations are separately credited.

Many people have gone out of their way to help in this research. My special thanks to the staff at the National Library of Scotland, in particular to Iain Brown and John Morris for their help and advice; and to the librarians at the Mitchell Library, Glasgow; the St Bride's Printing Library, London; and the library of the London School of Economics. I am indebted to Jonathan Zeitlin who first told me about the women compositors of Edinburgh and sent me the relevant parts of the thesis he was then writing; to Eleanor Gordon who lent me her thesis on women workers and trade unions in Scotland; to Kay Syrad, Rohan McWilliam and Lorne McCall for helping to trace information and material.

I would not have known where to start without Sarah Gillespie's official history of the Scottish Typographical Association (see Chapter 1, note 7) which was my constant companion long before I had the pleasure of meeting the author, now Dr Sarah Orr. I am most grateful to John Davidson and to the late Archie Simpson for information about women compositors in Aberdeen and Edinburgh in more recent times. My father, Ben Reynolds, commented on part of the manuscript and recalled for me what he knew of his own father's life as a compositor. I did not dare submit the manuscript to my mother, Mair Reynolds, who would have been a formidable reader and made me correct every sentence. Peter France did read an early draft and I am grateful to him for much else besides. My thanks too to Catherine Lyons for her extremely thorough and sympathetic copy-editing and to the staff of Edinburgh University Press for all their help.

Most of all, I should have liked to thank the four surviving women

compositors whom I was able to interview in 1986, when they were all in their nineties. All four have, alas, now died. I am most grateful to their families for helping me to contact them and for information: my thanks to Mrs M. H. Lawson, Mrs Joan Spalding, Mr Ian Crosbie and Mr G. Simpson. Mrs Elizabeth Finnie and Miss D. Mathewson kindly provided photographs and information about their mothers, which proved very valuable.

This book is dedicated then to the memory of all the Edinburgh women compositors and in particular to those I had the privilege of meeting: Miss Ethel Brechin; Mrs Joanna Crosbie (formerly Miss Joanna Martin); Mrs Bella Meikle (formerly Miss Bella Wallace); and Mrs Jenny Simpson (formerly Miss Jenny McNaughton).

INTRODUCTION

In March 1909, the following news item appeared anonymously in the *Scottish Typographical Journal*:

> Edinburgh printers, on Saturday 13th March, received something very like a severe nerve-shock when they learned from the local press . . . that printing in 'Auld Reekie' was at present enjoying a 'boom' caused in large part by a re-issue of the 'Ency. Brit' [the famous eleventh edition of the *Encyclopaedia Britannica*]. This particular job has now been on the 'boards' – the keyboards of typesetting machines worked by female labour! – for nearly a year. A boom indeed! – why, one of our Edinburgh typo branches has at present so very many men idle that . . . they are levying themselves for the benefit of idle members . . . Is that a 'boom'? – rather think it's a 'boom-erang'.

The printing of the 1911 edition of the *Britannica*, takes us straight to the subject of this book for a number of reasons. The reader who takes the trouble to look at the back of each volume of that edition – the last to be produced in Britain – will find as I did, rather to my surprise, that the printing was distributed between the Clay family firm (of London, Bungay and Cambridge) and a number of Edinburgh printing firms. There was a reason for sharing out the work rather than having it all done in one place. The particular novelty of the eleventh edition was that instead of publishing the work in instalments as in the past, the editors for the Cambridge University Press wished the encyclopaedia to offer its readers 'knowledge as part of an ordered system',[1] and therefore to publish all the volumes simultaneously. So the articles which contributors had begun writing in the early 1900s were kept on file until the writing was complete. Then 'arrangements were made so that the printing of the whole edition should eventually take hardly any more time than had been required for the printing and correcting of a single volume under the old system'. This was made possible by two solutions: sharing the work out between a number of firms in Edinburgh and the south of England; and making use of the recently invented Monotype composing machine (consisting of the keyboard referred to above and a casting machine). The Monotype was quickly beginning to replace typesetting by hand in bookwork, particularly in the south of England, although it was still in 1909 a comparative newcomer to Scottish printing offices.

The distribution of the printing of the *Encyclopaedia Britannica* tells in microcosm the story of British book printing in the early twentieth century. From about mid-nineteenth century until the 1900s, Edinburgh had been a major centre outside London for the printing of books – the reader can check this by glancing at the back of books published around the turn of the century: books published in London were often printed in Edinburgh. The city was also the home of previous editions of the *Encyclopaedia Britannica* itself, and traditionally its printing-houses offered their customers high quality and expertise, and low prices. The latter were in part made possible by a unique feature of the main Edinburgh printing firms and the subject of this study: the employment since the 1870s of large numbers of women as compositors. The compositor's calling, one of the most highly skilled among the craft trades, was traditionally confined to men; and in the rest of Britain, with comparatively few exceptions it remained so. As a rule, women were employed in printing only in the unskilled or semi-skilled parts of the trade. The Edinburgh women compositors formed a special group: they were doing work usually performed by men. But they were being paid like women – at much lower rates.

By the turn of the century, despite the advantage of their lower wage bills, Edinburgh firms were facing stiff competition from Clay and similar firms in the Home Counties, which had invested heavily in the new machines and which also enjoyed lower rents and freight costs. The largest Edinburgh firms, as the opening quotation tells us, began to buy Monotype machines and to employ women compositors to operate them – thus securing at least part of the *Britannica* contract. The combination of competition from both women and machines proved to be the last straw for the male compositors in Edinburgh. Their trade union, the Edinburgh Typographical Society (ETS), the local branch of the Scottish Typographical Association (STA), had been trying unsuccessfully for years to stop women entering the trade. It was indeed just as the *Britannica* was going to press, in 1910, that a concerted campaign on the part of the men, backed by the Scottish labour movement as a whole and culminating in a threat of an all-out print strike, led to an agreement with the employers that no more girl apprentices would be taken on.

The ban was originally for six years, but in practice it became permanent. It was a condition of the agreement that no woman at work in 1910 should lose her job. Several hundred remained at work over the next decade or so. But, as marriage, retirement and what would today be called 'natural wastage' ate into their numbers, the group dwindled away. It had been an unrepeated experiment in printing history. But I hope to show that it is one from which something of interest can be learned.

It is impossible to say how much the ban on recruiting women contributed to the later decline of the Edinburgh printing trade, for which other

reasons can plausibly be invoked. But it is a fact that the late nineteenth and early twentieth century witnessed Edinburgh's heyday as a printing centre for the whole of Britain, and that this period coincided with the large-scale employment of women as compositors. For the male compositors, it was therefore a time of mixed feelings. This study looks at what is still a little-known episode in the troubled relations between men and women workers. It takes the 1910 dispute as its centre (hence the term 'Edwardian': King Edward VII died in the summer of 1910), but looks back to the first women recruits to the trade in the 1860s and 1870s, and forward to the inter-war period when some of the women apprenticed before 1910 were still working out their time in Edinburgh composing-rooms. There had been about 850 of them at the time of the ban, and some were still working in Edinburgh (and in one or two other Scottish cities, notably Aberdeen) as late as the 1950s. Hardly any of them will still be alive today, but some lived long enough to see both the equal-opportunities legislation of the 1970s and the second wave of new technology in the printing trade, which combined to raise once more the question of women entering the printing trade.

The changes of the last decade or so and their implications for the respective roles of men and women in printing have been analysed with clarity and humanity by Cynthia Cockburn in her marvellous book *Brothers* (1983).[2] The present work concentrates on the historical case of the Edinburgh 'compesses', as women compositors were sometimes known, whose story Cockburn briefly summarizes. At one level, my aim is to document, using the rich and previously unexplored archives in Edinburgh, the existence of a group of women workers who, in the words Angela John used of women pit-brow workers in Victorian mines, 'have been virtually ignored by historians [but] who in their lifetime became the centre of a spirited and protracted debate about their right to continue working'.[3] At the same time, it is also intended to contribute to the small but growing body of literature about women in Scotland from a broadly feminist perspective, that is one drawing on the critical concepts that have been developed over the last twenty years or so in what is known sometimes as women's history, sometimes as feminist history.[4]

In his recent wide-ranging book *A Century of the Scottish People 1830–1950*, T. C. Smout writes that 'the history of the family and of child upbringing and the place of the woman within and without the home, is so neglected in Scotland as to verge on becoming a historiographical disgrace'.[5] I would perhaps phrase this differently: 'the place of the woman', embedded in a sentence about family, home and child, is not the same thing as 'women's history', 'the history of women' or the subject which might take us furthest of all, 'gender and history', where gender refers to the socially constructed, as distinct from biological, differences between the sexes. But there is certainly a dearth of research into the history of Scottish women, particularly in the late nineteenth

and early twentieth century. This cannot but seem odd when one con-
siders the extraordinary concentration on this period of much women's
history south of the border and much labour history north of it.
The field is not entirely unworked, but the results are rather patchy.
There are one or two recent surveys covering the period: Rosalind
Marshall's *Virgins and Viragoes* (1983) spans several centuries but has less
to say about the last hundred years than about earlier periods. J. D.
Young's *Women and Popular Struggles* (1985) embraces an unwieldy
collection of data from Scotland and the rest of Britain over a long
time-span, with uneven results.[6] The collection of essays by various
hands *Uncharted lives: Extracts from Scottish Women's Experience 1850–1982*
(1983) is a welcome indication of the original research now being done,
and another collective work is in preparation, the first volume to be
devoted to women's work in Scotland.[7] On women, work and politics
in this period, Esther Breitenbach, Eveline Hunter and Elspeth King
have written short but useful and stimulating books or articles,[8] and
Eleanor Gordon has recently completed a thesis on women workers
and the labour movement in Scotland, to which I am indebted and
which is shortly to be published.[9] Lynn Jamieson has published parts
of her helpful thesis on the family in the twentieth century, which
draws on oral history. And in the last few years oral history projects
have burgeoned in many parts of Scotland, most of them helping to
bring women out of the shadows where they seem historically to have
been.[10]

But compared to the wealth of material on the last hundred years
published in England and France, it remains true that in Scotland there is
still so little secondary literature on women that one often has to start
from scratch with primary sources. To take one area where this problem
arose for me, the women's suffrage groups in Edinburgh became in-
volved in the dispute over women compositors' jobs in 1910. But there
are practically no books about the suffrage movement or indeed the
women's movement generally in Scotland. Elspeth King's helpful pam-
phlet was the only serious piece of writing devoted to the subject, but it
was necessarily short on detail of the kind I wanted. To find out more,
one has to go through both the suffragist press and the Edinburgh daily
press. There is plenty of material on the various reforming movements in
which a number of Scottish women were involved still awaiting a
historian.

So one of the aims of this short study is to provide some detailed and
precise data in the Scottish context. The episode itself has an evident
Scottish dimension within the general history of printing in Britain, as
well as taking place within an overall culture different from that south of
the border. A certain amount of ink has been spilled over whether
Scotland was (and is) in T. C. Smout's words 'an exceptionally male-
dominated society'.[11] There are reasons why this question should be

asked, but I remain wary of huge explanatory generalizations so long as the historical record remains a fragmentary one.

Some things can certainly be said about Scottish industrial culture in the late nineteenth century which have some bearing on the subject. In many ways it combined features found in the industrial cultures of northern England and South Wales. Scotland had not only a textile industry but also and increasingly a major investment in heavy industry, from coal-mining to shipbuilding and engineering. In the period we shall be looking at, there was a sexual division of industrial labour of a kind not experienced elsewhere to quite the same extent, with men taking jobs predominantly in heavy industry, at what were high wages for the time, and the textile industry becoming virtually a women's monopoly, at lower wages. A whole tangle of cultural factors are associated with this, some of which will be explored here. One important point is that Scottish cities were each differently placed within this context. This is an Edinburgh story, not a Glasgow or a Dundee story. Edinburgh men had very little opportunity to work in heavy industry, and Edinburgh women had no textile factories nearby. They experienced the context indirectly. The dominant pattern of writing about labour history in Scotland has been shaped by the overall context, but there was ample space within the Scottish working class of the late nineteenth and early twentieth century for conflicts that did not follow obvious cleavages. This is one example, and there are no doubt more.

As well as its Scottish dimensions, this story does of course fit into some familiar patterns within labour history and women's (or feminist) history in general. Neither craft control and the exclusion of cheap labour, nor conflicts between men and women workers are peculiar to Scotland. The printing trade was in many countries a particular focus both for new technology and the employment of women at about this period. In England, printing technology was brought under trade-union control and women were quasi-permanently excluded from both the union and the trade in the twentieth century. In France, there were many more women in the trade, and exclusive practices by the union were eventually abandoned in favour of admitting women.[12] Historical interest has centred on the practices of exclusion from the trade, the introduction of new machines and the question of skill, and there is now quite a substantial body of theoretical and empirical writing.[13] It is sometimes possible, by looking at a detailed case-study, to throw some light on theoretical debates while remaining within a manageably small compass, and this is the present study's aim.

There is usually a passion behind a book. I should own up both to a passion for the old-fashioned printing trade and some annoyance at its exclusion of women. My grandfather was a young compositor in South Wales at about the time of these events. He provided my own first

intoxicating taste of printer's ink when he printed at work a poem written when I was seven. Proof-reading a student newspaper, years later, I went once a week to an old-fashioned printer's out of town and became familiar with the clanking Linotype machine and with all the paraphernalia of the printing office. Later still, I learned hand-setting at an art college and first encountered the bar on women from joining the NGA (which lasted more or less until the anti-discrimination law of the 1970s). It seemed terribly 'unfair', to use a word which (you will see) was often used by the women compositors in Edinburgh.

The passion diverted itself onto operating a small hand-press and later to research on the French printing trade, including the story of the conflict between women compositors and the French printers' union. When, in 1980, I came to live in Edinburgh, a fellow historian Jonathan Zeitlin told me about the existence of women compositors. What he did not know about was the rich series of archives in the National Library of Scotland, deposited both by the printing firms and the trade unions. This study could not have been written without them. They include minutes of meetings of the Edinburgh Typographical Society, both the men's and (after 1910) the women's sections; correspondence, registers, membership lists etc. All of these usefully supplement the knowing and anonymous columns of the *Scottish Typographical Circular* (later *Journal*), of which it is so hard to find a complete run. The employers' records include wage-books and records of entrants and leavers. By doing a certain amount of detective work, it was possible to build up the group portrait (Chapter 6) of the 'compesses' in about 1910, from registration records and other sources. In particular, precious first-hand evidence came from four former women compositors, interviewed at the very end of their lives, as well as from the daughters of former compositors. They were able to tell me things the written documents leave out.

The book is written more or less chronologically, after an opening chapter which is a survey of the printing trade in Edinburgh in general. It does not necessarily have to be read chronologically. A reader who would like to find out straight away who the women compositors were, what kind of background they came from and what kind of life they led, could turn first to Chapter 6; someone more concerned with the mechanics of dividing up the trade and what women were actually doing in the composing-room might single out Chapter 4. The other chapters tell the story: Chapters 2 and 3 explore how women first entered the trade in different ways; the 1910 dispute is described in detail in Chapter 5; and Chapter 7 looks at the improbable co-operation which eventually followed the setting up of a women's branch of the union after 1910. This was an unusual arrangement in the British Isles. Some of the general issues are discussed in a brief conclusion.

1

'PUTTING INTO TYPE MORE OR LESS IMMORTAL WORKS': THE EDINBURGH BOOK-PRINTING TRADE

Surprisingly, no book has been written about the Edinburgh printing trade, extraordinary chapter though it is in the city's history.[1] In late Victorian and Edwardian Edinburgh, printing-houses were among some of the city's largest employers. Unlike Glasgow, then expanding rapidly to become 'an industrial megalopolis', with a concentration of heavy industry and textile manufacture unrivalled elsewhere, Edinburgh never became a city dominated by industry. Its population (combined with that of the port of Leith) did, it is true, more than double in the last half of the nineteenth century, to reach over 400,000 by 1911 (cf. Glasgow 784,000, Aberdeen 164,000, Dundee 165,000). But despite the new industrial areas growing up alongside the railway lines, the only really large-scale enterprises in Edinburgh were its foundries, breweries and some of its printing-offices. Otherwise it continued to be a city of 'small-scale crafts catering for a "luxury" market', until late in Victoria's reign. No single industry employed large numbers of people, and indeed domestic servants were the largest occupational group in the population (20.51 per cent in 1881 and still as many as 16.05 per cent in 1901).[2]

As this suggests, Edinburgh was a city with a large and well-to-do middle class, whose 'stolid villas with their ample gardens of lilac and laburnum' were being built in the suburbs of Newington and Morningside.[3] Edinburgh was then, as it is now, a financial, legal, ecclesiastical, educational and cultural centre, giving employment to the professional classes and to those who provided services for them, printers among others. The occupational structure of manufacturing industry was varied, with a multitude of small firms. The biggest industrial work-force (some 7,000 in mid-century) was employed in the building and furniture trades, but printing and allied trades – including bookbinding and type-founding – accounted for as many as 3,000 workers in 1861.[4] As a percentage of the total employed population, they represented 3 per cent in mid-century, rising to 4.42 per cent by 1901, a figure which includes all print workers, skilled and unskilled (see Table 1).[5] Workers in other trades, as Ian MacDougall points out, 'were numbered in hundreds rather than thousands': brassfounders, coachmakers, leather-, glass- and rubber-workers, bakers, tailors, shoemakers etc.[6] It is against this background, fundamentally different from Glasgow with its shipyards and textile factories, or Dundee with its jute-mills, that the Edinburgh

TABLE 1. *Industrial occupations as percentage of total occupied population, Edinburgh, 1841–1901*

A. Industrial groups	1841	1861	1881	1891	1901
1. Printing	3.04	4.28	4.57	4.45	4.42
2. Building	10.49	7.30	9.34	6.96	8.49
3. Engineering and Metals	3.85	4.19	3.93	4.02	4.49
4. Clothing	14.09	12.59	9.27	9.23	7.01
5. Transport	2.17	4.21	5.41	5.88	7.12
1. Printer	1.94	2.17	2.52	2.53	2.83
Bookbinder	0.95*	1.48	1.55	1.31	1.15
Lithography	0.11	0.45	0.33	0.44	0.44
Other printing	0.04	0.18	0.17	0.17	–
2. Mason	4.49†	2.36†	1.97	1.26	1.66
Joiner	1.84	2.19	2.70	1.68	2.23
Painter	3.64	1.14	1.50	1.26	1.45
Slater, tiler	0.23	0.28	0.29	0.25	0.28
Plasterer	0.20	0.39	0.52	0.30	0.40
Plumber, gas-fitter	–§	0.62	0.95	0.85	0.97
Building labourer	–	–	1.03	0.97	1.06
Other building	0.09	0.32	0.38	0.39	0.44*
3. Engineer	0.38	0.72	0.87	1.05	1.34
Blacksmith	1.76	1.39	0.99	0.81	0.81
Brass manufacture	0.67	0.89	0.78	0.71	0.61
Iron manufacture	0.20	0.36	0.49	0.55	0.42
Tin-worker	0.36	0.33	0.38	0.38	0.37
Electrical apparatus	–	–	–	0.06	0.35
Other engineering	0.48	0.50	0.42	0.46	0.59
4. Shoemaker	4.53	3.06	1.65	1.43	0.91
Tailor	3.28	2.33	2.32	2.24	2.04
Other clothing‡	6.28*	7.20*	5.30*	5.56*	4.06
5. Rail	0.01	0.86	1.39	1.78	1.98
Cabman, coachman	–	0.71	0.47	0.43*	1.07
Carrier, carter	0.77	0.88	1.30	1.44	2.02
Tramway	–	–	0.10	0.28	0.38
Messenger, porter	1.39	1.76	2.15	1.95	1.67

B. Other occupations	1841	1861	1881	1891	1901
Furniture trades	2.59	2.28	1.95	1.34*	1.25*
Cooper	0.23	0.24	0.36	0.48	0.45
Other wood	0.46	0.39	0.23	0.22	0.32
Leather	0.71	0.70	0.58	0.57	0.42
Jewellery, precious metals, watches etc.	0.81	0.83	0.72	0.59	0.51
Baker	1.47	1.34	1.34	1.54	1.69
Brewer	0.25	0.32	0.57	0.77	0.54
Other food and drink	0.70*	0.94	0.88*	1.16*	0.53
Paper-making	0.04	0.20	0.46	0.60	0.76
Type founder	0.60	0.50	0.42	0.38	0.24
Coach-maker	0.60	0.47	0.35	0.32	0.29
Brush-maker	0.15	0.16	0.13	0.09	0.06
Glass	0.19	0.28	0.26	0.23	0.39
Rubber	–	0.33	0.54	1.17	0.82
Merchant seaman	0.08	0.13	0.15	0.15	0.35
Stone quarrier	0.07	0.12	0.10	0.11	0.17
Paviour, road labourer	–	–	0.10	0.11	0.17
Gas	0.02	0.22	0.27	0.29	0.37
General labourer	3.64	2.31	1.90	2.62	1.63
Undefined manufacturing	0.03	0.20	1.00	0.91	0.78

Notes:
* Figures based partly on estimates.
† Probably includes masons' labourers: not strictly comparable to later figures.
‡ Mainly female (i.e. seamstresses, dressmakers etc.).
§ Included with Painter.
– Not separately enumerated.

Source: Census occupation tables, in Robert Q. Gray, *The Labour Aristocracy in Victorian Edinburgh* (OUP, Oxford, 1976), pp. 22–3. Reproduced with permission.

printing trade must be seen, in a city resembling Paris rather than Manchester.

THE RISE AND FALL OF PRINTING IN EDINBURGH

How did Edinburgh come to be a centre of printing not only in Scotland, but even rivalling London? Although it was in Glasgow that the eighteenth-century renaissance of fine printing in Scotland began, with the Foulis brothers, it was in Edinburgh that book-printing and publishing really took off in the late eighteenth and early nineteenth century. The number of printing houses in the city jumped from 5 in 1745 to 27 in 1779, and by 1837 'there were over eighty letterpress printers in Edinburgh, great and small'.[7] There were two reasons, both of which remained important, why the book trade in particular thrived in Edinburgh. The first was the issue of cheap editions of popular works by booksellers like Alexander Donaldson, who 'saw the lucrative possibilities of reprinting English books not protected by . . . copyright'. The second was the rise of original publishing in Edinburgh from the time of the Scottish Enlightenment, which saw the first edition, by William Smellie, of the *Encyclopaedia Britannica* (1768–71), to that 'magnificent period' in the early nineteenth century, 'when Edinburgh took the limelight from London', largely as a result of the efforts of a particular generation of men, including Sir Walter Scott, James Ballantyne and Archibald Constable.[8]

It has been claimed (by a partisan writer) that James Ballantyne, Scott's friend and publisher, 'inaugurated a new era for printing in Scotland' on account of the 'correct and elegant workmanship till then comparatively unknown'.[9] It is certainly true that publishing – of books, periodicals and reference works – flourished in Edinburgh in 1800–50 as never before and that new printing houses were set up, often by publishers or booksellers, to produce these works.[10] But by about 1850, the heyday of Edinburgh as an intellectual centre was over, and publishers were moving to London, or at any rate opening London offices. Most of them kept up their printing links however with Edinburgh firms, who now produced books for the London market and London publishers. From the start, Edinburgh had had the advantage of its own paper supplies from the mills of Midlothian, and the development of the railways helped to secure communication, with North British opening up the Edinburgh–Berwick line to connect with the main London line in 1846.[11]

A pattern was now set which would last until 1914. In 1869, Bremner could refer to printing and its allied trades as 'the staple industry of Edinburgh'.[12] The latter part of the century, particularly after 1860, saw a phenomenal growth in demand for printing nation-wide. Compulsory elementary education, the spread of literacy, the expansion of the periodical market, the popularity of lending libraries and the extended tentacles of government and other bureaucracies all brought 'undreamt-of opportunities in the book and magazine markets'.[13] The cycles

of expansion and contraction in the printing industry were, as Gray remarks, relatively unaffected, or only indirectly affected by larger cycles of economic activity in this period. Technical and structural innovation and the changing nature of demand had relatively greater impact than economic depression. On the other hand, in Edinburgh as in London, there were distinct seasonal patterns of high and low employment (to do with legal and administrative timetables for instance).[14]

I should remind the reader at this point that what follows will be concerned mainly if not exclusively with book production, or work which closely resembled it: government publications, voting rolls, legal work and so on. Although book production was the reason for the expansion of printing in Edinburgh, the capital city's legal and administrative status brought plenty of contract work to the book printing offices. One sector of the industry, namely newspaper work, will hardly be referred to at all. Women were rarely if ever employed in daily newspaper offices, largely because of the Factory Acts, which forbade them to do night shifts, though they were occasionally employed on local newspapers. Neither will the many small printers who handled everyday jobbing work – playbills, tickets etc. – figure greatly in this study, since women were employed predominantly in the book-houses, where large quantities of solid type were set, rather than by jobbing printers, who required greater versatility from a smaller number of compositors.

Edinburgh had its newspaper and jobbing printers of course, but by the end of Victoria's reign it had established itself not only as a reliable source of scientific and academic books and high-quality printing but also as a centre for the cheap reprint trade. So in 1908, Anthony Keith could write:

> The fact is worth noticing that since publishing betook itself to the south, the printing trade in Edinburgh has increased by leaps and bounds, and if one cares to look at the back of books produced in London, the chances are that it will be found that Edinburgh printers have been entrusted with the putting into type of more or less immortal works.[15]

By the late 1890s and 1900s, the Edinburgh industry was at its peak, with orders flowing in. Other reasons, besides personal contacts with publishers, have been suggested for such success. 'The advantages of Edinburgh', said master printer Gillies in a lecture in 1888, 'were that they could do the finest work without asking a fancy price for it, and that the whole work was on a higher level of excellence and lower rates than London.'[16] Colin Clair refers to the 'excellence of machining' as an important element in the city's reputation, especially in such firms as T. & A. Constable, J. & J. Gray, R. & R. Clark and Ballantyne & Hanson. These firms and others – Neill's, Oliver & Boyd, Morrison & Gibb and Nelson's – had national standing and several of them came into Alford's category of 'large firms', with over 200 employees. The early association

of Edinburgh publishing with educational and reference books and its printers' acquired capacity to handle foreign languages and scientific material gave it advantages in the age of expanding education. There were some obvious reasons why Edinburgh rates were lower than London ones: wages and rents were lower in Scotland generally, as they were anywhere outside the metropolis. This point will be discussed later. But at least one element in the competitiveness of Edinburgh estimates after 1870 was the employment of women compositors. Child may be overstating the case somewhat when he explains 'the drift to Edinburgh' of the book trade in this period entirely by low composition costs, 'owing to the fairly general employment of women compositors'. But the economics of employing women was a significant factor.[17]

Child is probably right however when he goes on to note that the introduction of composing machines (Linotype and especially Mono-type) in England spelled the end of Edinburgh's ascendancy. Indeed 'by lagging behind in the installation of new machines',[18] partly because they could continue more economically with handsetting, the Edin-burgh printers were already tending to lose ground immediately before 1914. But a decisive blow was additionally dealt by the Great War, which brought a major slump to the book-printing trade. Edinburgh never really regained its position after 1918. By now it was not so much London that benefited as the low-cost provincial printing centres, like Bungay, Beccles, Frome and Aylesbury, where leading firms like Clowes, Clay and Hazell had invested in new plant. Edinburgh's competitive rates were no longer sufficiently low to compensate for the problems caused essentially by distance. The inter-war years, which saw the disastrous collapse of heavy industry in Scotland also witnessed the end of Edin-burgh's eminence in printing.

Print nevertheless remained, with brewing and rubber, one of the city's main employers, well into the 1930s when there were still some 50 firms. The *Third Statistical Account of Scotland* of 1966 points out that it was 'until recent years the city's largest industrial employer of labour'. Even in the 1960s, the industry as a whole still employed between 5,000 and 6,000 workers, and a number of the oldest firms have closed their doors or been taken over only in the last twenty years (e.g. Neills, Oliver & Boyd), while some (e.g. Blackwood and Pillans & Wilson) have amalga-mated in an effort to survive in the age of new technology. A recent casualty was Clark Constable (1982) which as its name implies was an amalgamation in 1982 of more than one firm (and which had already absorbed Morrison & Gibb in 1981). It was forced to close in August 1986.[19]

PRINTING-OFFICE LIFE
The original printing-offices had mostly started up in the Old Town, either 'down the closes or lanes or in some blind alley approached from

the High Street or the Cowgate'.[20] Many more set up in the New Town, north of Princes Street, particularly in the narrow thoroughfares of Rose Street and Thistle Street, where the smaller firms remained, but by the end of the nineteenth century, the bigger printing houses were moving to 'purpose-built factories in "the more commodious outskirts" in Newington and Canonmills'.[21] Thus Ballantyne's, the firm once closely associated with Sir Walter Scott, moved in 1870 from the Old Paul Work in the High Street to the New Paul Work in Causewayside, Newington. Morrison & Gibb, a firm employing over 200 compositors in the 1900s, had its Tanfield works in Canonmills, near the Botanical Gardens. (The empty building was still standing until recently (1988) but has now been demolished.) R. & R. Clark, another large firm, was nearby in Brandon Street, as was Neill & Co., the oldest established firm in the city, and for a long time the government printers. Founded in 1749, Neill's had moved to Bellevue Works, Canonmills, from the Old Town in 1898, but a disastrous fire in 1916 destroyed the building, and the firm moved again, this time to the building in Causewayside vacated by Ballantyne's not long before. Thomas Nelson & Sons, established in 1798, combined publishing, printing and binding in their grand Parkside Works, in Holyrood Park (now demolished). T. & A. Constable, founded in 1760 in the Old Town by Archibald Constable's father-in-law, moved in 1833 to Thistle Street behind Princes Street in the New Town, an area which quickly became a printing centre, with seven firms in the same street, including the long-established firms of Blackwood and Turnbull & Spears. W. & R. Chambers (the publishers of *Chambers's Encyclopaedia*), remained in the Old Town, as did Oliver & Boyd, whose sign can still be seen in Tweeddale Court.

The names of many of these firms may be familiar to the reader as publishers. The intermingled history of printing and publishing in the city has been described as a 'tangled picture', with some houses expanding their activities and others restricting them. Nelson, Oliver & Boyd, Blackwood, Ballantyne, Green, Chambers and Constable were all at one time both publishers and printers. One or two, like Nelson's and Oliver & Boyd, survived well into the twentieth century as publishers, others sooner or later became printing houses only. Some of the largest firms in the city – Morrison & Gibb, R. & R. Clark and Neill's – had never been publishing houses at all.[22]

The early years of the twentieth century saw the highest ever number of printing firms active in Edinburgh. The Post Office directory for 1910–11 lists some 135 names. Of these, about 80 were recognized by the union, the Edinburgh Typographical Society (ETS: – the Edinburgh branch of the Scottish Typographical Association). Table 2 is based on the register of employees (in the recognized offices) which the union produced in 1911. The unrecognized firms seem to have been small for the most part, though they included Simpson Label and W. Hodge, the

latter a Glasgow-based firm. The newspaper offices were unrecognized at this time because of disputes, but all the book-producing houses were recognized, and Table 2 shows the numbers of compositors, both men and women, and apprentices (all male) employed in the leading firms. Of these 23 firms, only Nelson and Baxter were not employing women compositors in any numbers in the early 1900s, and generally speaking it was the larger firms who employed the greater number of women.

TABLE 2. *Compositors employed in main Edinburgh printing houses in 1911*
(Top 23 firms, ranked by size of case-room overall)

	Total	Men	Women	Apprentices (male)	Mono casters
Morrison & Gibb*	282	112	136	28	6
R. & R. Clark*	234	89	114	27	4
Ballantyne & Hanson	215	107	70	34	4
Neill & Co.*	154	37	109	6	2
T. & A. Constable	125	87	11	24	3
Turnbull & Spears	104	56	34	12	2
Blackwood	81	50	19	12	–
Nelson	73	56	1	15	1
Green*	67	23	42	2	–
Cooperative Publishing	57	33	9	15	–
Riverside*	51	8	35	5	3
Oliver & Boyd*	50	14	29	7	–
Colston*	45	13	28	4	–
Murray*	43	8	31	4	–
Paton	29	16	8	5	–
Baxter	28	24	4	–	–
Chambers	27	13	12	2	–
Skinner*	26	6	19	1	–
Lorimer & Chalmers	25	10	9	6	–
Pillans & Wilson	25	16	4	5	–
McFarlane & Erskine	25	12	10	3	–
J. & J. Gray*	20	8	9	3	–
Banks*	20	7	8	5	–

Note: Table lists compositors only, not pressmen or semi-skilled workers.
*Firm employing more women compositors than men, excluding apprentices.
Source: *Register of Employees (Case-Room)*, 1911.

The compositors, who are central to this book, were not of course the only employees of these firms. The men and women who worked in the composing-room were but one group, albeit an essential one, among the several trades contained in the printing industry, sometimes brought together under one roof, sometimes handled by different firms. These included the typefounders (all male) who cast the metal into type;

engravers (also male) who prepared illustrations; the specialized crafts-men in map-making firms, like Bartholomews; various bookbinding workers, who by the late nineteenth century included many women, chiefly confined to the 'womanly' tasks of stitching, folding and glueing; and the various trades concerned with paper-making, where again a number of women were beginning to be employed. Finally there were the semi-skilled or unskilled ancillary workers in the printing trade, feeding machines or folding paper. On the whole, the less skilled the job, the more women were likely to be doing it (see Chapter 2).

But the two central trades, to whom the term 'printer' is properly applied, were those of the compositor and the pressman. There were virtually no women anywhere doing presswork. It was traditionally heavy work, carried out by men who had to be strong, and even after the mechanization of press machinery in the course of the nineteenth cen-tury, it remained both dirty and strenuous. (In France the nickname for a pressman was 'un ours', a bear, while a compositor was 'un singe', a monkey.) But presswork was much more than a matter of brute force: to get a clear and even print required skill in setting and controlling the machines, whether they were the old hand-presses, the mechanized presses or later the rotary press introduced for newspaper work in the latter part of the nineteenth century.

Hand-composition called for different skills. It is almost impossible in Britain today to find hand-setting going on outside art colleges and private presses, though here and there the odd jobbing printer still survives with neat racks of typecases. As recently as the 1970s, hand-setting had still not completely disappeared, while in the 1950s it was fairly standard in small shops. Instant-print and photocopy shops have all but eliminated these in the 1980s, and old typecases turn up regularly in second-hand shops, as no one has any use for them. But in the Edinburgh of the 1870s and through to 1910, hand-setting was the chief occupation of most compositors, men or women, working in the book trade. Since this process will be referred to throughout the book, a short description of it here may be helpful. As Cockburn puts it, 'it is impossible to understand the claims and counter-claims about skill without understanding the labour process on which they are founded'.[23]

Lead alloy type-characters, in different sizes and designs (typefaces), which had been cast in a foundry and then bought by the printing office, were stored according to size and typeface in flat wooden cases: these looked like shallow drawers divided into compartments, one for each letter of the alphabet, plus punctuation signs and spacing material. (The upper half of the case was originally for capitals, the lower for small letters, hence the terms upper- and lower-case.) The first thing a compos-itor had to learn, as a typist has to learn the layout of the keyboard, was the 'lay of the case'. The British lay corresponded roughly to the fre-

quency of letters in the English language, with the 'e's in a large compartment in the middle.

The compositor's work consisted of picking out the letters and slotting them, upside down, into the composing 'stick' (actually a metal clamp) held in the left hand. His or her skill lay partly in speed and accuracy and partly in devising acceptable spacing for each line by judicious use of the thick or thin spaces, so that the line of type fitted tightly into the pre-set stick. Blocks of a few lines at a time would be taken out of the stick and placed in a galley, or metal tray, after which the typeset matter would be 'made up', that is set tightly or 'locked' into a 'chase' to form a page, with the addition of headings, page numbers and 'furniture' to provide margins. Southward lists thirteen different tasks between setting the type and 'ascertaining if the forme [the completed chase] lifts'.[24]

Compositors were also responsible for 'imposition', that is ordering the pages into a combination which would print both sides of a given paper size. This was a different skill which could only be learnt under instruction, and the compositor had to be familiar with the different patterns of imposition. Mistakes were expensive, so imposition tended to be done by the more experienced workers. Corrections however, after a first proof had been pulled, were usually undertaken by all compositors; they required if anything better eyesight and dexterity than setting. Proof-reading was a senior job to which the more meticulous and well-lettered compositor might progress (though not all readers were former compositors). Finally, distributing or 'dissing' type back into the type cases, to be used again after a job was finished, was a tedious but necessary job which all workers were supposed to share. With the possible exception of lifting formes, none of these tasks was particularly heavy work, but they called for physical as well as mental exertion.

One should also be aware that by no means all compositors did identical work. In jobbing printing, the ability to do 'display', that is a particular kind of making up, appropriate for advertisements, handbills etc., was the most sought-after skill, whereas in bookwork and especially in newspaper work, many compositors spent most if not all of their time 'setting solid', line after line, while a few men did the up-making. In all cases, literacy was obviously essential, general intelligence was helpful, and physical speed and accuracy had to be acquired. Gray concludes that the craft also called for the ability to judge spacing and to make up correctly, and a general familiarity with the sizes and styles of type plus the ability to find one's way round the case-room.[25]

It will be obvious from this brief catalogue that the trade of the hand-setting compositor was a varied one, requiring a number of physical and mental skills which took time to acquire. Whether it required the seven years which was the normal apprenticeship period was already open to question in the nineteenth century (since apprentices often spent much of their first years running errands and clearing up). But this

TABLE 3a. *Comparative rates of pay of male compositors in Edinburgh and Glasgow (1853–1902)*

Year	Book and Jobbing						Newspaper work
	Edinburgh			Glasgow			Edinburgh and Glasgow
	Stab	Piece (per 1000 ens)	Hours worked	Stab	Piece (per 1000 ens)	Hours worked	
1853	25s	n/a	57	25s	n/a	57	35s (stab, morning daily)
1872	27s 6d	5½d	57	27s 6d	5½d	57	30s (stab, evening daily)
1872	30s	6d	54	30s	6¾d	54	
1877	30s	6d	54	32s 6d	6¾d	54	
1891	32s	6¼d	52	34s	6¾d	52	40s (stab, morning daily)
1902	32s	6¼d	52	34s	7d	50	34s (stab, evening daily)

Notes:
Here and elsewhere wages are expressed in shillings (s) and pence (d). Before decimalization in 1971, there were 20 shillings to the pound and 12 pence to the shilling.
The en is a unit of width used in typography.
Stab (establishment) rates were paid according to hours worked.

TABLE 3b. *Comparative rates of pay of Glasgow compositors, masons, engineering fitters (1894–1902)*

	Compositors	Masons	Engineering fitters
1894	34s standard 40s top rate newspaper	36s 2d	30s 4¹/₂d
1902	34s standard 40s top rate	40s 4¹/₂d	36s

Source: Sarah C. Gillespie, *A Hundred Years of Progress 1853–1953: The Record of the Scottish Typographical Association* (Glasgow, 1953), 61 ff.

was a matter of controlling entry to the trade, which lies at the heart of our subject.

In the old days, the craft was possessed routinely by all compositors. The official history of Ballantyne's contains a vivid description of the interior of the Old Paul Work off the High Street, before the move in 1870. In the 'long case-room',

One would find about thirty or forty compositors, busily dipping their fingers into cases of types – spelling, capitalising, punctuating line after line from the manuscript or 'copy' before them – amidst the jokes and chaff flying among themselves and the noisy hammering of wooden 'mallets' at the imposing tables or 'stones' down the centre of the room, on which the 'formes' of type were being 'got ready for press'.[26]

In later years, as Gray comments, there was a 'relative decline in the versatility and initiative of the compositor', on account of the kinds of specialization mentioned above. Nevertheless the male compositor regarded himself, and would be regarded by others, as indisputably a skilled worker.

Traditionally, skilled workers were paid at double the rates of unskilled workers. Printing was the kind of trade into which fathers recruited sons to give them a secure future, and in the nineteenth century it was still possible for a journeyman compositor to aspire to setting up as a master printer on his own account. London wages were higher than elsewhere in the country, while within Scotland, rates paid in Glasgow and Edinburgh were higher than those in other towns. Table 3a shows the rates paid during the latter part of the nineteenth century in the two main Scottish cities.[27] Note that overall in this period, Glasgow men succeeded in getting 9s advance on the 1853 standard wage, while Edinburgh men received only 7s, something which reflects not only the greater bargaining power if not combativity of the Glasgow men, but more generally the gap in wages between the West and the East of Scotland. While in 1886 the wage census shows that printers were getting wages roughly comparable to other skilled workers – say masons or fitters – by the next comparable wage census in 1906, the great changes on Clydeside had produced a much bigger gap between the high earnings possible for skilled engineering workers in the shipyards and more traditional trades. Whereas during the depression of the 1870s and 1880s print workers had been more successful in maintaining both wages and employment levels than other trades, the rise in prices after 1896 saw them increasingly left behind, not only by their London counterparts but also by workers in heavy industry in Scotland. An average pay packet of 30s a week was a good wage at the beginning of the period, not so good at the end.[28]

What was more, there were differentials between different groups of compositors and between compositors and machine-men. The latter, who were all on time, that is paid by the hour not at piece rates, regularly took home more than their colleagues in the case-room. Since so much capital was tied up in the machinery in the press room, the men were in a stronger position. Fluctuations in the workload, particularly seasonal ones, weighed more heavily on the more labour-intensive composing-room, and led both to unemployment and lower take-home pay.

In addition, Edinburgh alone applied what Gillespie calls 'the pernicious mixed system' whereby within the same office, some men were stab (establishment) hands, that is paid by time, while the majority were on piece rates.[29] The latter were the more vulnerable and inevitably ended up with thinner pay packets. Two other groups deviated from the norm: men working on daily newspapers then as now, were the most highly-paid workers in the trade, (see Tables 3a and 3b) while women composi-tors, when they appeared on the scene, were being paid rates roughly half that of the journeymen. Gray refers to such differences, particularly those between stab and piece rates, to argue that with variations in pay and security and the 'casualization' of a large part of the work-force, printing workers cannot automatically be assumed to belong to that privileged élite among the working class often referred to as the labour aristocracy.[30] Later chapters will explore the implications of wage-rates for the employment of women. For the moment, we may merely note that while the printing trade was apparently prospering at the end of the century, male compositors in the Edinburgh book trade had seen their earnings slip in relation to the high wages possible elsewhere in Scotland for adult male skilled workers.

THE MALE COMPOSITORS' CULTURE

The conventional assimilation of compositors to the 'labour aristocracy' was not only a matter of incomes and living standards. The nature of the craft was enough in itself to create a special atmosphere, incomprehen-sible to outsiders, while conferring on insiders something of an élite status. Most important for our present subject is that the composing-room, or case-room, was a very male world, from whose rituals all the profane (and particularly women) were excluded. Printers described their trade as 'the art and mystery of printing'. The vocabulary of the case-room was specialized, full of imagery and lent itself to jokes and puns, as a glance at any trade journal will show. It was a matter of pride to be able to joke and talk while working, as appears from the description of the Old Paul Work quoted earlier. But there was more to life in the printing-office than the vocabulary of work. An entire culture, jealously guarded, with its own rites, had developed over the centuries, and an apprentice was literally initiated into what was more like a brotherhood than a trade. A trade-union branch in printing is still known as a 'chapel', a term with distant and still obscure origins, and the focus for a set of complicated rules and customs, rewards and punishments. As Cynthia Cockburn has pointed out, it is hard to imagine a girl rather than a boy undergoing the bizarre eighteenth-century initiation rites in which, among other things, a sponge of strong beer was squeezed over the apprentice's head in a ceremony reminiscent of masonic ritual, while the journeymen processed round him 'their right arms being put through the lappets of their coats', conferring upon him some title 'generally that

of the Duke of some place of least Reputation near where he lives'.[31] Indeed in our own time, when the first girl apprentices entered the trade after the Equal Opportunities legislation of 1975, chapels were at a loss how to celebrate the end of apprenticeship for them – boys were still subject to traditional horseplay involving glue and feathers.[32]

Drinking was also part of chapel life, if anything more so in Scotland than in London. A nineteenth-century compositor remembered the 'men sitting comfortably at their whisky and ale between 5 and 6 o'clock', and Gillespie remarks on the 'annual jollifications' at which whisky was drunk by the gallon.[33] Drinking was in some ways a necessity in working conditions far from comfortable: dusty, noisy, often hot in summer, because of skylights needed to see by, and correspondingly cold in winter. The occupational diseases of compositors were tuberculosis and other chest disorders, for which various reasons have been suggested, among them the stooping posture, and the airlessness and extreme temperatures of the composing-room. A further feature of the nine-teenth-century compositor's way of life was the persistence of 'tramping' – the system whereby out-of-work printers could travel to various towns in search of jobs and benefit from the union allowance and hospitality, generally dispensed in a designated public house.[34]

As Cockburn points out, a formal ban on girls entering such a trade was hardly necessary: 'It would have been an odd family that was willing to see a daughter enter so male-oriented a trade.' She goes on to recon-struct the view of women held by compositors, from elements of their codes of behaviour. 'Saluting a woman in chapel' for instance was an offence punishable by a fine. The birth of a boy to a comp's family meant a levy of a shilling, but a girl rated only sixpence. The same view can be gleaned from the various jokes in the trade journal. (Example: 'What did the printer say when his wife gave birth to a daughter?' 'Wrong fount'.) Women did occasionally turn up at work – in very precise circumstances. Kinnear remembers the 'sundry visits by sorrowing wives' to the over-seer to get their husbands reinstated after they had celebrated payday too energetically and been sacked.[35]

As this instance would suggest, although drinking was part of print-ing culture, excess was incompatible with keeping a job, and, on the whole, compositors were typical of the 'respectable artisans' so well documented by Gray in his account of Victorian Edinburgh. Most had a strong commitment to the family and a dread of falling into the ranks of the non-respectable. By and large this went with wholehearted accept-ance of the notion of the husband as breadwinner and the wife as domestic manager, and a commitment to the 'family wage': the view that a man should be paid a wage sufficient to keep wife and children without his wife being obliged to take a paid job.[36] The respect often expressed for the wife as 'purse keeper', 'chancellor of the exchequer' and so on, while corresponding to a certain reality, neither concealed nor contradicted a

firmly hierarchical perception of family roles with father as head of household. Perhaps the conformity of all printers (and other skilled workers) to this domestic ideology has been overstated and there were some who protested against it, but they seem to have been a minority. Fairly representative of the tone of the printed records at least is the prize-winning essay in an Edinburgh competition entitled 'The working man's home', organized by the Rev. J. Begg in 1864. The winner, a compositor named John Symington, produced a compendium of notions of respectability: 'the respectable working man who strives to protect his children from evil [has] often his efforts stultified by the viciousness and disreputable conduct of his neighbours', he begins, with a reference to the social distinctions which could exist, in the same Edinburgh tenement building, between different sets of tenants. He goes on even to disapprove of the working men's club (regarded by many, with its library and debates, as a means of self-improvement). Symington's objection was that it distracted the worker from the family:

> The head of every family has been elected president for life of a club and called to preside over an association, by a higher fiat than the suffrage of his fellow men . . . The hours he is asked to spend in the rival club-room . . . are the very time when his presence is required at home, where the vice-president, in the person of the devoted partner of his joys and sorrows, who has fulfilled all the onerous duties incumbent upon her while her lord has been engaged in 'work, study or rest', naturally looks forward with a feeling of relief to the hour when the father of her family can unrestrained, resume the presidential chair.[37]

To read this as mere pomposity is tempting but misses the point. It is a statement about the family seen as the locus of both duty and repose, the scene of respect and affection between husband and wife, hierarchical though that relation clearly appears. In the tenement blocks of Edinburgh where most working families lived, there was widespread misery directly related to absentee or hard-drinking fathers. The wife of a sober, respectable 'president' like Mr Symington may have counted her blessings and accepted his pomposity because she was aware of the alternative. She would, however, be most unlikely to formulate her view of the family in this sort of language: presidents, vice-presidents, suffrages, associations and the 'chair' were likely to be conceptions far removed from her everyday experience. Her husband saw his private life in categories derived from his public life, automatically transferring the imagery of (in this case) trade-union or fraternity meetings to the home.

Even a man as committed to the home as John Symington would have spent a certain amount of time absent from it if he was a conscientious trade-union member, while the wife of an official would have been lucky to see him more than a couple of evenings a week. Trade-union consciousness – something completely removed from most women's

experience – ran very deep in the male compositor, as we may guess from this description of the typical compositor, this time in London, by another printer-writer in 1881:

Our friend is a strong believer in the Trade Society and a firm supporter of all its rules. He not only attends every meeting when he does not work late, but he has got bound up at home, as part of his family library, all the annual reports from the days of Mr R. Thompson to those of Mr Self. He can tell you when every advance or change in the scale took place and the names of all the chairmen at the annual meetings for the past 30 years.[38]

The world of the chapel was supplemented by a whole range of mostly male after-work pursuits: golf, cricket or football matches, 'smokers' and so on. By the late nineteenth century, football was the 'favourite amusement of a large number of printers' according to the *Scottish Typographical Circular*, and friendly matches between printing-houses were organized on the Meadows on the South Side of town. Functions had traditionally been organized at Christmas or in the summer for the staff of individual firms, incidentally creating ties of sociability and bonhomie between masters and men. The accounts of lectures by master printers, all-male dinners and so on, as reported by the *Circular*, give the impression of a degree of inter-class conviviality. Gray comments ironically on a 'soirée' when 'superfine black coats' were worn, and Burns's 'A man's a man for a' that' was recited. Many masters had of course begun as journeymen themselves, and shared much of the same cultural universe of their employees. There were some occasions when 'wives and sweethearts could be safely invited along', and once there were women working in the trade, more mixed functions were organized. But these were exceptional occasions, far from creating the close ties that for instance membership of the Bowls Club or Volunteer Rifles produced.[39]

It must be clear by now that the irruption of women into the complex world of the composing room as workmates – equals – would be a very different matter from tolerating them as unskilled machine-feeders or paper-folders in another part of the building, or from welcoming them as 'wives and sweethearts' at social functions. It would pose problems both to do with the work process and with the invasion of a sort of privacy. Although masters and men found themselves bitterly opposed over the question of employing women, there was a sense in which they had a shared perception of women's presence at work, as their use of language often reveals. Both journeymen and employers voiced the opinion that the women would never be as good as men. Thus in a general article on R. & R. Clark published in 1896, the author (writing from the master printers' standpoint) remarks that 'for straightforward setting, ordinary stonework, simple imposition and first proof reading, the women are found to be fully qualified, though of course they do not attain to the

status of the first-class man'. He nevertheless feels that the sight of 'these bright intelligent-looking girls in the female composing room is most agreeable' (thus reminding us that the sexes were segregated at Clarks, as was often the case). And we finally learn that the 'frames are arranged in single files – one of the contrivances for the prevention of chatter'. Thus with one word, the unsuitability of women for the 'art and mystery' of printing is suggested. What was a source of professional pride in men, the ability to work with 'jokes and chaff flying about', is something to be dismissed as mere 'chatter' if done by women, and discouraged if possible by special working conditions.[40]

In the circumstances it is hardly surprising that before the last third of the nineteenth century women had practically never been employed as compositors. In the seventeenth and eighteenth centuries, it was not unknown for the widow of a master printer (like the widows of other artisans) to take over the management of the business on her husband's death, but she did not necessarily possess the craft herself. Some master printers allowed their daughters to pick up a training informally. But the notion of setting out to train girls as apprentice compositors was essentially a new one in the 1860s. It came in the first place not from the employers but from the pioneers of women's emancipation; these early experiments had a direct bearing on the introduction of women compositors to Edinburgh, so it is worth looking next at the reasons why the idea was raised.

2

A SUITABLE JOB FOR A WOMAN? EARLY ATTEMPTS TO
BREAK INTO THE TRADE

Opening up the printing trade to women could be seen either as the
unscrupulous recruitment of low-paid labour or as the expansion of
opportunities for educated working-class girls. The question of cheap
labour will be explored later. This chapter looks at the efforts of philan-
thropists and defenders of women's rights to expand the range of
employment for both working-class and middle-class girls who needed
to earn a living. Printing was from the start seen as a promising trade for
pilot schemes. Since the schemes in question paid the male rate for the
job, they cannot be tarred with the brush of cheap labour. But they
certainly alerted employers to the possibility of employing women and
therefore roused the immediate distrust of the unions. These were early
skirmishes in a long-running conflict.

WORK PROSPECTS FOR SCOTTISH GIRLS

A working-class girl leaving school in the second half of the nineteenth
century, whether she was Scottish or English, would have much less
choice of work than her brothers. Although modern research has
pointed out that women's paid employment is underestimated by the
available records (in particular the census), since it was more irregular
and less likely to be recorded than that of men, women's *choice* of work
was certainly in practice severely restricted, first and most crucially by
what was effectively segregation by sex, secondly by local opportunities.
To imagine what a girl's prospects actually were, we should bear in mind
three by now well-established points about the employment of women
in general: by and large women were doing different work from men of
similar age and class; women were concentrated in unskilled and low-
paid jobs; and a majority of women in paid work were young and
unmarried. Since Edinburgh is the focus of this study, the context will be
a Scottish one: there are many similarities between the profiles of
women's employment north and south of the border, but they are not
identical.[1]

To begin with occupational segregation: in 1851, over 90 per cent of all
women registered as active in the labour force in Scotland were ac-
counted for by four categories of employment: agriculture, domestic
service, textiles and clothing. By 1911, the percentage had dropped to a
still quite high 60 per cent. The largest single category nationally con-

TABLE 4a. *Occupational classes, Edinburgh (1881)*

		Men	Women
I	Professional	9905	4122
II	Domestic	2617	18902
III	Commercial	10950	1024
IV	Agricultural	1041	244
V	Industrial	42146	14034
VI	Unoccupied/		
	Non-productive	37588	85785

tinued to be domestic service, which occupied 22.7 per cent of Scottish women workers in 1911, as compared to 22.65 per cent in textiles and 12.37 per cent in clothing.[2] These percentages were not uniform across the country: local specialities dictated what was available. The textile industry was predominantly concentrated in the Glasgow area, but there were woollen mills in the Borders and jute-working in Dundee. The latter was exceptional in many ways because of its large-scale employment of women rather than men in the jute mills. But in any case a lower proportion of men were employed in Scottish textiles than in English mills, partly because better-paid jobs were available to them in heavy industry.[3]

Edinburgh had practically no textile workers, men or women; but as we have seen it had a great many domestic servants. In 1911, no fewer than 17,035 women (but only 624 men) were working as domestic indoor servants in the city, while another 702 women worked as domestics in hotels, and a further 3,500 were registered as charwomen or laundry-women (see Table 5a).[4] The advertisement pages of *The Scotsman* in the golden Edwardian afternoon carried long columns of vacancies for parlourmaids, cooks and housemaids (so it is not surprising, though it must have been a source of irritation, that male printers hostile to women entering the trade often urged them to look for work 'in service').[5]

Without the option of textiles, the only other really large-scale employer of women in the city was the clothing trade, where women were more likely to be classified as milliner/dressmaker or seamstress than as tailor. Between 1851 and 1911, the number of Edinburgh women listed by the census as milliner/dressmaker remained constant at about 4,500. Few industrial occupations (apart from the printing trade) accounted for more than two to three hundred women, and in many single trades the total in the city was less than 100 (see Tables 4b and 4c, and for percentages, Table 1).

Only rarely were women doing similar work to men. In Scotland as a whole and in Edinburgh in particular, working-class women and girls mostly found themselves in work that in some sense extended their domestic role: housework, laundry, sewing, while better-educated

TABLE 4b. *Industrial sectors, Edinburgh (1881)*

	Men	Women
Books, prints, maps	3758	1654
Machines, implements	2235	133
Houses, furniture	11899	339
Carriages, harness	662	6
Ships, boats	63	—
Chemicals, compounds	441	37
Tobacco, pipes	162	223
Food, lodging	6448	2132
Textile, fabrics	1032	512
Dress	4277	5908
Animal substances	1722	109
Vegetable substances	1784	938
Mineral substances	5339	178
General commodities	3146	1744
Refuse matter	178	118

middle-class women who worked were caring for the young and the sick as teachers and nurses. True, textile-processing did not echo domestic work, but the French saying 'women work on soft stuffs, men on wood and iron' was particularly applicable in Scotland. Similarly, the increasing employment of women in the growing sector of food, drink and tobacco manufacture by the end of the century, and even the dramatic growth in the number of women commercial clerks (4,467 in Edinburgh by 1911, compared to only 366 in 1881)[6] did little to alter the fact that in Scotland generally (perhaps rather more than England in the same period) there was a very clear division of the labour market and a *de facto* segregation of 'men's work' from 'women's work', which would face any girl looking for her first job. The sector with which we are here concerned was thus an exceptional breach in a hitherto all-male part of the labour market.[7]

This brings us to the second general point: that women were not working in what were known as 'skilled' occupations. Traditionally, skilled jobs have tended to be defined as those requiring apprentice-

TABLE 4c. *Selected occupations from industrial category 'Dress', Edinburgh (1881)*

	Men	Women
Tailor	2173	262
Milliner, dressmaker	9	4373
Shirtmaker	24	872
Shoemaker	1551	189

Source: Census, Scotland, 1881 (Parliamentary burgh of Edinburgh).

TABLE 5a. *Domestic servants in Edinburgh (1881 and 1911)*

	Men	Women
1881 Total	2617	18902
Of whom 'indoor'	484	16094
1911 Total	2701	21738
Of whom 'indoor'	624	17035

Note: Total includes laundryworkers and charwomen.

ships. Both 'skill' and 'apprenticeship' are notions which have been challenged by feminist writers as having less to do with the intrinsic nature of the work than with the sex of the people doing it. Skill, it is argued, like gender, is a socially constructed notion. For example, 'tailoring', mostly done by men, is usually classified as a skilled trade whereas 'dressmaking', done by women, is usually not, although it did require a formal training. 'Skilled work is work that women don't do', as Anne Phillips and Barbara Taylor succinctly put it.[8]

Contemporary perceptions continue to be reflected in historical writing: thus Robert Gray's valuable study of the 'skilled workers' in Edinburgh is confined to an all-male sample; no dressmakers for instance are included, and he refers only in passing to women compositors.

Since most women were working in occupations classified as unskilled, or at best semi-skilled, it is no surprise to find that they were almost uniformly badly paid. They were caught in a vicious circle: in low-paid jobs because they were women, while the jobs were low-paid because women did them. On the rare occasions when they were doing work comparable to men's, women were regularly paid less. Explanations both at the time and later have tended to point to assumptions about the lower needs of women, irrespective of the work they were doing. Women were normally assumed to be dependent members of a family unit: daughters living at home before marriage; wives of employed husbands; or if unmarried, sheltered by parents or siblings. And as we have already noted, many male workers, especially in 'skilled' occupations, were committed to the notion of a male 'family wage' high enough to keep wife and children. Although as Eleanor Gordon has remarked, the family wage was hardly a reality for most

TABLE 5b. *Ages of women domestic servants in Edinburgh (1881)*

Under 20	4438
20–5	4572
26–45	5549
46–65	1329
65	654

Scottish working-class families, its notional existence had an impact on wages paid to women: if the normal 'women's wage' was low, employers taking on women for newly created jobs were unlikely to look to the male rate as a guide.

TABLE 6a. *Employment in printing and paper trades, Edinburgh (1881 and 1911)*

	1881		1911	
	Men	Women	Men	Women
Printers	2164	491	3502	1802*
Bookbinders	590	1035	688	1219
Litho printers	312	31	559	163
Paper manufacture	35	127	108	122
Envelope makers	4	174	156	458
Stationers	383	183	490	376
Paper stainer	11	—	8	14
Paper-box/bag maker	5	189	26	408

*approx. 850 of these were compositors, the others in semi-skilled trades.

A further result of the identification of women with unskilled workers was that they were ideal recruits when the de-skilling of a trade was already happening because of technological change. Dramatic examples of this occurred on Clydeside, during the First World War, in the engineering industry, but the printing and bookbinding industry had already seen the breaking down of the labour process into a number of relatively less skilled tasks. By the end of the century, quite a few of the less skilled operations in the paper and print sector were being handled by women: machine-feeding, paper-ruling and folding; manufacture of boxes, cartons, bags and labels; and in bookbinding, operations which had gradually been downgraded from 'skilled' to 'semi-skilled', such as stitching and collating, were largely being carried out by women. By 1911, there were about 1,000 women and girls in Edinburgh employed on unskilled work in the printing trade, another 1,219 in bookbinding and over 800 in envelope and paper-bag manufacture (see Table 6a).[9] This development was not unusual. What was atypical about Edinburgh was the large number of women recruited to the trade of compositor. Although this certainly coincided with attempts to break down the work process, matters were bound to be more complicated in such an un-equivocally skilled trade. It was to be an opening of a very different kind for our hypothetical school-leaver.

Finally, on entering work of any kind except domestic service, she would find herself among mostly young women. According to the

TABLE 6b. *Ages of women 'printers',*
Edinburgh 1911

14	63
15	112
16	135
17	143
18–19	246
20–4	601
25–44	454
45–64	45
Over 65	1
TOTAL	1802*

Source for Tables 5 and 6:
Census, Scotland, 1881, 1911.

* approx. 850 of these were compositors,
the others in semi-skilled trades.

census, most women in full-time employment in Scotland were in the under-25 age-group. Twenty-five was about the average age of marriage for Scottish women,[10] and it does appear to be the case that with the notable exception of Dundee (where a large number of women continued working) it was usual throughout the period up to 1914 to give up regular employment on marriage and to return to it only if widowed or in great hardship. Domestic servants often remained unmarried, or if they did marry could sometimes carry on working, so their age structure more closely resembles that of male professions (see Table 5b). But in industrial trades, the number of married women was low. For the whole of Scotland the official percentage of married women in employment was only 4.1 per cent, compared to 9.6 per cent in Great Britain as a whole.[11] Sally Alexander and Eleanor Gordon have both pointed out that this is one area where the census figures are particularly unreliable, since they inevitably omit or underrepresent casual, seasonal, irregular or part-time work, which was the only kind many older married women could manage. In the sector that concerns us though, the figures from within the trade and the individual records of women employees tell a clear story: almost all the women compositors were single, and for as long as normal recruitment continued, up to 1910, the majority of them were young. In this respect they were typical of most industrially employed women in Scotland at the time (see Table 6b). The fact that the female work-force in general had a different age profile from that of the male, and that many (though by no means all) women left work in their mid-twenties, was yet another reason for the low pay and status of 'women's work'.

From this very brief outline of the main characteristics of women's employment in Scotland and how they related to the Edinburgh context, we can at least form some kind of picture of the 14-year-old Scottish girl's

expectations about her working career during the last half of the nine-teenth century. Looking around her, she would see that while her brothers might follow their father's trade or profession, whatever that was, or perhaps look for an apprenticeship in a traditional craft, or take advantage of the new opportunities in, say, transport – in short choose, within limits, a career that appealed to them – she was not likely to be able to indulge a personal preference. Her father's trade was probably closed to her; if her mother worked, it was more likely to be in an irregular way as a charwoman than in a regular, let alone a skilled occupation. If she lived in a mill town, the choice was more or less made for her. Otherwise, and particularly if she lived in Edinburgh, she could answer one of the advertisements for a housemaid; or she might, in-creasingly as the century wore on, try for a coveted job as shop assistant; she might enter one of the monotonous and repetitive unskilled indus-trial jobs in say paper-bag making; or use her school training in needle-work to become a dressmaker. She would expect to work for at least ten years, but not to continue after marriage. And she would have little illusion about being able to save anything from the low wages she would receive from any of the available jobs. It is against this background of restricted choice that one should initially view what was really a middle-class pressure group for women's rights: the campaign to open up the compositor's trade to women.

EMILY FAITHFULL AND THE VICTORIA PRESS: THE EDINBURGH CONNECTION

Apart from the few wives and daughters of master printers who had picked up something of the trade in the family firm, the first women compositors in Britain to receive anything like a 'systematic training' were apparently taken on by the firm of McCorquodale of Newton-le-Willows in about 1848.[12] It was a little-known experiment that did not last. Greater publicity and much controversy attended the opening in London twelve years later of Emily Faithfull's Victoria Press, employing a number of women. From the start, this was an isolated experiment, marked by the middle-class philanthropic circles in which it originated. But while there was no direct link between the Victoria Press and the later recruitment of women in Edinburgh, the Scottish capital was the one place in Britain where Emily Faithfull's experiment was imitated in the 1860s. She was directly responsible (by speaking on the subject in Glasgow and Edinburgh) for the introduction of the idea to Scotland, and indirectly for its application on a large scale (as the men's union, the Scottish Typographical Association never forgot: thirty-five years later, in a scathing obituary of Emily Faithfull entitled 'A Pseudo-Philanthro-pist', its journal challenged the view that 'having introduced female compositors to the printing trade' could in any sense be regarded as 'philanthropy').[13]

A clergyman's daughter, aged only 25 in 1860, Emily Faithfull was one of the 'strong-minded women' of the mid-nineteenth century.[14] Remaining single, she devoted herself to a lifetime of campaigning and was, with Bessie Rayner Parkes, Jessie Boucherett, Barbara Bodichon and others, one of the founder members of an organization specifically designed to find work for women, especially the much-spoken-of 'half million extra women' in the population who were statistically unlikely to marry. The Society for the Promotion of the Employment of Women (SPEW for short, unfortunately) was closely linked to the National Association for the Promotion of Social Science (NAPSS) founded in 1857 and including among its members many prominent academics, reformers and philanthropists. From the start, the NAPSS had a number of energetic women members, and also concerned itself with the question of women's employment. Leading members of the SPEW spoke at NAPSS conferences but also had their own headquarters and magazine: they were almost identical with the famous 'Langham Place Circle', and the editorial board of *The Englishwoman's Journal*. It was in this context that Emily Faithfull and Bessie Rayner Parkes first became interested in the idea of opening the compositor's trade to women. SPEW and the NAPSS were both concerned with a whole range of possible openings for women in commerce, the services and industry.

It is not in itself surprising that any mention of industrial employment for women should bring the printing trade to mind. Typesetting in particular had the reputation of being light work, for which the main requirements were literacy and manual dexterity. (Gladstone was not the only public figure to join the chorus about women's 'nimble fingers' being particularly suited to the trade;[15] and fifty years earlier, Napoleon on being shown round a printing office had growled that it was 'women's work'.) It was Bessie Rayner Parkes who, in order to find out what truth there was in it, first bought a small press and some type, and she and Emily Faithfull took instruction in the trade themselves. 'A short time [had] convinced them that if women were properly trained, their physical powers were singularly adapted' to such work.[16] With help from both SPEW and the secretary of the NAPSS G. W. Hastings, a house had been taken in Great Coram Street, off Russell Square, and the Victoria Press was created with five women apprentices in March 1860. 'Intelligent, respectable workmen' were engaged to do the tasks the women could not: which according to Miss Faithfull meant 'lifting of the iron chases . . . the carrying of cases of weighty type . . . and the whole of the presswork'.[17] By October there were nineteen women compositors in the office, several of them the daughters of master printers. The interesting story of the Victoria Press has been told elsewhere.[18] What most concerns our subject is the effect on her Scottish audiences of Emily Faithfull's lectures about it.

It was the NAPSS which brought both Emily Faithfull and Bessie

Rayner Parkes to Scotland for its fourth annual conference, held in Glasgow in October 1860. Both speakers gave papers on the employment of women in printing, and such local interest was aroused that they were asked to repeat their lectures in Edinburgh a few days later. There, the meeting in the Queen Street Hall, although not publicly advertised, was 'crowded with a highly respectable audience, chiefly composed of ladies' and also including many well-known male supporters of charitable or progressive causes. After hearing about the founding of the Victoria Press, the audience took part in an animated debate, in which the question of wages was immediately raised.[19] Although we know from other sources that Emily Faithfull's London apprentices and journey-women were in fact paid the full male rate (though with some amend-ment of the apprenticeship system), it was clear that she and other promoters of the scheme *did* anticipate that the consequence might be to lower wages in the printing trade. This does not seem to have caused them undue concern. Emily Faithfull herself rather naïvely replied to one questioner:

> Suppose a printer receives from 30s to 36s a week and suppose his wages were reduced 10s per week, and his daughters who before had been in no employment receive each 10s, 12s or 15s . . .

The family, she implied, would be better off. Bessie Parkes more pru-dently replied that she thought it was 'undeniable' that it would bring lower wages but 'it was only fair to let women have a fair share in the competition'. G. W. Hastings, who was present, went much further in his hostility to male printers and thought it would be a positive 'ad-vantage if wages were lowered in the printing trade', referring to the London union (the London Society of Compositors) as 'one of the most powerful and most structured trade unions in London', which, un-justifiably in his view, 'prevented any printer employing any compositor at less than 33s a week'. He also made dark references to drink. Other speakers expressed unease about disturbing the wage structure, and James Wilkie, an Edinburgh compositor in the hall, warned that the city already had too many apprentices, too low wages and not enough work: 'with the exception of a month or two in the winter time, there were always printers looking for work'.

THE CALEDONIAN PRESS IN EDINBURGH

Whether or not as a result of the unease expressed at this meeting, two completely separate organizations were set up in its wake. The first and more 'official', was the Edinburgh Society for the Promotion of Employ-ment for Women (ESPEW). This was the new name of a group which had already existed informally for a few years, with a number of repre-sentatives from well-known 'reforming' Edinburgh families on its com-mittee: the McLarens, Mairs and Stevensons for instance. ESPEW did *not* set out to make the printing trade a priority recruitment area. Its first

public letter to the *Scotsman* referred to 'clerical work' or supervisory jobs as being the best area to concentrate on, but within a short time it had established a register for women's employment of a wider kind. The annual report for 1862–3, by the secretary Phoebe Blyth, lists the following occupations as those in which it was trying to place women:

> Teachers . . . female missionaries and Bible women, sick nurses, book-keepers, colourists and printers of photographs, hairdressers, shop girls, waitresses, copyists, amanuenses, dressmakers, upholsterers, sewers . . . from finest embroidery to sewing machines, knitters and daily workers [i.e. charwomen].

It was hoped to add 'French polishing and telegraphy' to the list, but printing is conspicuous by its absence.[20]

It was quite a distinct and separate organization – though one clearly inspired by the NAPSS conference and the Victoria Press – which placed an advertisement in the *Scotsman* in January 1861, a month or two after Emily Faithfull's visit to Edinburgh.[21] Describing itself as the 'Scottish National Institute for Promoting the Employment of Women in the Art of Printing', it claimed the patronage of a host of 'distinguished persons', headed by the Duchess of Kent and several other noble ladies, and was supported by a list of professors, provosts, clergymen, mayors etc. From the lack of overlap between the patrons of the two ventures, it seems likely that the progressive bourgeoisie of ESPEW were not disposed to back the printing initiative supported by a more conservative section of the upper class, nor apparently was the venture connected to the NAPSS, which, as the *Scottish Typographical Circular* pointed out, 'so far as Scotland is concerned, declined to have anything to do with the attempt to introduce women into the printing business'.[22]

The new 'Scottish National Institute' did however refer in its prospectus to the NAPSS meeting, and went on to speak of the 'surplus female population' which required 'fresh fields for the employment of their energies'. It proposed to establish a printing office in Edinburgh, 'with eventual auxiliary branches in Glasgow, Aberdeen, Dundee, Perth, etc . . . for the instruction and employment of women in the art of printing'. Apparently the only one to be created was the Edinburgh office, christened the Caledonian Press. Our knowledge about its brief existence is sketchy and comes mostly from one internal, and therefore highly favourable source, the magazine the *Rose, Shamrock and Thistle*, and one external and extremely hostile source, the union journal, the *Scottish Typographical Circular*. The latter denied all philanthropic motives for the new press, describing it as 'really a private business speculation'. The moving spirits behind the Caledonian Press were members of the Thomson family of Lasswade near Edinburgh, described by the *Circular* as 'a father with cash, a son with brains and a daughter as nominal figurehead'.[23] About Miss Mary Anne Thomson – the shadowy Scottish equivalent of Emily Faithfull – it is certainly hard to find much information, but

then it is often hard to find much out about women in Scotland, even those who were quite prominent in public life. Perhaps she really did little more than lend her name, but it was to her at any rate that Queen Victoria's secretary wrote with royal support for her venture (the Queen had also supported the Victoria Press, named after her). An article on the Caledonian Press, in the magazine it later published, attributed the initiative of the whole enterprise to her: 'To whatever credit this may entitle her, Miss Mary Anne Thomson may justly lay claim.'[24]

The Caledonian Press was a much smaller concern than its London inspiration. By 1862 it was established off Princes Street, in a district where many printers already had offices. Beginning with 8 apprentice girls and three journeymen tutors, by 1863 it was employing 14 women. The *Circular* was not impressed. Referring to it as an artificial 'pampered velveteen system', the union journal was scathing about its 'pretentions':

> The small office in Edinburgh called the Caledonian Press . . . was opened a year ago, under the patronage of many of the nobility and members of the learned professions: yet with all its boasting about promoting the employment of women . . . and opening up a fresh field . . . to the 'surplus female population' . . . it actually employs fewer women than any simple respectable milliner, of whose philanthropy the world takes little note.[25]

Unlike the Victoria Press, the Caledonian produced little in the way of books. In one respect at least, however, it preceded Emily Faithfull's London office, by creating a monthly magazine with the express aim of providing a 'constant supply of work for the "hands", all female'. The *Rose, Shamrock and Thistle* was launched in May 1862 and ran until March 1865. Described as a 'magazine for the fair daughters of Great Britain and Ireland' it contained a variety of essays, articles, poems and serials when it first appeared, and announced that its aim was to 'convince the sceptical that it is wise and well to qualify women to maintain themselves honourably and decently when through illness, death and desertion or bankrupt circumstances [they are] thrown on their own resources'. Editorials regularly refer to the magazine being produced by an all-women team,

> from the Editress and her fair, brilliant and chivalrous staff, down to the merry-faced ruddy-cheeked little lassie that in quainter and ruder hives of literature would be represented by a grim-visaged imp in paper-cap and corduroys yclept a 'Printer's d---l'.[26]

(This was typical of its style.)

Editorial inspiration for the *Rose, Shamrock and Thistle* seems to have flagged long before its official end. By 1864, it was already publishing comparatively few articles about the position of women for instance, and by the time it closed in 1865, the copy consisted almost entirely of serials. The closure was linked with the failure of the Caledonian Press, and both

were greeted with rejoicing by the *Circular*. Having 'been got up avow-
edly . . . to lower the wages of men', the union journal reported, the
venture was doomed from the start. It had struggled from beginning to
end, had depended entirely on charity throughout its four-year exist-
ence, and now the girls working there were being irresponsibly left
destitute. The collapse must have been much commented on in the
Edinburgh print and publishing trade, but the local press was discreet.
An advertisement appeared in the *Scotsman* drawing attention to the sale
of 'the whole valuable stock of letter-press and printing materials belong-
ing to the Caledonian Press, who are giving up business with the
premises No. 31 Hanover Street'.[27]

A CLASH OF INTERESTS

From the widely reported experience of the Victoria Press in London
(which survived into the 1880s, though Emily Faithfull had moved on by
then) and the lesser known and less successful Caledonian Press in
Edinburgh, what provisional conclusions can usefully be drawn? In the
first place, there was not only a sex difference but a gap of glaring
dimensions politically, socially and even of age, between those who
promoted the introduction of women to printing and those who op-
posed it. Emily Faithfull, young, confident and securely middle-class,
appears to have been operating from first principles rather than speaking
or understanding the language of journeymen printers. On the face of it,
hand-composition in letterpress printing seemed to be well suited to
women's 'dexterity'. And since literacy was a prime requirement, type-
setting was of all the manual trades the nearest to teaching, governessing
and clerking: traditionally the only hopes for educated girls who needed
to earn a living. It seems indeed that the social categories Emily Faithfull
had in mind as 'compositoresses' were the educated daughters of re-
spectable tradesmen: the only ones whose origin is known for sure, and
who were ideal for the experiment, were the daughters of master print-
ers (rather different from the daughters of journeymen). She appears
also however to have had in mind the entry to the trade of unequivocally
middle-class girls, arguing that 'the most cultivated class of women'
could become proof-readers (which was almost like 'working in publish-
ing'). But 'before the office of proof reading can be properly undertaken,
a regular apprenticeship to printing must be worked out . . . I would urge
a few women of a higher class to resolutely enter upon an apprenticeship
for this purpose.' A third category – and here presumably the notion of
philanthropy is to the fore – consisted of orphans or destitute girls in
institutions – of unclassifiable social origin but genteel upbringing. She
had herself taken on 'a little deaf and dumb girl from the Asylum in the
Old Kent Road'.[28]

Thus from the point of view of journeymen compositors in London
and Edinburgh alike, there was an immediate sense in which the whole

venture must have appeared socially alien – launched in an atmosphere of middle-class philanthropy, pursued by young and perhaps slightly naïve women of that class, and seeking to introduce to the trade young girls of perhaps middle-class, perhaps marginal, but not necessarily working-class origin. The patronage of the liberal intelligentsia (in the case of Emily Faithfull) or of traditional notabilities and aristocrats (in the case of Mary Anne Thomson) did nothing to allay suspicion of this kind. Class antagonism is in fact rarely expressed openly in the caustic comments of such journals as the *Scottish Typographical Circular*. References are generally oblique: for instance in the argument that if a woman had enough education to do the job, she was probably 'in a class aspiring to a higher social position'. The *Circular's* report of the NAPSS meeting in Edinburgh referred to the confusion over the 'class' of the women to be introduced, noting that Miss Parkes had actually said 'lower-class'. More often, the subject lies concealed somewhat under the more visible question of wages.

It was taken for granted that the introduction of women generally to any trade carried the risk of lowering wages; basically because as we have seen, the wages paid for 'women's work' were so low. A woman would be quite prepared to accept a wage lower than a male compositor's, since it would probably still be a great improvement on what she could earn elsewhere. This worried not only trade unionists but some of the liberal progressive backers of the efforts of SPEW. It is true that the question remained at a rather theoretical level in the 1860s. The Victoria Press in fact paid its women workers the 'London scale', that is union rates, as even the *Circular* admitted, and the Caledonian Press seems to have paid the male rate too. At the same time Emily Faithfull modified the length and pay of apprenticeships, and the workers had extremely good conditions and shorter hours than elsewhere. (It is not known if the Caledonian Press did likewise.) But it was argued by the trade unions that the exceptional circumstances of such pilot schemes permitted these 'fantasies':

> It is not probable that any attempt will be made in London or Edinburgh to reduce the women's prices, so long as the movement has the sympathy of the benevolent public, but when left to compete by themselves with establishments conducted on commercial principles, the temptation to resort to this course might prove irresistible.[29]

Finally, there is a sense in which these two enterprises in London and Edinburgh were perceived as particularly worrying not just because of the social origins of promoters and beneficiaries, or because of the threat to wages, but because they meant bringing women into the work-place. After all, in the real world, compositors' wages were already being theatened by cheap *male* labour – that of apprentices and non-union men for instance. But the same anxiety is not present in union objections to

these groups. When it came to women, there was a flurry of gender-specific arguments: printing was 'a calling for which their delicate frames are wholly unsuited'. Commenting on Gladstone's support for the scheme, the *News of the World* said: 'picking up type is not the same thing as picking up needles and stitches: the mental and physical labour demanded in the compositors' room is infinitely greater than anything that has yet been required of women'. Health and hygiene were also cited, with special reference to women's 'future usefulness as wives and mothers'.[30] These arguments had already been well rehearsed in France, where in 1862 there was a major strike by the Paris compositors against the employment of women. The *Scottish Typographical Circular* reported of this conflict that 'people are beginning to see that making women printers . . . will only unfit them for the active and paramount duties of female society'. Since both the Victoria and the Caledonian Press explicitly claimed to be offering work to women who really needed it, and who might never marry, arguments about the appropriateness of married women working were not particularly relevant, but they were made just the same: woman should be 'man's helpmeet not his rival'.[31]

Such reactions are a familiar enough story, and the printing trade was by no means the only one where they were found. But objections to women as women also recognized the specific threat they posed in the printing-office. Firstly, it looked as if the experiments in London and Edinburgh were introducing a division of labour on sexual grounds within the very 'art and mystery of printing'. The breaking down of any skilled trade into less skilled or specialized components carried a major threat to the whole apprenticeship system and to the notion of the craft as well as damaging the control of the worker over the work process, as Taylorization in the twentieth century would clearly demonstrate.[32] What was crucial about the 'women's offices' was that part of the trade – straight typesetting – was being defined as 'particularly' suitable for women; indeed it was being said they were actually better at it than the men, while the other tasks in the compositor's repertoire were variously described as 'heavy' (thus by definition not skilled) or on the contrary as highly skilled (make-up and imposition) but requiring fewer persons to do them. The fragmentation of the trade – the implications of which were only dimly perceived at the time – was to become of crucial importance later and will be looked at in more detail below. But even in the 1860s, the notion that a 'mere girl' might learn the trade very quickly and be doing as well as a man in a short time, was not only a threat to employment but a threat to the craftsman's pride in his skill.

Secondly, the appearance of a woman in the composing room could be seen as a sort of violation of male privacy, which could only be viewed with horror by male comps. Girls, even if they were the daughters of master printers, had no experience or knowledge of collective traditions. The language and rituals of the chapel were, as we have seen, so

uncompromisingly masculine that it would have seemed impossible for printing-house life to be the same again once women were admitted to the craft. It is true that the Victoria and Caledonian experiments did not introduce women into an existing office, but neither were they exclusively all-women affairs. The journeymen who were employed 'to do all the tasks the women did not', as well as to train the novices, meant that they were mixed offices from the start. The extension of the project could not but mean bringing a mixture of the sexes to regular printing offices.

Looking back over this early venture, it is easy enough to see in it the seeds of what was to come. In their earnest and determined way, the promoters of women's employment were calling the bluff of the skilled journeyman, but without appreciating the violence of feelings aroused by the threat not just of cheap labour but of cheap female labour. The men's fear of change took the form of vociferously defending the status quo in which after all they had everything to lose. The actual women themselves – or rather girls, for they seem mainly to have been under 18 – who worked in these experimental offices, are not heard in the debate, silenced not so much by their sex perhaps, as by their mostly humble circumstances and extreme youth and inexperience. (After all the voices of male apprentices are not usually heard in the debates over apprenticeship.)

In the event, although the Victoria Press did last for over twenty years, and despite the creation in London in 1876 of the rather similar Women's Printing Society, which also paid the full male rate, women compositors never penetrated the London trade to any extent. The powerful London Society of Compositors managed to see that women were on the whole excluded from the capital, even if some employers who had moved to the provinces did employ women.[33] In Edinburgh, where the Edinburgh Typographical Society heaved a sigh of relief when the Caledonian Press failed in 1865, that must have seemed like the end of the matter. But within a mere eight years, the movement had begun which was to result in the large-scale recruitment of women to the Edinburgh book-houses.

3

THERE TO STAY: HOW THE FIRST WOMEN ENTERED THE EDINBURGH CASE-ROOMS

It was the received wisdom in Edwardian Edinburgh printing offices, and it has been repeated by writers ever since,[1] that women first entered the trade as strike-breakers during the great print strike of 1872–3 in the city. When examined closely, this turns out to be a half-truth, and as with many half-truths, exploring the point at which it breaks down can be instructive. To do so means asking some questions about the relative strengths and weaknesses of the male compositors' trade union, the Scottish Typographical Association (STA) and in particular its Edinburgh branch, the Edinburgh Typographical Society (ETS); about the potential recruits for strike-breaking, whether these were non-union men, apprentice boys or women and girls; and about the circumstances in which the first women crossed the threshold of Messrs Constable's and Chambers's offices in December 1872 or January 1873.

THE STA AND ITS ENEMIES

Until the expansion of heavy industry in the West of Scotland in the latter part of the nineteenth century, most Scottish workers were in a low-wage economy, and trade-union organization was not well advanced. Certainly it was more localized (by town) than its counterpart in England, and the relative autonomy of local unions may have contributed to weaknesses in the early days. The old craft trades were on the whole the first to organize trade societies, giving the labour movement in Scotland a particular character and (some have argued) a particular ideology in which the influence of thrift, temperance and respectability was very marked. Commenting on the composition of the Edinburgh Trades Council in mid-century, Ian McDougall writes: 'local trade unionism was predominantly, though not exclusively, that of the skilled workers or labour aristocracy'.[2] In printing, a craft trade *par excellence*, organization went back at least as far as the eighteenth century in Edinburgh and several other towns. Attempts to set up a national printers' union in Scotland date from 1836, but both the General Typographical Association of Scotland and its successor, the Northern District Board of the National Typographical Association, came to grief after only a few years. Eventually the Scottish Typographical Association was founded on a lasting basis in 1853, composed of branches in towns where there was a moderate degree of printing activity.[3]

Although the STA had a continuous existence from 1853, there were still imbalances between the different branches in numbers, strength and militancy. At first there were branches only in Glasgow, Edinburgh, Dumfries, Kilmarnock and Paisley: as yet none existed in Dundee, Perth, Inverness or Aberdeen. Essentially Glasgow and Edinburgh were the two towns which provided the bulk of the membership and carried the burden of administration.[4] The STA headquarters were in Glasgow (which thus acquired a degree of leadership in the union), but the union journal the *Scottish Typographical Circular* was written and produced by the Edinburgh branch until the 1900s. Estimates of the numbers in the trade, or of union membership, are necessarily vague before the union began publishing statistics in the mid-1870s. Of the estimated 1,500 journeymen and 1,200 apprentices working as printers (pressmen and compositors combined) in Scotland in the 1850s, rather more than half were working in the book and jobbing section of the trade, the rest in newspaper offices.[5] As we have seen, bookwork tended to be concentrated (though not exclusively) in Edinburgh, and the Glasgow trade contained more newspaper and jobbing printers. It seems that in Edinburgh the ETS grew from an average of 265 members in the late 1850s to about 650 in the late 1860s.[6] In Edinburgh, as in the other towns, the membership consisted of compositors and press- or machinemen, side by side, within the same branch.

Even in the early days, when wage differentials between the two cities were not great, the Edinburgh compositors were considered by their Glasgow colleagues to be lacking in spirit: 'The printers [i.e. compositors] of Edinburgh had the unenviable reputation of being willing to accept work at a reduced rate in almost any town in the United Kingdom before 1840.'[7] Whether this was a deserved reputation is not altogether clear, but may be explained by the peculiarities that made Edinburgh a special case long before 1872. The Edinburgh journeymen compositors had succeeded in 1803 in their appeal to the courts to sanction a document known as the *Interlocutor* – an extraordinarily complicated scale of piece-work rates – which was regarded as a great victory. Its long-term effect however was to provoke Edinburgh employers into various devices to evade the high piece-work rates stipulated by the *Interlocutor*. The most notorious was the introduction to Edinburgh (as nowhere else) of the 'mixed system' referred to in Chapter 1. To avoid the 1803 rates, employers hired a number of skilled men to do the most expensive work (known in the trade as the 'fat') and paid them by time or stab (establishment) rates. The less complicated typesetting ('lean') – essentially solid lines of text – was allocated to piece-workers known as 'linesmen', i.e. men paid by the line (in practice by the 1,000 ens). Whenever trade was slack, employers tried to keep stab men fully employed at the expense of linesmen. The result was to keep linesmen's wages down: before 1862, when the stab wage was 25s a week, most linesmen averaged 15s 2d; in

1894, when the stab rate was 32s, 24s was the best a piece worker could hope for.[8] When laid off, the linesman went elsewhere in desperation, thus causing Edinburgh men's reputation for accepting low rates. The Edinburgh branch of the union faced particular problems from the start, then, with a sub-category of skilled, fully apprenticed but low-paid compositors in the trade well before any mention is heard of women, and with a division of labour between groups of compositors already well established.

The gap between stab hands and linesmen, peculiar to Edinburgh, was not the only division in the work-force with which the union had to contend. In any confrontation with employers, the ETS had to reckon with the potential split between compositors and machinemen; with the apprentice question; and with the threat from non-union men recruited from outside.

In most branches of the STA, compositors and machinemen were not in conflict. But in Edinburgh, the mixed system meant that a large number of compositors were on piece-work, while the machinemen were virtually all 'on time'. This led to tensions, uneasily held in check and would eventually, though not until after the 1872 strike, bring about a split within the Edinburgh branch.

Inside the composing-room itself, there was the perennial 'apprentice question'. As the overall Scottish figures show, the ratio of apprentices to journeymen in the trade was high, far too high in the view of the union, which was always trying to get employers to reduce the intake of apprentices. A root cause of the numbers was the long seven-year apprenticeship at low wages – a restriction of entry to the trade which compositors were reluctant to alter, but which was increasingly becoming a two-edged weapon. Although apprentices wasted a lot of time in their early years, most of them had picked up enough of the trade to be useful typesetters long before the seven years were up. A particularly vexing category was the 'turnover': the apprentice who had served most of his time but was not yet a journeyman, and who was snapped up by employers to do a man's work at a boy's pay. The apprentice problem was by no means peculiar to Edinburgh, but it was one more source of cheap labour for Edinburgh employers, and further divided the work-force, this time by age.[9]

Because of their youth and vulnerability, and since they were less likely to be union members, apprentices and turnovers might be persuaded by employers to carry on working during a strike. But the real strike-breakers usually came from outside. 'Foreign' or 'rat' labour, as it was called in the trade, consisted of unemployed compositors from other towns, who might be tempted to work for lower rates, or to move into a strike-bound area because they were 'on the tramp' and desperate for jobs. Edinburgh, as a large and well-known printing centre, exerted a powerful attraction on all such men in the north of England, who came

flocking when jobs were advertised. Sometimes the union was success-
ful in persuading newcomers not to take the work, but employers'
inducements often proved too strong. Here then was a further division
among male compositors, well established before 1872.

Despite the weaknesses in their position caused by such divisions, and
despite their supposed 'apathy', the Edinburgh printers showed a
marked willingness to combine, as the history of their confrontations
with the employers shows. But in Edinburgh they were opposed by
extremely entrenched resistance from a determined group of employers.
The latter had formed a Master Printers' Association in 1846, with the
explicit aim of keeping out unionists and outlawing strikers. It was the
attempt by the men to boycott these employers, energetically under-
taken, that had eventually led to the collapse, through debt, of the
Northern District Board (the predecessor of the STA) in 1847.[10] In later
years several of the STA's 'forward movements', that is claims for higher
pay or shorter hours, began in Edinburgh.[11] The 1872–3 strike would be a
further example of a determined effort by the Edinburgh branch which
met with tough employer resistance. As in the past, the cost to the union
would be high, and an enforced period of recovery and retrenchment
would – not for the first time – follow.

THE STRIKE OF 1872–3

During the 1860s, the various branches of the STA had made modest but
steady progress towards a higher wage. It was in Edinburgh that the
question of reducing hours was first raised, in the wake of the nine-hour
day movement which had been launched in the building trades. In 1865,
the hours in printing offices were reduced from sixty to fifty-seven per
week. The early 1870s were a time of prosperity for the trade,[12] and the
ETS felt sufficiently confident to present a memorial to the employers in
1871 asking for a further reduction to fifty-one hours. A compromise
settlement of fifty-four hours was reached, but the union returned to the
fifty-one hour claim, this time combined with a demand for better over-
time pay and piece-work rates, in September 1872 (just before the year's
busiest season began). When the employers refused the claim, a 'largely-
attended meeting' of the men unanimously decided to harden their line
(asking for an increase in the stab rate) and to 'tender notices', i.e. to give
notice of a strike on 1 November. Despite some conciliatory moves on
both sides (notably, an offer to meet some of the pay claims, though not,
significantly, on piece rates) the masters remained adamant on the main
demand of reduced hours. 'On 2 November, 800 employees, inclusive of
apprentices, journeymen, readers and men in positions of trust, gave
two weeks notice' and the strike began on 15 November.[13]

It started amid much cheerfulness, confidence and good humour. The
men met at Drummond Street Hall for recreation including 'chess,
draughts and dominoes . . . and walking parties were organized to

explore the fastnesses of Corstorphine, Braid and Pentland Hills . . . The Meadow Park is lively each day with football players'. Only two dozen members of the union did not join the strike.[14]

But the mood did not last long: 'rat' labour was soon in town, attracted by the comparatively high wages, combined with the lower cost of living, and the additional inducement of three-month contracts offered by some employers. The Minute Book of the union strike committee reckoned the number of strike-breakers by 11 February 1872, that is three months into the strike, as 404 : 253 'foreign comps' and 70 'home comps'; 43 'foreign machine men' and 39 'home machine men'.[15] At a general meeting held on the evening of 13 February, it was reported that there were 475 non-union journeymen at work in Edinburgh and that 'additional hands were daily arriving'.[16]

There can be little doubt that the chief strike-breakers were the outside 'rats', contempt for whom was freely expressed in union journals which commented in disgusted terms on their 'greasy nondescript attire . . . blotched faces and unkempt locks . . . [and] hangdog look'.[17] Their capacity to do the work was doubted: 'a blackguard horde of broken down incompetents [have been taken on] to take up our work'. 'Botched . . . hideous proofs, damaged machinery would be the result'.[18] The Edinburgh strikers held out firmly, and had the support of other unionists in the town. The Trades Council recorded in its minutes of 28 January that

> elements of pressure had been put upon [the Edinburgh printers], enormous sums of money had been expended, rare inducements had been held out, untruths had been circulated, even religion had been abused [?] and brought to play on purpose to shake the men, and yet after all these means had been expended and an income verging on starvation, the men had remained as firm as at first.[19]

But two weeks later, it was clear that the strikers were losing. Many had been forced to leave town, and even the unusually low subsistence allowance the union was paying had eaten alarmingly into its funds. At the general meeting of 13 February mentioned above, and on advice from STA headquarters, conveyed by the ETS secretary John Common, the men voted to return to work on 'the November conditions', that is with an extra 2s 6d on the stab rate (to bring it up to the Glasgow figure) plus some concessions on overtime, but no joy on piece rates or on the question of hours. The voting was 200 for, 131 against (the meeting, 700 strong, included 'newspapermen and those currently working' who did not vote).[20] The letter which the employers sent to John Common, acknowledging the return to work, congratulated him on 'the manly and frank tone in which you intimate the termination of the dispute.'[21] Of the 750 men who had originally walked out, 450 were still in Edinburgh; of these 200 were still unemployed a week later and it was thought that full

absorption would take up to six months;[22] in fact by early April, only 20 strikers were still without work.

In all these 'manly and frank' affairs, where were the women? I have cheated a bit by not mentioning them until now, but the first mention of women by the union does not actually occur until late January and early February, that is when the strike was already entering its final phase. There is evidence to suggest that they had indeed been introduced before this to some offices – possibly as early as before Christmas 1872 – but it is clear from the strike committee minutes that they were not regarded by the union as a threat of any significance compared with that of outside labour. The first mention of women – and as a potential threat only – appears in the strike committee minutes for 25 January 1873. A member reported that a circular had been issued by Mr Constable, a leading employer, 'to boarding schools etc., intimating his willingness to receive young men and women and educate them as compositors'.[23] The committee decided to pass on this information to the editor of *Out On Strike*, the strikers' newsletter, to use at his discretion.[24] A fortnight later, W. & R. Chambers placed an advertisement in the *Edinburgh Evening Courant* (the first of its kind that I have been able to find in the local press), reading: 'Printing: wanted: young women of good education and character, to act as compositors'.[25] However some employers must have moved more quickly, since the *Scotsman* for the same day carried the following report:

> The masters say they have engaged workmen from England who have proved equal to the occasion, while *for the past few weeks* an experiment was made with educated females at the case. This experiment has proved eminently successful and the largest employers in the city who have engaged these women – varying in number from 4 to 20 – state, we understand, that the females give every promise of great efficiency as compositors.[26] [my italics]

The contemporary evidence is fragmentary, but it is clear enough that the strike was the occasion for certain master printers to revive the idea of employing women. A later commentator says that the plan 'had been cherished by them for years'[27] and it could very well have its roots in the Caledonian Press experiment, which had ended a mere eight years earlier. All the same it is far from true that they were used to break the strike. This, as the strike committee's Minute Book, the articles in the *STC* and the local press emphatically record, was primarily the doing of foreign male labour. The distinction may not seem an essential one, but there is a difference: 'strike-breaking' suggests a degree of capability for the work and willingness to do it which may have been possessed by the 'rats' of 'London and Liverpool',[28] but was unlikely to have been displayed by the handful of girl apprentices actually engaged during the strike. Their appearance in the case-room while the men were absent was little more than symbolic. They could not have learned the trade in

time to be of any practical use to the employers in keeping orders going. But it is as strike-breakers – with all that that implies of betrayal of working-class solidarity – that they went down in ETS history. And the label was retrospectively applied to all 'females' in the trade, although it had originally been relevant only to a handful of school-leavers, comparable to the boy apprentices who also worked during the strike. They were undoubtedly used by the employers, and the strike was seized as a chance to bring them in – but it should be firmly stated here, since it is usually glossed over, that the damage to the strikers' cause was not for the first time, the result of actions by other men.

THE FIRST GIRL RECRUITS

Who were these early recruits? The fact that 'educated females' were the desired targets of the newspaper advertisment suggests that the 'philanthropic' nature of the experiments of the 1860s was uppermost in the minds of the employers. And we have also seen that the 'boarding schools' were to be circulated. In Edinburgh at the time, there were various schools which might come under this heading, including the Merchant Company schools which provided a good education originally for children of humble backgrounds, but increasingly for middle-class children. They did take in boarders, many of whom were orphans or the recipients of charity.[29] The historical sketch included in Macdonald's 1904 survey of women in the printing trades states that it was indeed the pupils of Merchant Company Schools who formed the first recruits, and that these were 'a better class of girl', sometimes described as 'stickit' (would-be) teachers.[30] The heading may also cover orphanages. In both cases, the girls would have been brought up in a genteel atmosphere, although they might originally have come from very poor families. One compositor, Jean Henderson whose daughter kindly provided me with information, went into the trade (in the 1890s, that is some time after the earliest entrants) straight from the Dean Orphanage, where she had received a good education (see Plate 1). Her father, a sailor from Shetland, had been lost at sea, and her mother had to bring her two young children up in desperate poverty until they went to the orphanage. We do not know whether all the original recruits really were from orphanages and boarding schools, but if so, they were a particularly vulnerable group of people with a very confused class identity and little choice of work when placed under pressure from patrons. We do know that 'they were for the most part young women of eighteen and upwards' in the first instance.[31]

It may well be that the better education of orphan girls was a particular feature of the experiment. The Education Act (Scotland), making education compulsory for children from five to thirteen, had only just been passed in 1872, and the capacity to read complicated copy could by no means be assumed in all girls (or indeed boys) even from 'respectable

artisans'' families, as is illustrated by the remarks of Mr McCrie, the owner of a paper factory, reported in the *Edinburgh Daily Review* in January 1873. At a meeting called by a philanthropic group to discuss funding of 'education for artisans', Mr McCrie spoke of the low educational attainments of his work-force: twenty 'girls between thirteen and twenty . . . each girl respectably connected'. Not one of them, he said, was able to read the Bible correctly, but all could dance a quadrille, sing, and half of them could waltz. The teacher found that 'four could read Messrs Nelson's Shilling Book, six the Sixpenny Book, and ten only the Threepenny Book'.[32] With the 'board schools' in their infancy, it was by no means clear that it would have been possible to recruit many girls of working-class origin into the trade in the early 1870s. As we shall see, that would quickly change.

It is possible to plot fairly closely the rate at which recruitment of girls increased, once the strike was over. In June 1873, the *STC* reported that it was 'scarcely possible' to speak with confidence of the numbers employed, 'perhaps they may reach 50 [overall] . . . but the number is increasing at an alarming rate'.[33] In September that year, the ETS sent out a questionnaire to its chapels, the results of which indicated a total of '63 girls' in employment.[34] Some partial statistics in February 1874 suggest that in certain firms the number was rising particularly fast. The largest houses were the ones who most readily hired girls. There were 13 or 14 at R. & R. Clark, and 22 at Ballantyne's (out of a total work-force of 94 – the male workers being 36 piece, 16 stab and 20 apprentices). Turnbull and Spears had 6 girls out of a total work-force of 30. At Neill's, there were already 20 girls to 30 men. Only one large firm in Edinburgh – Thomas Nelson's – never, throughout the whole period in question, employed any women compositors.[35] By the end of 1875, the increase was, if not dramatic, still considerable. By now there were '114 females employed at case'; they compare with a total of 928 men in the trade (compositors and pressmen included), 434 of whom were members of the ETS. By this stage it could fairly be said that women had gained a footing in the Edinburgh book-houses. Whereas the 'rats' had broken the strike, its long-term effect was to allow the 'mice' to creep into the trade.

WOMEN COMPOSITORS: AN EDINBURGH SPECIALITY

Why was there no protest from the men? Part of the explanation is that the strike had (like previous disputes) left a legacy of financial burden and division within a much weakened union. The fullest retrospective account of the union's difficulties at this time is contained in the 'Statement by the Edinburgh branch on the Female Question', printed in the *STC* almost thirty years later in 1904.[36] This argues that there was a drift away from the union after the strike, although it did not, apparently, happen immediately (and there are some discrepancies between the figures it gives and the 1870s records). In December 1874, the statement

says, the ETS had 900 members including the 200 machinemen, but by 1880, there were only 342 union men left. The machinemen had seceded, claiming that the interests of the press section of the ETS were 'always subordinated' to those of the compositors. Gillespie suggests that there were other reasons, including the purely personal, but whatever the immediate causes, the 1872–3 strike was an underlying factor.[37] The division between compositors and machinemen offered employers an opportunity to play one off against the other, weakening the union's bargaining power. (Significantly it was only after the definitive healing of the breach – in 1907 – that the ETS made its all-out effort to 'resolve the Female Question': see Chapter 5.) But the secession of the machinemen was not the only source of weakness. The STA as a whole was left with debts totalling £6,260 in the 1870s, and 'the greater part of this sum was absorbed by the members of the Edinburgh branch . . . [who] above all others might have been expected to stand by the office-bearers till the debt was at least liquidated'. As it was, 'with a depleted membership, with chapels thoroughly disorganized, the branch for years after the strike, was not in a position to remedy the grievance of female labour'.[38]

It must also be said that during these early years, in the 1870s, there was little hostile reaction from most of the men. 'At present [the employment of women] is treated with indifference by the great bulk of compositors'.[39] Evidently the employers were expecting some hostility, as the reminiscences of one elderly compositor suggest: 'back in the 70s . . . I was just finishing my apprenticeship, and the shop I was in was trying to start female labour. The girls were being taken in at night after we left and what a mess we got in the morning! Type was pretty plentiful on the floor and the stuff on the galleys, well 'nuff said!'[40] But before long, a correspondent of the STC was pointing out that '60 to 70 per cent of the fair intruders are being sedulously drilled into the p's and q's of the art by members of our own society!'[41] The Society had asked members not to let their own daughters enter the trade, but now, for a few shillings extra, they were training the girl learners. The minutes of the ETS executive committee, available only up to 1875, while periodically recording the numbers of women compositors with some anxiety, are more concerned with the pressing problem of money and sliding membership. The warning voices raised from time to time in the journal appear to have been in the minority. Most surprising of all, at a quarterly delegate meeting at the end of 1873, 'it was generally held that there could be no reasonable objection to their [women's] employment to a certain extent; the main point in dispute being, was it right to put a limit on their number and . . . to what extent and how to apply the rule'.[42]

It may well have been the case that at this time, only a few months into the venture, the women were being paid much the same wage as boy apprentices at the same stage, and this would therefore explain why the delegate meeting decided merely to try to apply the same rule as, in

theory at least, limited apprentices' numbers. The threat to adult com-
positors was not yet clear. But probably equally important was the fact
that the early 1870s was a time of full employment in the trade. With
work plentiful, the women's influence was 'not . . . much felt . . . but with
the start of depression, more attention was focused on them as a threat to
the employment of journeymen'.[43] By 1879, the STC reported that while
'the influx of females' was 'not unbearably felt' while trade was good,
'now the necessity on purely philanthropic grounds of course, of keep-
ing the ladies supplied with copy', had led to 'dispensing with the
services of a large number of journeymen'. Those out of work quickly
reached unprecedented numbers. 'The number . . . wholly or partially
idle has not been excelled within the memories of most living printers,
even the oldest'.[44] Trade continued to fluctuate in the 1880s, and from
now on worries were regularly expressed in the STC: 'however reluctant
we may have been to realise the position into which we were slowly but
surely drifting' the threat was now a permanent reality.[45]

By this time, Edinburgh had emerged as the recognized centre of 'the
Female Question' (as it is always known in the union literature). Else-
where in Britain, notably in London, women compositors were a small
and declining proportion of the total. There may have been as many as
200 women compositors in London in the early 1890s,[46] but as has been
noted, the London Society of Compositors was able to exert pressure on
employers and see that on the whole they were vanishing or being
expelled to printing-houses in the Home Counties. In 1899, the authors
of an article in the Economic Journal estimated the total numbers of
women compositors outside Scotland as about 300, of whom 225 were
employed in firms in the London region, another 35 in two other firms,
and the rest scattered in small houses employing single numbers.[47] By
the time of the Fair Wages Committee of 1908, T. E. Naylor of the LSC
was able to report that the only 'serious competition' between men and
women compositors outside Scotland was in 'Reading, possibly Dun-
stable, Wolverton, Bushey and Maidenhead'. He also remarked,
significantly:

> If it were not for the Union, I venture to think that women would be
> all over the London trade. Fortunately the London Union has been
> strong enough to keep them entirely out but these London houses,
> as soon as they get beyond the sphere of the . . . Union by moving
> twenty or thirty miles outside, at once they set up conditions that I
> know they would set up in London if they could do so unchecked.[48]

(The Women's Printing Society continued to operate, as an exceptional
case, with women being paid male rates.)

In Scotland too, apart from Edinburgh there were few women com-
positors. Margaret Irwin told the Royal Commission on Labour in 1893
that she did not think many women were 'at case' outside Edinburgh.[49]
There were certainly women employed in Aberdeen,[50] and instances

were also reported in Falkirk and Glasgow in the 1880s, and in Perth in the 1890s, where the numbers of women were at least such as to be 'reduced by seventeen'.[51] In 1908 women were still being employed in both Perth and Aberdeen.[52] But nowhere were the numbers concerned anything like those in Edinburgh. We have seen that there were just over 100 there in 1875. Figures quoted at irregular intervals by the STC and other sources suggest that there were approximately 150 in 1879; 200 in 1885; 300 in 1888; about the same in 1892; 540 in 1899; 651 in 1908; and about 800 in 1910, the year in which the last girl apprentice entered the Edinburgh trade.[53] In fact the total on the *Register of Employees* for 1911 was 844. This seems to indicate that after a fairly steady climb and a certain standstill in the late 1880s, the numbers really took off in the late 1890s and the first decade of the twentieth century. They were concentrated in the largest firms: Clark's, Neill's, Morrison & Gibb's etc. (see Table 2). It may be tempting to relate the figures to the general depression of the 1880s and the revival of the nineties, but the figures are too approximate for fine dating, and while the general economic situation undoubtedly played some part, other factors, to be discussed below, had their importance.

From a tentative experiment, bringing in a few girl trainees, mostly from charitable institutions, the employment in Edinburgh of women compositors had by Edwardian times become an institution. Some of the larger houses now employed more women than men: Clark's in 1911 had 114 women and 89 journeymen (plus 27 apprentices). Morrison & Gibb had 136 women and 112 journeymen; Neill's had 109 women and only 37 journeymen compositors. Why had it happened? The short answer, as far as employers are concerned, is that women were cheap, and increasingly gave good value for money. As early as 1879, the union secretary was reporting in consternation: 'So highly are they prized that one master who employs 20 girls vauntingly said that with his girls and the ... foreman, he could carry on the work of his establishment, dispensing with journeymen!'[54] The way this worked in detail will be explained in Chapter 4. For the moment we may note simply that if the experiment had not worked, it would have been dropped. Women were able to do the job for which they were hired and they cost less than men. With better education in the late Victorian period, literate girls could easily be found. One employer remarked in 1902 that:

> In regard to girls from Board Schools, our experience in regard to their reading powers is exactly the reverse of that of the boys, most of them being able to read both print and manuscript with ease and accuracy.[55]

Why was it so easy for master printers to recruit girls? Again the short answer is simple, but this time the other way about: because the wages paid to a 'compess', while less than a man's, were high compared to the wages a girl could earn elsewhere. Chapter 6 will look in detail at the

women compositors and their background, but it is worth making the point here that it quickly became obvious to certain categories of working-class girls in Edinburgh that a new opportunity was open to them. Family connections – always important in finding the first job for a girl or boy leaving school – could now be used in the printing trade, whatever the union said. One of the employers interviewed by Margaret Irwin for the Royal Commission on Labour in the early 1890s reported that 'the girls in our composing room are in many cases daughters of compositors and machinemen and men employed in other departments of the establishment . . . they introduce their relations in the form of sisters'.[56]

Thus the original recruits from boarding schools were gradually replaced by younger girls, mostly straight from 'board' (that is ordinary elementary) schools, and from ordinary working-class families in the city. They were likely in the early days to come from families connected with the trade, but as time went on, recruitment was wider. By the late 1890s and early 1900s, typesetting was apparently well established as a possible career for a school-leaving girl. In the 1896 article on R. & R. Clark in the *British Printer*, there is a photograph of 'the girls' case-room': on the wall at the end of every row are the pegs on which the 'girls' hung their hats. By then it looked as if the hats were there to stay.

4

WOMEN, THE WORK PROCESS AND THE PAY QUESTION

> Gentlemen, not only had our trade been inundated with boys, but fortunately or unfortunately, we have had another element introduced, and you know that I have never been a person who ignored the company of the opposite sex. As the father of eleven children (laughter and applause) – I have not been a disciple of Dr Malthus but you will clearly understand that, while I appreciate the ladies, I am strongly of the opinion that they have their proper station in life (Hear! Hear!) . . . I don't object to ladies being printers, provided they are placed on the same equality as men. If our young girls are to learn the profession, let them serve a seven years apprenticeship and when they have completed it, I ask for them the same wages as are paid for journeymen . . .[1]

In his after-dinner speech as secretary of the Scottish Typographical Association, John Battersby was quite jovial and his demand for equal pay (or, as he put it, 'female rights') impeccable. The problem was that equal pay was entangled with a restructuring of the work process in the Edinburgh printing trade: increasingly there was a division of labour, with certain men, and almost all the women, directed to straight typesetting, while a few of the men concentrated on the finishing processes. In this chapter, the everyday division of labour at work is looked at in some detail, in order to understand how all the parties involved – employers, men and women – interpreted the questions of skill and pay.

There is by now a plentiful body of evidence to show how labour processes in nineteenth-century Britain were broken down, particularly after mechanization.[2] Trades that had once been skilled were being divided into their constituent parts so that less skill was required to carry out any one process. For women workers, this almost invariably meant that they ended up with jobs classified (whatever the real degree of skill or expertise required) as the least skilled, and certainly the worst paid. Some detailed examples of how this worked in hosiery and tailoring are described by Nancy Grey Osterud and Jenny Morris in the collection of essays, *Unequal Opportunities*, edited by Angela John, in which Felicity Hunt also analyses how mechanization affected women workers in the printing and bookbinding trades. Because she is chiefly concerned with the London trade, from which women compositors were quickly excluded, Hunt does not consider the possible division of labour *within*

traditional manual typesetting that their introduction brought in Scotland; nor is the subject much discussed by Cynthia Cockburn who is more concerned with the trade after mechanization. The plentiful records in Edinburgh provide a unique example of the way this classic re-structuring of the work process was already operating in the bookprinting houses, *before* the introduction of composing machines. Since the questions of apprenticeship and pay lie at the heart of the problem, we should first examine the surviving evidence to discover how long an apprenticeship women actually served, and how much they were paid, before going on to analyse the re-organization of the work process.

APPRENTICESHIP AND LENGTH OF CAREER
It was unofficially agreed by masters and men alike that no apprentice really needed seven years to learn the trade. The journeymen were reluctant to give way on the question though, since the seven years was still a way of controlling entry to the profession – a proposition brutally shaken by the entry of women who hardly ever served 'full' apprenticeships. Even for a boy, it was becoming rare, by the latter part of the nineteenth century, that he had fully mastered the trade. He would have graduated from sweeping the floor, running errands and being a 'reading boy' in his first two years, to distributing type and learning the case, then to typesetting and if he was lucky to making up and imposition, though rarely to the refinements of display work. 'If at the end of seven years, he can make up the fraction of a quarto forme and impose it, or is able to lay down a sheet of 16's correctly, the apprentice so qualified may considered himself well advanced.'[3]

But a girl was treated differently from the start. She never wasted time running errands. Her first employment was likely to be as a 'reading girl', that is to sit on a stool and read out the copy to a compositor. This is not often mentioned in the documents, but two of the surviving women compositors I was able to interview said they had started this way. Indeed it seems that girls very quickly replaced boys at this task: 'Evidently [the boys'] tongues do not go so glibly as the girls,' as the STC was already saying as early as 1875, 'for in most of the offices where girls are employed, reading boys are now unknown.'[4] The next stage was to learn the case. At Morrison & Gibb, according to one survivor, the girls went up to a special room to learn all the types, and another former Morrison & Gibb 'learner' remembered that 'you were given a card with the lay of the case' and just had to get on with it, practising until you could pick up the type correctly. She did not remember being formally instructed by anyone, not even the older girls, though in some houses, men were evidently called in to show girls how to handset. Girls were sometimes called apprentices, more often simply 'learners': indicating that they were not really acquiring a skill, just 'learning on the job', which was the standard training for most semi-skilled occupations.

Accounts vary as to how long a girl (usually starting, like a boy, at 14) was regarded as a learner. Macdonald's 1904 account says it could be anything from 'two to four years'. Fraser (of Neill's printing office) said in his evidence to the Fair Wages Committee in 1908 that it was 'three years, but they are not expert immediately after the three years'. One union man giving evidence at the same time, said that it was 'not . . . above twelve months'. One survivor told me that her apprenticeship lasted about four years and that that was normal at the time (she started work in 1909 at 15 after an unsuccessful start in dressmaking).[5]

What did they learn? It seems to have been unusual for any girl to go beyond straight typesetting to learn much about the other processes at this stage: a crucial point. As we have already seen, a boy might not have got beyond typesetting at an equivalent stage either, nor did he automatically get much further anyway; but the girls were almost all set to handsetting for the firm once they were competent at it. This critical division, between the 'basic' skill of the trade (on which many male compositors also spent most of their time) and the 'more skilled' processes, was to persist after the 'learning' stage, and was much to the employers' advantage.

When challenged on this point, employers always produced a unanimous chorus to the effect that this was what women wanted, because they would not stay long in the trade before they married. This was a very familiar argument, and one which contains a degree of truth, though not as much as employers (and unions) may have liked to think. They variously reported: 'Most of them get married when they get about 20'.[6] 'After about 4 years, the lucky ones get married.'[7] 'We have an apprenticeship of seven years to begin with, but 99 out of 100 of these girls when they go to the trade expect that they will be married before that time passes.'[8] Sometimes the judgement is nuanced: 'The pick of the girls get married. The qualities which make a girl smart and successful at her work would similarly make for her success in the marriage market.'[9] Even Mr Fraser of Neill's, a source of many choice quotations on this issue had to admit that not all the women got married: 'there are some who stay a long time. There is one who has been with us a long time – but then those are old maids of course. There are a good few of these unfortunates.'[10] An anonymous writer to the Scottish Typographical Circular in 1904 pointed out that 'some of the females have been at the trade since 1872 [over thirty years] and were grown-up young women when they started', so they would more or less count as 'veterans'.[11]

But since the majority were likely to leave sooner, it was argued, 'they want to make money at once'. 'They become full wage-earners at a much earlier stage . . . than their contemporaries among the men. This practice is said to suit them better since it is probable that they will marry and leave off work and they hardly like to spend seven years out of their wage-earning life in being trained.'[12] And from here it was but a step to

suggesting that women did not take the whole thing seriously as a profession. 'She has no intention of ever being [a comp] in any sense of the word.' 'They have no intention of relying on the trade.' After all as one employer opined, 'twelve years is said to be the maximum working life of a woman compositor'.[13]

It is impossible to dodge the question of marriage: as has already been noted, the majority of women *did* marry, and if they lived in Edinburgh, they almost invariably gave up paid work on marriage. But wishful thinking sometimes informed the remarks of both employers and trade-union officials, whether about the age at which women compositors married or the likelihood of their doing so. We should remember that it was in the employers' interests to claim that it was not worth providing women with a long training because they would waste it by leaving early; while it was in the trade union's interest to claim that women were incompetent because they had only received a short training.

Details about the careers and life histories of the women compositors will figure in a later chapter, but a few remarks about the evidence relating to marriage will provide some perspective for the training question. As it happens, the concrete evidence about marriage in the '1910 sample' analysed in Chapter 6 (those women in the trade in 1910) very largely relates to women who were aged about 18–28 during the Great War, and it could reasonably be argued that the war played such havoc with the marriage chances of this generation that it will have contained an unusually high proportion of women who never married. The figures actually suggest that of the women compositors employed in 1910, at least 25 per cent never married. Even if we adjust this figure downwards to say 20 per cent for the pre-1914 period, this still represents quite a large number of women (160 out of 800) who were in the trade for life, which usually meant until well over 60. Of those who did marry, comparatively few did so as young as 20. Taking from the 1910 sample only those marriages recorded before 1914, which can therefore be assumed to represent the pre-war pattern, the age distribution of the twenty-nine brides was as shown in Figure 1.

The preferred age of marriage was about 24 or 25 (average 24.6). This is a small sample: the average age of all brides in Scotland in 1908 was 26.8 years,[14] and perhaps our compositors were nearer the average than the precise records can show. But at all events, it must be concluded that, assuming an entry age of 14 in most cases, the *average* length of time in the trade *for those who married* was ten or eleven years, while for those who did not it was very much longer. To speak of twelve years as a *maximum* then, or to talk airily of 'girls marrying when they get about 20' as the employers quoted earlier did, is misleading. It would be more accurate to say that very few spent less than seven or eight years in the trade, the majority spent at least 10–12 years, while about a fifth remained in the trade for life. It is true that statistics on marriage are one

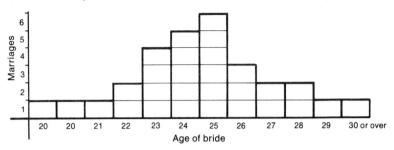

FIGURE 1. Marriages 1911-1914 of women compositors: age of bride in the twenty-nine recorded cases.

Sources: Union records and Register Office records.

thing, expectations of marriage another. Since most women did marry, most teenage girls assumed that they would do so and that they would give up work then. Nor could they predict the age of marriage at the outset of their careers, and there is no doubt truth in the employers' point that such expectations coloured their attitude to work. But the employers who were in fact well placed to have a statistical view of the matter, were not inclined to draw attention to the inconvenient figures. From their point of view, women were a particularly useful breed of apprentices, to whom the old rules need not apply. And since they were not 'serving their time' in the way a boy did, they could therefore be paid less when their training was complete.

WAGES

Before looking at women's wages, let us consider the men's. The stab or time rate for a journeyman compositor in Edinburgh in the 1890s and early 1900s was 32s (£1/12/0), while piece workers or linesmen were usually earning considerably less – perhaps 25s to 27s.[15] The real take-home pay of both men and women can be clearly seen from the wage-books of firms like Oliver & Boyd or T. & A. Constable, which are in the National Library of Scotland.[16] From these it is easy to follow the career of an individual apprentice through to adulthood. It was normal for a boy to start at 4s at age 14, and for the next four years his pay went up a shilling a year. For the next two years after that, it increased at 2s a year, and during the seventh and last year of apprenticeship it moved more quickly, so that at the end of the seventh year, the by now 21-year-old man could be earning more than double his wage of a year before. Not all apprentices made the smooth transition to the 32s stab rate. Thus if we compare two male apprentices in Oliver & Boyd's the figures tell different stories. J. Riley, aged 14, started his apprenticeship on 31 July 1903 at 4s and the wage-book shows him getting the regular rises described above. At 18 he was earning 8s, at 20 he was earning 14s, then in

August 1910, his seven years being served, he was earning 32s. Indeed by December of the same year, his take-home pay was over £2 (40s). But his near-contemporary J. Chalmers, who had begun his apprenticeship in August 1900, found himself still stuck at 14s in 1907, when he was 21 years old, and over the next year or two his pay was usually between 23s and 27s a week: he seems never to have made it to 32s. In 1909 he left Oliver & Boyd, presumably to seek better fortune elsewhere. For whatever reason, he had been put on to piece-work at age 21. Here we have a documented example of the difference between the stab hand and the linesman.

If we now compare the fortunes of a girl apprentice in the same firm (and the wage-books describe her as such, rather than a 'learner'), Miss Whyte, she began in 1901 probably at 5s. (The record for 1901 is incomplete, but this is what all other girl apprentices in the book started at.) Three years later in October 1904, she was earning 11s, while her male contemporaries had only reached 8 or 9s. However, she never advanced far beyond this, and in March 1909, she was still only earning 12s 6d, eight years after starting work. Similarly, Miss Robertson, of T. & A. Constable, who had begun in 1894, was earning 6s a year later, and 13s in 1900, at age 20. After this, progress was slow, though most women compositors of seven years or so experience could apparently expect to move up to 16s: roughly half the male wage of the time. A few earned 18s or more, and a handful, who became readers could earn even higher wages, though rarely anything like 32s in the period up to 1910. If we take the women's case-room wages at Oliver & Boyd, the pattern is as shown in Table 7a.

TABLE 7a. *Case-room wages for women compositors at Oliver & Boyd, 1904–1906*

Approx. age	Under 17	17–19		20–22	23 *or over*		Total
Wage	5s or under	5s–10s	10s–13s	13s–16s	16s–18s	18s or over	
1904	6	5	2	3	1	3	20
1905	6	5	5	7	2	2	27
1906	4	9	4	3	1	3	24

The wage-scale was revised upwards in 1910 (see Chapter 5), and the printed schedule in the wage-book gives the rates for 'female compositors' as listed in Table 7b.

It is clear enough what was happening: a girl was paid more than a boy on entering the trade and continued to earn more until both were approaching 20 years old, when the male rate drew ahead and suddenly leapfrogged to become double that of the female rate. Almost all women

TABLE 7b. *Case-room wage-scale for women compositors at Oliver & Boyd, revised 1910*

During 1st year	5s
End of 1st year	6s
End of 2nd year	7s 6d
End of 3rd year	10s
End of 4th year	12s 6d
End of 5th year	17s 6d or over

Source: Printing wage-book 1903–12, Oliver & Boyd (NLS, MSS, Acc 5000 (47)).

were in practice put on to piece-work as soon as they had 'learnt the case' (that is they followed the pattern of the male apprentice Chalmers). Their pay, expressed in pence per 1000 ens, varied, but was still less than a man's. Margaret Irwin reported in 1894 that in one Edinburgh firm the piece rate was $6^3/_4d$ per 1000 for a man, $3d$ to $5d$ for a woman; in another, men got $6^1/_2d$, women $4^1/_2d$ to $5d$. Although for a man a stab wage was invariably better than piece-rates, it could sometimes be the other way round for women. Margaret Irwin refers to some women making between 20s and 30s a week on piece-work on a particular contract (the valuation rolls).[17] The survivors I have interviewed mostly remembered going straight on to piece-work and staying there, although in larger offices, like Clark's, some experienced women workers did become stab hands.[18] But the majority of adult women compositors remained earning 16s–18s, perhaps a bit more if they were lucky. The only possibility of further promotion was to (proof-) reader, a step taken by some of the women who spent a lifetime in the trade.

Putting together what we know about girls' apprenticeships – lasting three or four years – and wage rates, it can be deduced that from the age of say 17 until perhaps 25 for those who married, women compositors were doing the equivalent of full-time typesetting for wages that varied between half and two-thirds the adult male wage, depending on whether stab or piece rates are measured. Their value to the employer should be obvious. But were they doing the equivalent of men's work?

THE DIVISION OF LABOUR: WHAT WOMEN DID *NOT* DO
There is an almost unanimous chorus, unchanging over the thirty or more years around the turn of the century, about the division of labour that existed in printing houses where women compositors were employed. When examined in detail, the chorus is not quite in harmony about where the dividing line actually came. Women, it was generally claimed, were put to do 'straight setting', that is composing lines of type (by hand for most of the period), and only rarely moved from the type-case to do the other tasks regarded as part of the trade (making up, imposition, locking up chases, carrying formes, etc.). It was usually

agreed that they *did* do correcting and distributing (a rather thankless task, left to apprentices if possible). It would be tedious to quote more than a few examples of the evidence from parliamentary commissions, the *STC*, union reports and surveys etc., but the following quotations are typical: 'About the only work which the women can do is to stand or sit at their formes and set up type; and to distribute the types back again into the cases, but of course this is only a portion of a compositor's work' (an employer);[19] 'As far as mere type-lifting is concerned, she may do, but there is other rough work in connection with compositors' work which I do not think a woman is qualified for' (a union leader);[20] 'Women . . . get the best, i.e. the simplest jobs . . . they are kept always at pretty much the same kind of work' (an employer).[21] When a representative of the London Compositors' Society was asked whether this was a 'lower class of work', he replied, with honesty, 'I do not think that would be a correct term to use. They are doing work which every compositor is called upon to do at some time or another, that is plain composition,' but he added that the men do 'the many operations that go to make up the comp's calling'.[22] However there are sometimes indications that women were doing at least some of the other operations. Thus a description of R. & R. Clark's works in 1896 commented that 'for straightforward setting, ordinary stonework, simple imposition and first proof-reading, the women are found to be fully qualified, though of course they do not attain to the all-round excellence of first-class men'.[23]

That 'of course' tells us that even if women were in reality doing other things besides typesetting, almost all commentators were nevertheless agreed that there was such a thing as a 'true compositor' who could handle every process of the trade, and that women were being trained to do essentially the simplest part of the work. The corollary is obvious: a printing office employing women at low wages to do straight setting could dispense with a number of ordinary linesmen, keeping on only a highly skilled minority of men at rather above normal wages to 'service' the type set up by the women. As the description of Clark's tells us: 'Besides the girls, the able foreman is assisted by three or four *skilled* men who have the direction of matters and see to imposition and locking up, carrying formes and so on.'[24]

The use of the word 'skilled' conceals the fact that the work which women were *not* doing fell into two categories. One of the tasks always mentioned first in any discussion of the question is the carrying of formes containing set-up type (they were indeed very heavy and it did no one's back any good to carry them). Type-cases too were heavy, and if one fell it took a long time to sort out the type again. But 'the heavy work of carrying type in which men alone are employed',[25] could by no means be described as *skilled* work. It could be, and was, done by printer's labourers or apprentices. One former Edinburgh male compositor who worked at Constable's told me in a letter that 'we as apprentices . . . used to help

the ladies by lifting the formes of type on to the stones, so as they could do corrections, and lift them down'.[26] It could in fact have perfectly well been done by a strong woman or by two women co-operating, and in any case took very little time. One gets a slightly different perspective on the question of lifting formes and chases from the women compositors questioned by Margaret Irwin in 1893. Thus 'an experienced woman worker' told her that

> men do the same work as women in many cases and at different rates, but there are certain parts of the work that women never do, such for instance as the lifting of the 'formes' and 'chases'. Witness could not say how much of a man's time this might occupy per day. In her shop, one man lifted the 'chases' &c. for twenty girls and did his own work in addition.

Another woman, in a different firm, who had been twenty years in the trade (so must have been one of the original beginners) reported in similar terms: 'in the regular bookwork, the girls do the same work as the men, but they do not lift their own "formes" and "chases". Witness could not say how much help in this a girl would need from the men because it varied so much, but she did not think it amounted to much, and no special men workers were employed for it'.[27] Lifting is therefore not denied, but its importance is distinctly minimized when a woman is speaking, maximized when a man is. And all agree that in any case it did not require skill, merely strength.

Rather different is the question of the other processes between setting type and going to press. The evidence here is often contradictory, and suggests that in practice, there were variations in what was asked of women. Take correcting and the locking up of formes for instance: Margaret Irwin regarded women as precluded from some of these tasks by physical incapacity.[28] 'Such for instance is correcting on the stone. This requires the worker to lean in a doubled-over position on the large table or stone while making corrections.' Irwin had seen a girl in one firm doing corrections, but was told this was not customary. However as we have just seen, women did correct at Constable's and despite what seems to be an oblique claim by Margaret Irwin that their breasts got in the way, they certainly did correcting in several other printing houses. Locking up formes did not really require much physical effort either, nor, once you had been shown how to do it, very much skill. When the union representative Alex Ross was asked by a Royal Commission whether he would 'ask a woman to lock up a form (sic)', he replied spontaneously, 'Oh yes, they can do that as far as I understand'. 'The small forms?' 'Yes.' Macdonald's survey of 1904 claimed that in Edinburgh women were involved in 'every process except making up and carrying type', suggesting that they did lock up formes and do corrections.[29]

Other finishing processes posed more problems. Proof-pulling for instance can perhaps be regarded as a mixed process, requiring both strength and skill. Margaret Irwin cited it as another process from which women were excluded for what seemed to her good reason: 'It requires both muscular strength and a certain "knack".'[30] As for making up and imposition, the tasks most often cited as barred to women, they could certainly not be carried out by anyone who had not received a proper training, and were rightly regarded as skilled work. In addition, men often insisted on the 'heavy' side of all these processes: asked to define the finishing processes, one employer's representative listed 'making up into pages and locking it up in the chase, which involves manual heavy labour, lifting and things of that kind – pulling proofs and what I call the heavier labour'.[31] What all the 'finishing' processes had in common, apart from a degree of exertion greater than was needed for hand-setting but not necessarily greater than could be expected from a normal young woman, was that these were tasks an apprentice learned only towards the end of his time. What women normally did was 'what a boy would be at when half-way through his apprenticeship'.[32] Even so we do sometimes find admissions that women were doing the more advanced tasks. One of the Edinburgh employers (perhaps inadvertently) revealed that 'either *very experienced girls* or experienced men make it up into pages or make it up into sheets'.[33] It is a concession of importance, since it indicates a greater convergence between the male and female work pattern than is usually suggested. But it also makes what is the critical point about finishing processes, namely that in any given office, only a handful of the work-force were actually required to do this. It was a division of labour among men and other men, as well as between men and women.

The reason for this is not so much that it was beyond some people's capacity to do imposition and so on; but rather that it cost employers money to train people to do such tasks. While anyone could go off and learn typesetting in a corner, imposition could only be done with 'real' matter. Mistakes and botched work thus slowed down production at what was already a natural bottleneck. Furthermore, the finishing processes could not be regarded as piece-work. The unskilful typesetter on piece rates simply took home less pay; bad imposition cost the masters money. It was therefore greatly in the masters' interests to insist that there was 'no point' in the women learning the later skills (because they were not strong enough, because they would leave the trade early, because they would 'never be as good as a man' and so on). But male compositors made it easier for them to do this, and justified the division of labour, when they agreed that women could not attain all the skills of the trade. They were thus driving the wedge further and further into a division of labour from which they were the first to suffer.

THE DIVISION OF LABOUR: WHAT WOMEN *DID* DO

Those who suffered most from the new division of labour, it must now be clear, were the linesmen on piece-rates. In all offices (excluding newspapers) where close-set text was composed – bookwork, government publications, legal and official documents, directories, encyclopaedias and so on – both men and women piece-workers were normally employed. And what was tending to happen here, as the *Scottish Typographical Circular* regularly reported, was not so much a division of labour between women on straight setting and men on other processes, but rather the diversion of certain kinds of typesetting from the linesmen (male piece-workers) to the women, who were not only paid much less but who were also considered by some employers to be actually better at it.

One traditional distinction to which male compositors were particularly alert was that between 'fat' and 'lean' matter for setting. The 'fat' was well-spaced work, with less solid text, and it therefore took less time to set a page. 'Lean' consisted of lines of close-set text which took the compositor much longer. One of the major achievements of the journeymen in the nineteenth century had been to succeed in having both kinds of work paid at the same rate. Thus the distribution of fat and lean work made a considerable difference to the pay-packets of piece-workers.

Here are two ways of describing the system in the context of introducing women to the composing room. First Fraser, managing director of Neill's:

> The men are so greedy. For instance, a page with an illustration on it – a solid page with a picture – the men charge as solid type and if the page is a little bigger than an ordinary page, they will charge extra for putting that page in, besides charging it as setting up so many thousand letters . . . Then if there is a half-page or table, we have to pay a whole page for it, which is double the price of a half-page of ordinary type.

Now here is John Templeton, secretary of the STA:

> In framing the piece scale in printing, you have to frame the scale so that it covers everything, that is so that it covers what we call 'extras' as well. For instance in setting a pamphlet or a book, a half-page would count the same as a full page. The scale should cover everything between the pages of a book.

Templeton went on to explain how employing women played havoc with this arrangement:

> When the females get their work to set up, the whole of what we term the 'fat' is taken out, that is all the space is taken out and they simply get close matter to set, and they get paid for that. It is other girls who are on set wages who put in the fat work [i.e. the spacing] and the house gets the benefit of it. So it is cut to the finest as far as the females are concerned.[34]

To the journeyman, the equal payment of fat and lean, and the inclusion of the precious 'extras' in the scale, were hard-won victories of the past, the stuff of union history, to be safeguarded at all costs. To women, entering the trade without undergoing any of the initiation rites, excluded from the union, the whole business of fat and lean – one of the first things a boy apprentice would learn about – can have meant little. To the outsider, a priori, it might seem positively unreasonable, or to use a favourite word of the women compositors, unfair, to pay the fat the same as the lean. To the employers, the entry of women made it possible at last to nibble away at – or do away with – such 'restrictive practices'. The employer delegate Fraser, referring to equal payment for fat and lean said, 'of course, we could not agree to that sort of thing', and significantly there were no male piece-workers at all employed at his firm, Neill's. A trade-union official had told Margaret Irwin in the 1890s that there was a 'growing tendency to give' not only lean but fat work to women piece-workers. As she put it, 'a larger amount of this work can be got over than ordinary work in the same time, and a larger wage is earned by those on piece-work. Consequently the women get it in preference to the men, because they take it at lower rates'.[35] The point about this particular division of labour was that women, being outside the union and ignorant of the traditional battles over fat and lean, willingly complied with the work arrangements of the employers.

And there was more to come. A division of labour peculiar to Edinburgh bookwork is described in Templeton's evidence to the Fair Wages Committee:

I might explain that there is policy in giving the girls reprint work. It is simple work and easily got on with. Unfortunately, some of our best intellects turn out the most miserable specimens of penmanship conceivable and some of them are almost indecipherable. The result is that [such copy] is given to the piece work comp and he has got to make the best of it. If it was a girl, she would throw the whole thing away, put on her hat and away she would go to get other work. She would not do it at all. But the stab man, and the man on piecework rates . . . has got to do it, possibly spending more than half his time in trying to decipher it. There is good reason why the easier work should be thrown to the girls.[36]

(This is incidentally a good example of a sweeping statement. One of the survivors I talked with well remembered the problem of working from manuscript: 'sometimes you couldna read the manuscript. Some hands were very very bad'; but she was never tempted to walk out.)

The upshot of these various strategies by employers was to pose a real threat to the future of the male piece-workers, 'who in Edinburgh only get as it were the crumbs that fall from the girls' table . . . the girls get all the work and the men are thrown into the street'[37] (a union man). What was even worse, the women were unofficially said to be better at it.

'They are kept always at pretty much the same kind of work and thus become very skilful at it' (employer quoted by Macdonald).[38] 'So far as the finger-work or typesetting goes, she is as quick or quicker than a man? – They say she is more deft and better adapted to it' (a trade unionist).[39] 'For their particular work, they are better than men, probably.'[40] (an employer). As early as 1886, the *Scottish Typographical Circular* had been moved to remark that 'if they could finish without extraneous help the work they begin, they would indeed be very dangerous rivals'.[41]

Not all the evidence by any means concurs with the view that women were actually superior to men in some respects. It is precisely a feature of the debate that no statement was innocent: employers and unionists used the arguments they hoped would further their own cause and did not appear to be aware of the contradictions in their logic. Thus we have Macdonald reporting on the 'almost unanimous chorus of opinion that women's work as compositors is so inferior to men's that it does not pay in the long run' (the chorus in question being from employers).[42] But the testimony of individual employers is far from unanimous or even consistent. The evidence given to the 1908 Fair Wages Commission by Fraser of Neill & Co (the Edinburgh printers handling government work) is riddled with contradictions in this respect. One minute he is boasting that 'our girls set Greek, Hebrew, Algebra, indeed anything you like, they are all well-trained girls'; the next he is saying, 'their rate per line is not the same as a man's; their corrections are heavier and that kind of thing, they make more mistakes'.[43] Another Scottish employer is quoted by Macdonald as saying that 'given a certain area of floor space for men and women, on the former would probably be produced half more than on the latter'.[44] But Fraser, pressed on the question of value for money resorted to other arguments: 'they are more economical, but they are not so satisfactory, they are always going off for sickness of some kind or another, or their mother is ill or something of that kind – that is the greatest trouble, their mother is ill constantly'.[45] The London employer of women, Straker, similarly claimed that 'they come and go more readily, and they want more accommodation ... You get a staff of women together and then they either get married or they leave you'. Yet in the next sentence he says, 'I should strongly object to a bar being placed on the employment of women'.[46] He argued however that women would actually be more expensive than men if paid the same wages. Another employer, in the 1890s, rationalized women's lower pay as follows: 'the difference between the rate paid to women and that paid to men is almost entirely swallowed up by the additional work which the men require to do for the women, viz. making up, correcting, carrying about formes between the stones and the proof presses, etc.'[47]

While one has to admire the contortions into which employers forced themselves to go to prove that their current practice was rational, coherent and best for all concerned, one feels they do protest too much.

The margin of profit Edinburgh master printers made from employing women far outweighed the wages they paid the men who handled the finishing processes. Arguments about absenteeism (not borne out incidentally by the surviving wage-books) are hardly relevant when one is talking about piece-work in large firms. One has to read all this special pleading against the light so to speak to see what was actually happening in day-to-day practice. And central to the debate was the question of skill.

SKILL AND EQUAL PAY: WHO SAID WHAT?

What did skill really consist of? Different groups gave different answers. Employers for instance tended to reject the view that all men who had served an apprenticeship were skilled. 'Printers you know are not all highly skilled. There are two classes of printers, one called newspaper hands and set nothing but solid matter; and properly trained compositors who have been taught to do jobbing, tabular work and everything.' Fraser of Neill's claimed that only 'a few men can set music and only a few men can do a table and only a few men can do anything out of the way'.[48] Trade unionists would of course be most unlikely to admit that a time-served journeyman was not skilled and such admissions are rare, though they can be glimpsed behind the pleas for the vulnerable linesmen. They were adamant however that women were *not* skilled workers. While the employers tended to cast around for reasons outside the work process when they wished to disparage women workers, unionists spoke more often of the low level of women compositors' skill. Although the historic Interlocutor scale of rates enshrined the principle that some kinds of setting were more difficult and therefore deserved higher wages than others, the particular specialities of women (such as small type, foreign languages and before long, keyboard work) were not acknowledged. Since no outside authority – whether the employers, the journeymen or the union – ever gratified women's skills with the respect accorded to men's, women compositors must have found it hard if not impossible to think of themselves as skilled, or to have even a semblance of the mentality of the skilled journeyman and union member. The women who spoke to Margaret Irwin were themselves inclined to adopt the same low value of their work that they heard expressed by the men. One woman told her that 'the men get the more experienced and difficult work', while another reported that she thought 'the work very pleasant and suitable for women . . . but has sometimes found working with small type to be a slight strain on her eyesight'.[49] (A man's reaction about small type would have been to point to the scale and demand it be paid extra!)

This was not just a problem for women in printing: it was one by all women who were drawn into industrial trades just as mechanization was creating a new division of labour. Women would increasingly in the

future be recruited into the new semi-skilled jobs, often at piece rates, so that employers were able to benefit both from the job's lack of a craft tradition behind it, and from a work-force trained from childhood to regard anything they did as unskilled. Most women had been brought up to do sewing and dressmaking: it was no accident, nor was it a question of 'natural aptitude' that a teenage girl entering the composing-room was likely to be more dexterous at first than a boy, and to apply both the physical and mental habits acquired in sewing to the job in hand. This might mean for instance rapidity in execution, neatness and correctness, skilful handling of small type and so on. I deliberately use the word skilful, but this was neither asserted by women, nor granted by men, whether the men were employers or fellow-workers.

Masters and men, although deeply divided over the substantive issue as to whether women should be employed at all, were therefore united in a male solidarity which expressed itself – in public at least – by a discourse disparaging women and the work they did. One has to be extremely cautious about interpreting past usage of terms like 'women', 'girls', 'ladies' and 'females', but it certainly seems to be the case that 'females' and 'girls' – precisely the terms with either derogatory or patronizing over-tones – are used more frequently than 'women', while 'ladies' is generally used if the speaker wishes either to be polite or ironic. (It is true that to say 'women' could at the time, and even today for many people, be regarded as discourteous.) 'Males' is a term found hardly at all in the language of employers or workers, while 'boys' is used only of apprentices. Both masters and men moreover chose to depict women as wilful and capricious. We have seen above the image of the 'girl putting on her hat' and walking out (from a unionist); or being an absentee because her 'mother is ill constantly' (from an employer seeking to prove how unreliable women were).[50] It was also alleged for instance that women were too docile to make really good workers, too lacking in spirit and ambition: 'Boys [i.e. apprentices] would claim to be shifted on to the higher branches of the trade'.[51]

A compendium of assumptions about women is the sometimes quoted list of advantages and disadvantages (to the employer) of the woman worker in the printing trade (not just as a compositor) compiled by the 1904 survey edited by Ramsay Macdonald:

The advantages of the woman worker are:

1. That she will accept low wages; she usually works for about half the men's wages.

2. That she is not a member of a Union, and is, therefore, more amenable to the will of the employer as the absolute rule of the workshop.

3. That she is a steady worker (much emphasis must not be placed on this as the contrary is also alleged[!]) and nimble at mechanical processes such as folding and collecting sheets.

4. That she will do odd jobs which lead to nothing.

Her disadvantages are:

1. That she has less technical skill than a man and is not so useful all round.

2. That she has less strength at work and has more broken time owing to bad health and especially should she be married, domestic duties and that her output is not so great as that of a man.

3. That she is more liable to leave work just when she is getting most useful [in other words] there are more changes in a crowd of women workers than in a crowd of men workers.[52]

The collective 'she' is presented in this list as if a natural immutable category, ruling out the possibility either of individual traits or of conditions explaining any of the points on the list which might be subject to change. The voice we hear is, as usual for the period right up to 1910, an external voice: women are a group more spoken about than speaking, if we are to believe the written records. Only very occasionally is a woman's voice heard and even then it is not always certain. The *Scottish Typographical Circular* for instance rather specialized in joke articles over a woman's signature which are obviously not by a woman at all. But the two communications from 'Ella, typelifter' in 1886 do sound authentic and throw a little light on what women may have thought about the central issues here: their being employed as cheap labour and the question of skill.

Ella's first piece was in verse. It begged male comps faced with a female colleague to 'Be kind to her if you can't wed her or shift her,' and went on:

State broadly and fully wherein we are sinners

Remembering that many of us are breadwinners

For mothers and sisters whom we must assist, hence

We claim with yourselves equal right to existence

After her poem drew one in reply, Ella wrote an article in prose in the next issue in which she put a point often made in the later period (see Chapters 5 and 7) by women workers, and one which is central to the debate on women's pay generally. Women compositors did not want equal pay, she wrote, for

no girl of sense puts herself on the level of a comp all round but if the division of labour assigns her a task she can perform, what reason is there she should not do so? And if we recognise our true position as skilled labourers performing with more or less ability a given portion of a comp's duties, it would be utterly absurd for you to propose, or us to expect, equal remuneration with men – which I suppose is what you mean by insisting on getting the true value of our labour.[53]

Although women were in practice doing exactly the same work as certain categories of men, they too perceived the division of labour as a gender

division, and took as their point of reference for equality the 'all-round comp', whom both masters and men held up as the exemplar, rather than the humbler linesman. Consequently they feared that 'equal pay' would cost them their jobs.

In this chapter we have been looking at the details of the division of labour to which Ella was referring. It had the effect of driving all parties to the debate into separate corners: the employers wished to preserve the status quo. The union really wanted women out of the trade, but in public statements like Mr Battersby's after-dinner speech, said that they were prepared to settle for equal pay; while the women regarded the latter call as unrealistic if not hypocritical, since they felt (and were daily told) that they were not doing the equivalent of a skilled man's work (though even they thought the differentials too high). The debate became a dispute only in the 1900s, coming to a head in the famous confrontation of 1910, to which we now turn.

The girls of the Dean Orphanage, Belford Road, Edinburgh, in the 1890s, with the matron, Miss Addis. Jean Henderson (born 1883) is third from the right, second row from the back, and her younger sister Isobel is third from the left, second row from the front. A number of girls from orphanages, having received a good general education, became apprentice compositors at this time. Miss Addis encouraged Jean Henderson in her choice of career.

(Photograph courtesy of Mrs E. R. Finnie)

A group of compositors and Monotype operators from Ballantyne's in July 1912, copy belonging to Mary Thomson (first on right, middle row).

(Photograph courtesy of Miss D. Mathewson)

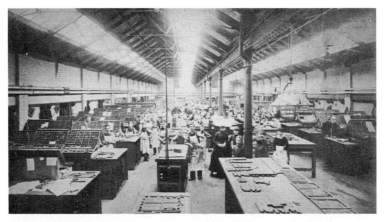

The case-room, R. & R. Clark's, date uncertain, probably 1890s. Several young girls, possibly reading girls, in the foreground.

(Photograph courtesy of The People's Story Museum, Edinburgh)

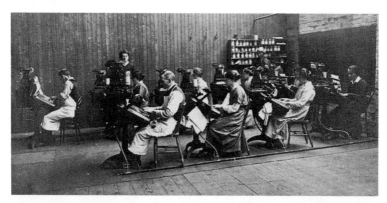

The Monotype department of Neill & Co.; date uncertain but probably between 1910 and 1914. The majority of operators were still women, but men had begun to take over machines after 1910. The Monotype machine consisted of the keyboard, pictured here, connected to a roll of paper ribbon. The perforated ribbon was then taken to the casting room in another part of the building for the hot metal itself to be cast.

(Photograph from Neill's deposit, Dep 196, courtesy of the Manuscripts Department, National Library of Scotland)

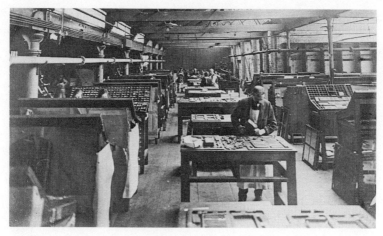

The case-room in Neill & Co.; same date. The Monotype department can just be glimpsed at the far end of the room. In the early days of Monotype, hand-setting was still the chief activity of most comps. Typecases and frames for handsetting and page upmake are arranged down both sides of the room, and stones for imposition run down the centre. Two women compositors are just visible on the left, while a man is working on the stone.

(Photograph from Neill's deposit, Dep 196, courtesy of the Manuscripts Department, National Library of Scotland)

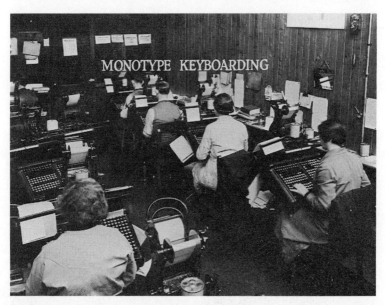

Monotype keyboarding at a later date, possibly the late 1930s. The process remains virtually the same, although the arrangement of the office has changed. By this time there were probably more men operators than women.

(Photograph from Neill's deposit, Dep 196, courtesy of the Manuscripts Department, National Library of Scotland).

Photograph taken to commemorate the amalgamation of the Women's Section
with the Edinburgh Case Branch of the Scottish Typographical Association in
1922, both committees.

Back row:	J. A. Leslie, Miss Elizabeth McLean, J. R. Skinner, H. Gilzean, G. Arbuckle, J. Stoddart, Miss Lauder, J. Noble
Front row:	W. A. Leslie, Miss Margaret Rendall, W. G. Hampton, J. Richardson, J. Urquhart, Miss Maria Goodfellow, J. L. Colquhoun,
In front:	Miss Margaret Crow, Miss Christina Collie
Not shown:	Mrs Peters, Miss Adams, Miss Hogg

(Photograph *Scottish Typographical Journal*, September 1922,
courtesy of the Trustees of the National Library of Scotland)

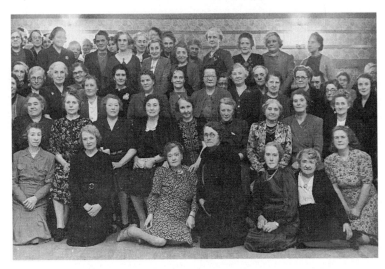

Reunion of women compositors, members of the STA, at the New Cavendish
Ballroom, March 1947

(Photograph courtesy of Mr G. Simpson and by permission of Scotsman Publications)

5

SLAMMING THE DOOR SHUT:
THE EVENTS OF 1910

The 1910 dispute, when the male compositors finally succeeded in putting a stop to the recruitment of girl apprentices to the trade, was not simply a battle of the sexes. It was equally a battle over the new technology, as well as over the future of book printing in Edinburgh. As Jonathan Zeitlin has pointed out in a similar context,[1] there are ways in which the product of an industry can affect the margin of manœuvre of both employer and trade union. Newspaper publishing is capital-intensive, and the product is vulnerable to even short-lived strikes. Machinemen in newspaper offices could (and to some extent still can) exert considerable pressure. But for the newspaper proprietors, outside competition is not always a problem. At the other end of the scale, jobbing printing is and was above all dependent on local trade; the office is usually small; and disputes when they occur can often be solved informally. In neither of these branches, in Edinburgh or anywhere else, were women employed to any significant extent. The book trade – where they were to be found in large numbers – differed from the other kinds of printing in several ways. It lent itself, as we have seen, to the various profitable forms of division of labour habitually practised in Edinburgh in the years in question; and the 'relatively standardized and durable product'[2] could be stockpiled during disputes. On the other hand, it was much more vulnerable to outside competition. A printing centre which could offer good quality work at moderate prices, for instance by paying its work-force less, by being located in a low-rent region and, at the beginning of the twentieth century, by introducing composing machines, could attract work from a wide radius. The key question here – and it is not easy to answer – is whether Edinburgh, by employing women in the period from the 1870s to the 1900s, was attracting more work than it otherwise would have from London and other publishers; or whether it was merely managing to prevent the work leaving Edinburgh altogether for cheaper printing centres. Edinburgh employers tended to express the latter view, trade unionists the former. To understand why the 'female question' came to a head in 1910, we need to look at Edinburgh's competitiveness as a printing centre, in particular after the introduction of Monotype machines; at the changing attitudes of the men in the Edinburgh Typographical Society (ETS); and finally at the history of the 1910 dispute itself.

EDINBURGH'S PRINTING HOUSES AND COMPETITIVENESS IN THE
1900S

Arguments about competition in the printing trade have to be treated
with some caution. It is unquestionably true that the large-scale employ-
ment of women made it possible for certain Edinburgh houses to offer
competitive terms in the years up to about 1900–10, and the argument
was made both at the time and in retrospective accounts. Thus Alex
Ross, representing the STA, told the Royal Commission on Labour in the
mid-1890s that 'London printers do complain that Edinburgh is under-
selling them, because wages are low. A large amount of work is done in
Edinburgh for the London publishers'.[3] And Child in his account of the
book trade supports the view that Edinburgh attracted work essentially
because of the low wages, 'owing to the fairly general use of women'.[4]

There could be other reasons why work left London though, and in the
case of the new firms springing up in the Home Counties and the West
Country, low rents rather than low wages appear to have helped Bun-
gay, Frome and other centres to build up a clientele. As the Macdonald
survey put it in 1904, 'a curious point in connection with the work being
sent out of London is that, except in the case of Edinburgh, the greater
cheapness of the work outside London is not due so much to cheaper
labour as to lower rents, etc.'. Macdonald also remarks a contrario, that
'while the cheapness of women's work as compositors in Edinburgh
seems to have attracted a certain class of work from London, the men's
success in keeping up wages in London bookbinding does not seem to
have driven bookbinding to the provinces'.[5] Both these latter points,
though Macdonald does not connect them, appear to lend some force to
the arguments of Edinburgh employers that by the end of the century,
they were not so much drawing extra work to Edinburgh as desperately
trying to stem an inexorable decline of the Edinburgh trade, occasioned
both by its geographical distance from London (incurring freight costs
and inconvenience, which would have affected bookbinding equally)
and by its comparatively high rents and cost of living (as compared to
country towns like Frome).

Thus in their reply in 1897 to a memorial from the men asking for a
50-hour week, the Edinburgh Master Printers' Association (MPA)
pleaded that competition was too intense for them to agree: 'The great
bulk of printing now done in Edinburgh is for London publishers.
Edinburgh has to compete with London (54 hours), the large provincial
towns (56 hours), and Holland and Germany (60 hours)'. In particular,
the reply cited the low-rent centres of 'Aylesbury, Beccles, Bungay,
Frome, Guildford, Lewes, Luton, Plymouth, Tunbridge and Woking' as
a threat. Transport costs for places near London were 10s or 15s per ton,
whereas the rate was 45s by rail or 30s by steamer to Edinburgh. There
was no longer any need for London publishers to 'send work 400 miles'.
The work at present obtained in Edinburgh was only by dint of 'great

energy and hard work by the employers'.[6] They were still pleading competition in 1910, when Mr Begg for Clark's argued that 'without cheap labour, the London book trade must leave Edinburgh, owing *inter alia* to greater freight rates'. And Mr Blaikie of Constable's claimed that a lot of scientific and university work had already gone elsewhere.[7] Their arguments were supported by a former compositor 'now in a position to place books for printing', who wrote in to the *Edinburgh Evening News* in 1910: 'Generally speaking, I can get work done in London, as well as in the English provincial towns, under Edinburgh prices, which proves that even with female labour, the Edinburgh printers have a hard task to keep their men fully employed . . . [It is asserted that] in many cases . . . the only profit on bookwork is represented by the difference between the prices of the women's and the men's composition'.[8]

Pleas about competition were regarded with much suspicion and little sympathy by the trade unions. In the early days, they simply challenged the notion of 'excessive trade competition' and were not 'prepared to admit that there has been much if any reduction in the price paid [elsewhere] for good bookwork, which has always formed the staple of the Edinburgh trade'.[9] In later years the argument was grudgingly admitted to have some force: one correspondent to the *STC* agreed that '50 per cent of the London and provincial work would be lost to Edinburgh and would never have been gained but for the employment of female labour'.[10] But the following year (1905) William Hamilton declared to a delegate meeting of the STA that 'even if it were true that work would be lost to Edinburgh, it would be better to follow the work and get fair wages than to see the bread taken out of our mouths at home'.[11] And another unionist explaining matters to the Fair Wages Committee in 1908, echoes his words:

Take the *Edinburgh Gazette*. That is produced by females. Those girls are getting from 13s to £1 a week for producing the *Gazette* and in London they would have to pay 39s at the lowest to the men who are producing government work, so that the competition is not fair. It is no benefit to us that the work is produced in Edinburgh, because we are not getting it. We should prefer to see it being done in London so long as it is done by male labour, it is no matter where.[12]

The difference between employers' and men's attitudes could not be put more clearly. The employers' interests led them to be 'nationalist', arguing that to safeguard their share of the market and to maintain the Scottish capital as a printing centre, they had to keep down costs, or go out of business. The men saw no advantage in Edinburgh remaining a centre of work if they were no longer sure of earning a living wage there. It was in their interests to be 'internationalist' and to move in search of work. In the printing trade, mobility had long been a traditional element in the organization of mutual support. The 'tramp' was sheltered and if possible found work by union officials if forced to take to the road.

(Though in fact by this time, 'tramping' was dying out as a practice and craft mobility with it.)[13]

Although both sides continued to use much the same arguments after 1900 as they had before, the question of competition was given a completely new dimension and greater urgency by the appearance of the first Monotype machines.

Some of the very earliest composing machines in Britain had been in use in Edinburgh in the 1860s. The house of Neill & Co. had patented their own,[14] and since this was one of the offices that most wholeheartedly recruited women, a number of the women compositors at Neill's in the 1870s were set to work the machines. But these early models, though ingenious, were no real threat to skilled hand composition, and their use seems to have been sporadic and eventually abandoned. It was only with the invention of first the Linotype, then the Monotype machines that mechanized competition really threatened hand-setting. The Linotype, invented in the 1880s, had appeared in the offices of the *Scotsman* and other Edinburgh newspapers by the 1890s. As Gillespie remarks, even in Edinburgh, the craft unions were able to see to it that only union men worked Linotypes, and 'by the end of the century, it was generally agreed that the effect of machines on employment had not been so bad as feared'.[15] It is important to note that there was never any question of women working on the Linotype. It was a machine particularly suited to the fast production of newspapers, and as has already been noted, women were not employed in the composition of daily papers, largely because of the Factory Acts. There was possibly another reason why they were kept away from it: the Linotype, hot, clanking and oily, *looks* like an industrial machine. The keyboard is combined with the casting machine (literally full of 'hot metal') which casts a slug equivalent to a line of type (hence the name). Although the action required of the compositor is very little different from that required by a typewriter, the atmosphere surrounding the machine would be perceived as a very 'masculine' one.[16]

The Monotype machine on the other hand was regarded by employers as 'in their opinion, pre-eminently suited for females'[17] (See Plates 4 and 6). In the Monotype, keyboarding and casting were separated. One room could be filled entirely with keyboards, which operated by punching coded perforations on to a roll of paper ribbon. The ribbon could be fed into a casting machine in another part of the building, where it cast single characters, producing a quality of type much better suited to bookwork than was a Linotype slug.[18] Even so, Edinburgh employers were comparatively slow to introduce Monotypes, presumably because they felt that their women hand-compositors made it unnecessary. We know that Monotypes had been introduced to R. & R. Clark's, as early as

1901 or 1902. Mr Begg later claimed that there had been no protest at the time.[19] Other houses were seemingly slow to follow suit. Turnbull & Spears acquired some machines at the end of 1906.[20] In February 1908, the manager of the Collins' Edinburgh branch threatened to buy Monotypes and set 'girls to work on them' if there was any attempt by the union to stop him recruiting women hand-compositors.[21] It seems that, just as in the 1870s, the abundance of work masked the new threat. The *Annual Report* for 1904–5 of the STA suggests that trade had been exceptionally busy for the previous few years. By 1907 however, trade was beginning to fall off again for the Edinburgh printing offices.[22] London and Home Counties printers were now increasingly installing machines, and the Edinburgh policy of using cheap hand-setters instead was beginning to look vulnerable.

This is no doubt why we find employers from now on not only buying machines more readily, but also setting women to work on them, a combination which aroused the union to sudden awareness of the threat. As has been noted, it was round about now that the *Encyclopaedia Britannica* contract was being fulfilled, and the houses involved (Clark's, Morrison & Gibb and Ballantyne's) all had women working their Monotypes in 1909.[23] Fraser, the director of Neill's, had told the Fair Wage Committee of 1908 that he did not think his customers would like the quality of machine work, but that if he did not employ women, he would certainly install machines instead.[24] In January 1909 the *STJ* (the *Circular* had now changed its name to the *Scottish Typographical Journal*) was sounding the alarm: 'Our trade is going over to machinery, and the machinery is in the hands of underpaid girls.' By the time the men put their 'memorial' to the employers in November 1909, the situation was acute: 'Not only has hand composition been lately going over more and more to female labour, but the operating on the type-composing machines has also been practically monopolised by the same class of cheap labour, to the consequent injury of our members.'[25] There were by now about 50 machines installed in Edinburgh book-houses.

Before exploring the history of the dispute itself, it is worth pausing to ask why no men were working the Monotype machines. Contrary to what one might expect, it was not simply the result of employer strategy. Whereas in London and in England generally, it had been a matter of principle from the start that Monotypes should be worked by male union labour,[26] in Edinburgh, the men do not seem to have come forward to learn the Monotype, even in response to invitations from the employers. Mr Blaikie of Constable's (a firm which, it will be remembered, did not employ many women) said during talks with the union in 1910: 'I delayed for years putting composing machines in my office, partly not to displace labour. I advertised for male compositors [to work the machines] and got no reply. The male compositors in my office declined to learn it.'[27] And Amelia McLean, a compositor who played a leading role

in the women's opposition in 1910, said in a letter to the *Evening News*: 'This is the first time the women have heard that the employers want to reserve monotypes for women. With the exception of one firm which has only males, they have been obliged to employ women on keyboards, because when they advertised for operators, no men came forward. I believe that one firm is at present training one male monotype operator, who is being taught by a woman.'[28] It is true that this evidence comes from the opposing side so to speak, but nowhere is a counter-assertion put forward by the union that men had applied to learn and been turned away.

Clearly (as the employers were quick to point out) keyboarding had nothing in common with what a man had learnt during his apprenticeship: it meant acquiring a new skill. But the men's reluctance is still surprising, and seems to be unique to Edinburgh. Was it perhaps because the work did indeed look like typewriting (by this time neither a highly paid nor a highly regarded occupation and mostly done by women) and therefore an effeminate calling and beneath a man's dignity? One did not get dirty hands working a Monotype. Was it fear of not being able to perform as well at this new skill as they could with the composing-stick? Or was it a form of Luddism for fear the machines would displace men? The *Edinburgh Evening News* picked up the point during the dispute and commented that 'the old story of the men's dislike to machinery appears in this dispute just as it was with the engineers'.[29] Whatever the reason or reasons, the men's unwillingness to handle the machines led directly to the situation of the late 1900s in which Edinburgh master printers were trying to counter the threat of London and southern firms by combining both the employment of women and the use of machines, thus posing a double threat of a new kind to the male compositor, and inspiring a more determined resistance from the latter than had been seen during the previous thirty-odd years.

THE UNION AND THE 'FEMALE QUESTION': THE GATHERING STORM

As was noted in Chapter 3, no very great resistance had been mounted to the employment of women in the early days, partly because the numbers were small, partly because the union had been weakened by the 1872–3 strike, and partly, it must be remembered, because the girls recruited to the trade were often the daughters of print workers. The tangle of hostile and sympathetic feelings towards the new recruits, while hard for the historian to penetrate, must have complicated everyday life in the printing office. In later years, one union member pointed out that there was 'a new generation of printers who have sprung up since the strike. When I say that some of them take [women compositors] to be wives, there cannot be ill-feeling toward them'.[30] (Though of course one of the most efficient ways of removing women from the printing houses was to

propose marriage, and this was more than once half-seriously proposed as a deliberate strategy.)

When in the 1880s, anxiety about the question grew more acute, and when exhortation to society members not to instruct 'female learners' or to allow their daughters to take up the trade seemed to have little effect, more organized attempts were made to confront the problem. At the conference held in 1888 by the three compositors' unions, the Typographical Association (English provinces), the London Society of Compositors and the Scottish Typographical Association, specifically to discuss the Edinburgh question, the following resolution was passed:

> That while strongly of the opinion that women are not physically capable of performing the duties of a compositor, the Conference recommends their admission to membership of the various typographical unions upon the same conditions as journeymen, provided always the females are paid strictly in accordance with the scale.[31]

Cynthia Cockburn calls this 'studied hypocrisy', arguing that as things stood no woman could expect to earn the same wage as a man, because of the Factory Acts among other things, and links it with the undoubtedly fiercely held view among many compositors that women really had no right to 'leave the home' anyway.

It is possible to nuance this view slightly as regards the Edinburgh union leadership. There may just have been some hope of effecting change through organization, especially when the numbers of women were still low (about 300 at the end of the 1880s), though the means chosen were not welcomed by the rank and file of the men's union. Although unfortunately details of the projects are tantalizingly hard to ascertain, at least two attempts were made after 1888 by the Edinburgh Typographical Society to set up a women's union. The first, in the late 1880s, is referred to only in the retrospective 'Statement on the Female Question', published in 1904:

> Miss Black of London [who must have been Clementina Black] a lady who was well-known for her efforts to improve the social condition of her sex, offered to make an endeavour to organise the female compositors in Edinburgh, with a view to remedying the evils complained of by the journeymen. The branch committee favourably entertained Miss Black's assistance, but on it being remitted to a general meeting of the Society, it was rejected on the grounds that if the females were organised, their position would be improved as an industry for females, which would result in great accession to their numbers in the printing trade in Edinburgh.[32]

What seems to have happened here (as on other matters) is a division of opinion between the ETS committee – who may have been quite sincere in trying a long-term solution – and the knee-jerk reaction of the

membership against the permanent acceptance of women as compositors which the project undeniably contained.

That some compositors, and not only on the committee, took a more sympathetic view of the problem is suggested by one writer to the *STC*, as far back as 1886, whose attitude seems with hindsight to be the most constructive approach voiced by an Edinburgh man: that the women be treated seriously as colleagues and an attempt made to integrate them into the cultural world of the compositor from which they were decidedly excluded:

A trade female society should be organised, having in connection a sick etc. fund; a reading-room provided with illustrated and comic papers and magazines; a library of high-class light literature chiefly and encyclopedias, dictionaries etc.: and an efficient committee to arrange for a grand picnic every summer and social gatherings in winter evenings.[33]

A rather patronising choice of literature perhaps, but the suggestion was a positive one. Such was not apparently the view of the bulk of the membership however, and the chance was lost to try an experiment in creating greater unity while the numbers of women were still comparatively low.

The strategy of continuing to exclude women from the union did not prevent their recruitment in ever greater numbers by the employers. So in the late 1890s, another attempt, this time apparently not vetoed by the membership, was made to organize a women's union. The central figure on this occasion was the more locally known organizer, Margaret Irwin of Glasgow, acknowledged to be an expert on women's trades in Scotland.[34] The delegate meeting of the STA at Dumfries in 1895 had called upon those branches affected by women's employment to 'exercise their influence in every way to secure the standard wages and fair conditions of employment for female compositors'. Accordingly, 'with the praiseworthy assistance of Miss Irwin, Secretary of the Women's Federal Council', and with financial help both from the ETS and the STA, a 'Female Compositors Society' was set up as the *STC* reported in July and August 1898. Margaret Irwin 'paid three visits to Edinburgh to address meetings at the invitation of the Typographical Association', and the STA *Annual Report* of 1898 claimed that the new society 'bids fair to succeed; if it will be the means, as anticipated, of improving the position of the *male* comp [*sic*, my italics] there will be no lack of well-wishers'. The next report however carried the sad news that the 'Female Compositors Society has not survived the ailments of its infancy: it closed at the end of the year'.[35]

The reasons advanced for this failure in the 'Statement' of 1904 were 'the difficulties which female organisers have had to contend with in other trades – apathy and lack of support'. This is familiar language, and Eleanor Gordon and others have argued that much more investigation of

the circumstances of setting up women's unions is needed before it can be accepted at face value. Material obstacles made union membership difficult for women: their low pay made it hard to pay dues, while their domestic duties as daughters and sisters, not to mention the question of staying out late, made it hard to attend meetings. These problems have to be weighed along with less tangible factors: what would women (as distinct from 'the male comp') get out of the organization? How far did it address their grievances? How whole-hearted was the men's support?[36] In this case, the lack of details urges us to caution. The literature (especially Macdonald's 1904 account) is full of references to women's 'pessimistic and listless' attitude to the fight for higher wages, but as we have already noted, women were often inclined to agree that they were not doing the 'full job', a view in which they were daily fortified by both masters and men. Margaret Irwin herself accepted that the lack of success was caused by 'the apathy of the women themselves ... the woman does not take her industrial work as seriously as a man ... [she] does not regard it as the permanent occupation of her life'.[37] Margaret Irwin's views are not to be dismissed lightly, but it is worth noting that she herself did not approach the question with any blazing convictions about equal pay. She argued that if women were paid the same as men, 'it would result in many women being dismissed from many trades', and also accepted without demur, when giving evidence to the Fair Wages Committee a few years later, the proposition that women were satisfied with less money because they were earning 'pin money' if married, and 'pocket money' if not.[38] With such pessimism about equal pay entrenched in the mind of their organizers, with such low evaluation being set on their work, one might argue that it would have been surprising if a militant women's union could really be organized in the prevailing atmosphere.

While it would be nice to imagine an alternative history in which either Miss Black or Miss Irwin succeeded in organizing the women compositors, who then ended up with a reading-room full of the encyclopaedias they had themselves typeset, it was not to be. Since later events were to show that women compositors were by no means incapable of taking action, we may be sceptical about 'apathy' as the sole explanation for the collapse of the early attempt to form a union. But in the mean time, encouraged perhaps by such apparent signs of weakness, perhaps simply by pressure on their order-books, the Edinburgh master printers began recruiting girl apprentices in larger numbers than ever before during the early years of the century, to the growing despair of the ETS and increasing anger from the male trade-union movement in general.

The Edinburgh 'female question' clearly had repercussions outside the city, as can be seen from the reasons given by the Arbiter who turned down the Glasgow compositors' pay-claim in 1904. Arguing that Glasgow wages were already higher than those in Edinburgh, and pointing

out that the Glasgow printers had successfully blacked firms trying to employ women, he went on (in rather clotted prose):

> I am satisfied that the employment of female compositors in Glasgow, while it would increase the total volume of work done there and admit of the natural development of the Glasgow book trade, would not injure the position of the Glasgow men printers, while it would enable the Glasgow printing trade, employed as well as employers, to obtain and retain work which at present ought to come to Glasgow, or at least might come to Glasgow but now goes to Edinburgh.[39]

The Glasgow patriotism of the Arbiter was more to the taste of the employers than the employed, whose irritation showed itself within the STA.[40] Branches without women rivals now sided with Glasgow in demanding a campaign to exclude women for good, while branches such as Edinburgh, who had to contend with the problem, tried to go on arguing for some form of recognition of women workers. The STA delegate meeting of 1905 passed a resolution urging branches to ban any new women entrants to the trade, and over the next year or so Edinburgh became increasingly isolated as first Aberdeen, then Dundee and Perth succeeded in closing the trade to new women recruits (there were far fewer women compositors in these towns anyway). During 1907–8, although a local committee was formed by the ETS to study the 'female question', priority went to the 50 hours campaign, which was finally settled in February 1909, thus leaving the way clear. Moves towards unity within the branch, and towards federation within the printing trades as a whole, strengthened the resolve of the Edinburgh compositors. In 1908, the longstanding split between themselves and the machinemen had been healed: 'a happy consummation' and 'an event full of promise for the future', as the local branch of the Printing and Kindred Trades Federation put it. The NPKTF, which had taken definitive form in 1902, had been pressing for reconciliation within the Edinburgh branch, and was to play a strongly supporting role in 1910.[41]

1910: THE MAIN ISSUES

It was with the new strength born of unity then that the Edinburgh Typographical Society presented the employers with its memorial on women workers in November 1909. For the first time, this took an uncompromising line; there was no more talk of limiting the damage. This time they demanded:

> That from the first of January 1910, there shall be no further introduction of females into our trade in Edinburgh, nor any importation of female compositors from other centres, and that in future, machine composition be solely undertaken by male union labour.[42]

Two things are worth noting at this point. First, the memorial did not call for the dismissal of any women employed in Edinburgh at the time. This

was important for relations with the existing women compositors, none of whose own jobs was under threat. The calculation behind the memorial was naturally that most of the women would leave to get married within a few years. Secondly, and this became clear in the negotiations that followed, machines were the real key to the whole question. This was a dispute about future technology as much as about women's labour. The memorial marks a striking turnabout in the men's approach to composing machines, which must have been the result of a fairly recent appreciation of the double threat posed by women Monotype operators. It has already been observed that male compositors had virtually boycotted the machines at first. Now, possibly alerted by advisers from outside (such as C. M. Bowerman, from the London Society of Compositors, chairman of the NPKTF, and member of parliament, who attended the negotiations during 1910), the committee of the ETS on behalf of its members, came into line with compositors everywhere else in claiming the right to work the machines.[43]

It is evident from the progress of the talks between employers and union, that the employers equally recognized this as the heart of the dispute. With hindsight, one can read from their responses that the days of recruiting women as hand-setters were in any case numbered. The master printers readily concurred with 'the desirability of gradually reducing the ratio of female to male labour employed in hand-setting' in their first reply to the ETS committee in January 1910, but 'they did not mention the proposal to replace the monotype keyboard operators by male union labour'.[44] Through the winter months, the larger firms gave further assurances that they were willing 'to take immediate steps for the gradual reduction of female comps'; some it seems went even so far as to dismiss women. The close attention which the union committee gave to every case of a girl being hired in the winter and spring months of 1910 argues that the recruitment had slowed to a trickle, as is borne out by an analysis by age of the sample in Chapter 6: whereas large numbers of the women would have been 14-year-olds in 1908–9, hardly any were younger than this. (Two surviving compositors, both of whom began work in 1909 told me that they had been among the last recruits.) The employers did however wish to keep the door open for the future, and proposed a ban of five years on women entrants – something which the union was prepared to accept in the hope that 'natural reductions' over this period would leave the men in a commanding position.

On machines however, a tough rearguard action was fought by the employers. Pressed by the men, they offered various compromises at the April 1910 negotiations of which the minutes have been kept.[45] Still pleading competition and the greater suitability of women for keyboard work, they proposed first that machines henceforward be given alternately to men and women workers; or, a further concession, that all new machines be given to men until there were 50 per cent worked by

each sex, and attributed alternately thereafter. Neither of these pro-
posals was accepted by the men who, both in December 1909 and May
1910, voted by two-thirds majorities to reject them.[46] The talks remained
in deadlock through the summer of 1910, but following energetic efforts
by the compositors and the unions representing kindred trades, press-
ure was mounting for a confrontation, which took place in the last weeks
of the summer

'NOT FOUND WANTING': THE WOMEN COMPOSITORS WHO JOINED THE MEN

It is during the summer, and before the September dénouement, that the
voices of the women compositors for the first time become audible to the
historian. Not before time, the reader may think, we can find out some-
thing of what the central figures in this dispute thought about it. Until
this date, it has been difficult to escape from a picture of the women
compositors as the subject of other people's discourse: employers, trade
unionists, parliamentary commissioners, commentators like Mac-
donald, organizers like Margaret Irwin. The 1910 dispute, which is
particularly well documented in the press as well as in manuscript
sources, enables us to see that on this occasion at least, the women did
not stand by and wait for it to be resolved over their heads. They took an
active part – but on both sides of the argument. One section of the
women backed the men; another formed a separate union for a short
while and tried to resist the ban called for in the men's memorial.

The first definite report of women taking the side of the men comes in
early August, when it was announced at the quarterly general meeting of
the Edinburgh Typographical Society that in the office of Neill & Co, 51
'female compositors had intimated their intention of tendering notices
on Friday 5 August' alongside the men. Neill's was one of the largest
employers of women and therefore one of the main targets of possible
strike action. The same source claims that the 51 women in question
'consisted of the best workers in that department' (presumably this
means the most senior).[47] Details of the circumstances at Neill's emerged
only slowly and selectively, but the women apparently exacted a price
for their support. Not only did they get a promise from the secretary of
the men's union that they would be paid full wages by the union if they
came out on strike (unusual, if not unprecedented for non-members) but
the agreement subsequently signed with Neill's management included
some improvements in their piece rates. 'Female comps' were in future
to be paid for 'inserting leads [i.e. spacing material] and justification'.
What was more, since 'a deputation from the female compositors [had
insisted] upon an agreement anent same', they were to be allowed to do
'upmaking and corrections on machine-set matter until the whole matter
is settled'.[48] As a result of the threatened strike – in which the women's
participation would have been crucial – Neill's came to a separate agree-

ment with the men, signed the memorial and thus dropped out of the dispute during the month of August. They were quickly followed by another large-scale employer of women, Morrison & Gibb. Less is known about the Morrison & Gibb case, but again it appears that the women indicated their solidarity with the men.

It may seem odd at first sight that women should actively promote their own exclusion from the trade. But it should be remembered that the memorial did not call for the dismissal of a single woman. If in addition promises were made, as it seems they were, of helping to boost wage rates, and if particular grievances were also thrown into the package, it is not necessarily paradoxical that women should have agreed both to the five-year ban on entry (they were not to know that it would really be a permanent one) and to the assigning of all new machines to men. There was no question of taking away their own machines from women already working as Monotype operators in 1910. What is also easily overlooked is the appeal to their class solidarity. When it was put to them that they were taking jobs away from men, many working-class women were prepared to agree that this was 'not fair'.[49] But there may be more to this than comradely debate.

At a subsequent mass meeting, John Templeton, secretary of the STA, referred to these 'two great cases' (Neill's and Morrison & Gibb) and said that women workers in these firms had been 'weighed in the balance and not found wanting'.[50] Jean Symonds, one of the women who organized resistance to the men, retorted that 'the girls he referred to had been weighed against their will. In one firm, the girls had practically been compelled to join with the men'. It appeared that she meant Morrison & Gibb.[51] It is hard to know how to measure this kind of evidence. It is not at all unlikely that some pressure was put on women in these two key firms, but it may have been of a persuasive rather than an intimidating kind. 'A woman worker' wrote to the *Despatch* in late August, claiming that 'persistent attempts are being made by the men to work on the motives of selfishness and self-interest of the women'. Another anonymous woman, 'a looker-on' claimed that 'the men have recently shown a curious and novel diligence in the way of coaxing, bribing or even fighting girls into joining a trade union'.[52] (The union in question was one of the unskilled unions in the NPKTF, a point developed below.) Whatever the tactics used, it soon appeared that the men were having some success in winning women over to their side in other firms as well. The *Despatch* on 9 September, as the dispute was reaching its climax, reported:

> It is claimed by the men that they are receiving a very large measure of support from the women. It is reported that in a large printing office in the city [which can only be R. & R. Clark] where there are about 100 females employed, more than 70 handed in notices to strike yesterday, while correspondingly large proportions of the

females employed in other firms are said to have signified their intention of going on strike, failing a settlement. Only a 'claim', but one that looked quite likely. It was not only the female compositors who were being asked for support. Amelia McLean, who led the resistance to the men, alleged that Mr Alfred Evans, general secretary of the Warehousemen and Cutters' Union, was 'trying to organise all the girls in the printing trade, including warehouse, machine room and stationery workers, [to come out] on strike with the men'.[53]

Mr Evans and his union were crucial to the men's strategy. The Warehousemen's and Cutters' Union might not seem the obvious place for compositors – even women – to find a welcome. But within the NPKTF, it was successfully recruiting a number of the unskilled or 'auxiliary' women workers in the printing trade. It was an English union, based in London and not affiliated to the STA, with whom it had dealings only within the NPKTF. Soon Alfred Evans was claiming women compositors as members: 'We have 420 female workers [in Edinburgh], 280 of them comps.' And later, 'we have 280 women comps enrolled in our society and over 100 fresh nomination papers handed in'. Ellen Smyth, an experienced organizer, helped in the recruitment campaign. This was the union which Edinburgh male printers had been 'coaxing, bribing even fighting' women to join.[54] Why did they not rather try to recruit them into the STA in some way, as a separate women's branch for instance, as in the past? Cynthia Cockburn is probably quite right when she refers to this as a way of getting women to recognize that they were inferior beings.[55] The 'looker-on' correspondent of the *Edinburgh Evening News* certainly thought so. She wrote that a woman who had been a comp for eleven years had told her that the subject of a union had never been mentioned to her before. 'Now a special male organiser from the South has been brought in' to get them to join 'not the STA, which by rights skilled workers like compositors should enter, but an inferior English union, composed of unskilled workers'.[56]

Amelia McLean also pointed out that skill was at stake: 'fortunately, the majority of women workers cannot see their way to join that union, as they claim to be skilled workers'.[57] For the first time, perhaps because by now there was a 'critical mass' of older and more experienced women to take a lead, we find some women taking a stand specifically on the definition of skill, and refusing to be absorbed into an 'unskilled union'. The women's resistance movement crystallized around this refusal, drawing hostile comment from Alfred Evans, who praised the 'shoulder to shoulder' solidarity with the ETS shown by his own members, while deploring the aid given to the resisters by 'middle-class women who are on the warpath on behalf of the employers'. For it was known and greatly deplored by male unionists, that the women's resistance movement did indeed have support from middle-class women's suffrage groups in Edinburgh.

THE 'WE WOMEN' MOVEMENT

So far as one can judge, the women's resistance movement was formed towards the end of June 1910, that is while talks were still inconclusive, and before the events reported above led the management of Neill's and Morrison & Gibb's to sign the memorial. At a meeting on 1 September, the 'Women Compositors', Readers' and Monotype Operators' Union' was described as having been in existence for some nine weeks.[58] Its most spectacular action had been the production, in June, of a separate memorial addressed to the employers (referred to as the 'We Women' memorial). Four hundred-odd signatures of women compositors were appended. This document read as follows:

That we, as representing a large number of the women compositors of Edinburgh, feel that a question affecting a considerable body of women should not be settled without these women having an opportunity of giving expression to their views.

That while recognising that the men have had a real grievance in that some firms have employed an unfair proportion of young girls at apprentice wages, or nearly so, we women regard it as a great injustice that one of the main skilled industries open to Edinburgh women should be closed against them.

That we women feel that the fact that women have been employed in Edinburgh as compositors for nearly forty years gives women a claim on the business.

That up to the time in Edinburgh, the Monotype machines have been largely, if not chiefly, operated by women, and that women have proved themselves entirely competent to work these machines, so that it seems a great hardship that women should be debarred from working at them in future.

That since we have realised the position of women in the printing trade is seriously threatened, we women have been trying to organise ourselves with a view to securing justice for ourselves and for the women who may in future desire to practise the business of compositors or monotypists.

That in view of the foregoing considerations we ask you to ask the Masters' Association to delay any decision hurtful to the interests of women compositors until the women's case has been given full consideration.[59]

Unfortunately, no record seems to have survived of the names of all those who signed the document: in an interview with the *Despatch* on 1 September, one of their leaders said they were mostly from printing offices which had not agreed to the men's memorial, that is on the whole the smaller offices. The two women named by the local press as leading lights of the women's union – Jean Symonds and Amelia McLean – both worked at Skinners, a firm employing 19 women and 7 men in its composing room. Skinner's had not signed the men's memorial during

the summer. I could discover very few details about either of these women. Jean or Jeannie Symonds was still working in Skinners in 1913, left the trade for a few years but was readmitted in 1927, so it seems safe to assume that she spent much of her working life in the printing trade and did not marry. Amelia McLean on the other hand, who was the movement's leading spokeswoman – writing articles for suffragist papers and giving statements to the local press – married and left the trade shortly afterwards. The daughter of a warehouseman, she was 26 years old in 1910, so had presumably been more than ten years in the trade. Her husband was described as an engineer (probably a skilled engineering worker). She was thus neither from a printing family, nor from a middle-class background, and felt obliged to counter rumours about her financial status: 'It has been rumoured that I am a suffragette and a paid official: as a matter of fact, I am neither. This fight has been an expensive business for me personally, but I do not mind that. It is the principle we are fighting for'.[60]

It was in part on 'middle-class interference' that polemic about the 'We Women' memorial centred. The *STJ* reported that 'the small section [i.e. the women's breakaway union] as has since been openly admitted, was formed and organised under a "West End" [of Edinburgh] suffragette banner . . . Altogether from first to last, there was evident much, far too much, of the patronising yet dominant "West End" about this opposition'.[61] Hints were dropped that the suffragettes in question were lady friends of the employers, that invitations to 'My Lady's tea-parties' were issued, and so on. Since the *STJ* always confined itself to veiled hints of this kind rather than anything more explicit, and since there is little or no literature available on the women's suffrage movement in Edinburgh, it is impossible to say whether there was indeed any personal connection between the Master Printers and the 'West End suffragettes'. What can be confirmed is that both national and local women's suffrage groups took an interest in the dispute.

Although all the groups, 'militant' or 'constitutional' seem to have followed events with attention, the Women's Freedom League (WFL) seems to have been particularly active, and the columns of its paper, *The Vote*, were opened to the Women Compositors' Union. As early as May 1910, the local WFL organiser, Madge Turner, commented more in sorrow than in anger on the dispute, admitting that 'the saddest part of it all is that the majority of women in all the departments are supporting the men. They have been gulled by the promises of the men that they will have better work, better wages, better conditions. The ugly fact that if women are ultimately shut out of the industry, organisation and better conditions will be of no use to them, has been carefully glossed over.'[62] At the beginning of June, the paper reported that 'Some of the girls are very indignant at the treatment they are receiving. A joint committee, formed of the members of the Freedom League, the WSPU and the

NUWSS, has been formed.' At a meeting held at the local headquarters of the WSPU, 'Mr Buckner, a prominent official in the STA, who spoke to the question from the men's point of view, was subjected to a very severe heckling.' On Tuesday 14 June, 'representatives of the girls in the composing department of the printing trade, attended to address our [i.e. WFL] members', and on 25 August a deputation went to see the employers and called for a Board of Trade enquiry.[63]

The women's union quickly ran into trouble though. In the first place, the 400 signatures were challenged. 'Three parts of the signatures were no signature at all', alleged one speaker at a men's meeting. In private, during talks with the employers, C. M. Bowerman said: 'In reference to the new Society and memorial with 400 signatures, we are men of the world and quite know what that is worth and how those signatures were obtained.'[64] The implication, whether private or public, was that somehow pressure had been exerted by the masters to get the women to sign (we have already noted that counter-allegations were made that the men had done the same to their women supporters). There is, not surprisingly, no surviving evidence about pressure or incentives from the employers' side. Miss Symonds, at a women's meeting held in early September, energetically denied the charge: 'This is absolutely untrue. Every one of the signatures was genuinely affixed by a female comp, reader or monotype operator in Edinburgh,' and subscriptions were being paid. If a rule book was not yet available, that was because it was . . . at the printer's.[65] But the Edinburgh Trades Council refused to recognize the women's union, describing it as a 'bogus association, engineered by women suffragists'[66] and its leaders found themselves beleaguered. Amelia McLean described how she had been 'waylaid . . . on [her] way home for dinner' by Mr Evans of the W. and C.U., who 'after calling her . . . everything but a lady, had said she was the most unsympathetic woman in Edinburgh'.[67]

The most serious charge against the women's union was that it proposed to carry on working if the men went ahead with their strike. The *Scotsman* reported on 1 September that 'members of the Women Compositors', Readers' and Monotype Operators' Union intend to remain at work in the event of a strike'. 'They simply cannot and could not afford to stop work. Many of the girls depend for their livelihood on their wages.' This was probably what caused most ill-feeling, and the end of August and beginning of September saw a number of well-attended and noisy meetings where each side accused the other of a multitude of sins. A mass meeting of all the printing and kindred trades was held on 31 August in the Music Hall of the Assembly Rooms in George Street, and over 2,000 people were present. In retrospect, this seems to have been the meeting which prompted the remaining employers to make their final concessions, but that was not clear at the time, and several of the orators, some of whom have already been quoted, loosed off broadsides

against the women's union on this occasion. The next day, the break-away women held a meeting attended by about 150, at which all the charges about bogus signatures, West End suffragettes and so forth, were energetically denied. Both the WFL and the WSPU held meetings on the issue in early September, but deliberately tried to cool the temperature. On 6 September however, the *Evening News* carried a report of a clash between women on different sides in the dispute: 'we understand the differences of opinion between the women who have amalgamated with the men's society and those associated with the women compositors, readers' and monotype operator's union found lively expression in a wordy warfare'.[68]

The remaining employers, during the negotiations which followed the mass meeting of 31 August and the threat of a strike, were still sticking at a compromise formula, one which Amelia McLean, putting the women's case in *The Vote*, said she was prepared to accept, viz: a five-year ban on women entrants from 1 January 1911, and the establishment of a 50 per cent distribution of Monotype keyboards between men and women. Miss McLean also outlined the position of the women's union on equal pay. This was a central issue, but not mentioned either in the men's memorial nor the employers' statements. Her attitude was one with which the reader will now be familiar: that women could not reasonably expect the same pay as men:

> That we know would be impossible, at least in the meantime, as up to now all girl apprentices have only served an apprenticeship of three years, whereas a boy serves seven. Therefore the woman, not having had the same training as a man cannot possibly demand the same wage; also not being physically as strong, she cannot compete with him where heavy lifting is required.[69]

She also mentioned the Factory Acts as a restriction on women's usefulness to employers. (While the Factory Acts did not usually greatly affect book-printing, it sometimes happened with legal or government work that compositors had to work longer hours than normal to meet deadlines.) By thus reproducing arguments in favour of unequal pay which had a long pedigree, Amelia McLean's article showed that she was either unable or unwilling to realize that, apart from anything else, the introduction of Monotype machines within the previous few years had completely redistributed the cards. Once machines seriously began to replace hand-setting, the argument about apprenticeship would be greatly weakened. Although she did call for a fuller apprenticeship for women, Amelia McLean did not argue (nor did anyone else) that the Monotype made old-fashioned apprenticeships redundant, and that by a historical reversal of the usual procedure, women compositors in 1910 actually controlled a skilled process while men did not. The women's resistance movement was inhibited by its own willingness to accept an

undervalued estimate of women's work, whatever the actual work process.

THE CONFLICT 'RESOLVED'

Even if Amelia McLean had made more ambitious claims, it is doubtful whether anyone would have listened to her. The dispute was being regarded as a trial of strength by the labour movement (in a nationwide context of increased union militancy) and the solidarity of all the trades in the printing industry impressed the employers still standing out against the men's memorial. Weakened by the capitulation of some of the bigger firms, the remaining master printers conceded their last point, about the machines. After further talks, another mass meeting on 15 September (the day the strike notices expired) voted to ratify the agreement, which was finally signed on 24 September. It stated that any women then in composing rooms could remain there, but that no new recruits were to be taken on before 30 June 1916. *All* new keyboards of composing machines were to be operated by male union labour, and fifty per cent of upmaking and correction on keyboard material was to be done by men. In return, the Edinburgh branch of the STA was to maintain peace on all questions of wages and hours for the next three years. Some small increases in women's pay were implemented, but these did not significantly affect the differential between men and women. It was later admitted by the men that 'unfortunately, in that treaty, they had not been able to obtain any particular conditions' for women.[70]

Although the result was generally welcomed as a great triumph for the men, some ETS members and some political groups thought they should have held out for even more concessions. *Forward*, the ILP paper, which was not unsympathetic to women's causes, including suffrage, nevertheless commented sternly:

> We don't think this quite satisfactory. For instance, the first point does not hinder the masters from introducing female labour at half rates [i.e. after 1916]. The second allows women still to operate keyboards. We do not object to women working the keyboards, so long as they are paid the same wages as men. Until they are, female labour at half rates will have a dangerous effect on the printing trade in general. As a matter of fact, most of the London publishers send their printing to Edinburgh to get it done at half cost by sweated labour. Thus while the girls are exploited, the men printers of London are unemployed. And the Executive's recommendation is not by any means wholly satisfactory. As it is, we regret that the printers, when they had the opportunity, did not make an end of the half-paid female labour and so established the principle for both sexes of 'Equal work, equal pay'.[71]

Very few dissenting voices were heard on the left. One of these came,

interestingly enough from the Socialist Labour Party, the extreme left-wing group of revolutionary socialists who made the work-place the centre of political struggle. The SLL was opposed to women's suffrage as a bourgeois demand, but fully supported the right of women to work outside the home. Lily Gair Wilkinson, writing in the *Socialist*, the SLL paper, in June 1910, had apostrophized the male printers of Edinburgh:

What economic or social argument can be put forward to justify the claim that the trade is yours? Whatever the justification there may have been in the past, when a high degree of ability may have been necessary to acquire and work at the trade, that reason has forever passed away if it ever was more than a trade gild superstition.[72]

The reclaiming of the trade by the men was nevertheless to become a permanent reality, as an editorial in *The Vote* had correctly predicted.[73] It is possible that if the war had not intervened, the men would in any case have been able to secure the prolonging of the ban on women beyond June 1916. In the event, no effort was needed: the early years of the Great War caused great damage to the Edinburgh printing trade, with several firms going out of business, others laying off workers or releasing them for other jobs since trade was so poor. In 1916, many of the women compositors found themselves being called to work as Post Office clerks. No firms were anxious to try to recruit more. And by the end of the war, the issue had fallen into oblivion. Several hundred women remained employed in Edinburgh printing houses, but they were destined to grow old in the job, with no girl apprentices joining them. Edinburgh thus came into line with the rest of Britain, and the trade of compositor became a male monopoly until the Equal Opportunities legislation of the 1970s, which enabled a few women to serve regular apprenticeships as compositors, before the widespread adoption of the new computerized technology convulsed the printing trade, in ways which have been thoroughly discussed by Cynthia Cockburn.

The Edinburgh 'female question' was 'resolved' by the 1910 agreement, resolved that is, as far as the men of the STA were concerned. Alfred Evans had claimed that 'this is not a sex question, but a wages question, wholly and solely'. Was he right? Unequal pay was certainly the heart of the problem. As Ellen Smyth said, 'women did for 14s the same work as men for 32s'.[74] (She was actually quoting the lowest rates: Amelia McLean pointed out that 'stab girls' made between 15s and 25s, while piece workers got 14s to 16s; 'if all the girls in the different occupations in Edinburgh had such a wage, there would not be much to grumble about'.)[75] What neither the men nor the resisting women ever came to terms with was the completely new skill represented by monotyping. If they had combined forces and demanded that the employers pay equal wages to anyone working a machine, man or woman, might the outcome have been different? It is at least arguable: the employers did after all give in when faced with a strike, and effectively surrendered

on this very question for the future, since they would have to pay the male rate to all the new (male) monotypists. Everyone was aware that the days of women hand-setters were in any case numbered. It looks very much as though this option was ruled out by entrenched feeling on the men's side and inadequate appreciation of their position by the women. Both sides perceived it as a 'sex question', even if it was 'a wages question'.

Unity seemed to be an impossibility in 1910: men's and women's interests were apparently quite incompatible. Mr Templeton of the STA bluntly stated that 'either the men or the women must cease to exist as comps',[76] while Mrs Pankhurst, speaking in North Berwick, remarked that 'the women were between the devil and the deep sea'.[77] But that unity did eventually come about. Hesitantly at first, and in the face of some opposition, the male union leadership, in consultation with the women, decided to set up a women's section of the ETS instead of pursuing the strategy of recruiting the remaining women compositors into the Warehousemen and Cutters' Union. This story, which deserves attention and is in some ways unique, is told in Chapter 7. But before that, it is possible, using the sources revealed by the 1910 dispute, to put together a sort of group portrait of the women compositors, as they were in 1910, and as they continued to be over the coming years. It is often easier to chart the high points of labour disputes than the realities of everyday life. Here we have a particular group of working women unparalleled anywhere else in Britain. What were their family backgrounds, their circumstances, their feelings about their work, their daily routines?

6

GROUP PORTRAIT: THE 'COMPESSES' OF 1910

History froze the numbers of women compositors at the point they had reached in 1910. This narrative will now freeze at the same point for the space of a chapter to look at the women whose names are listed as working in that year. Who were they? Where did they come from? Can we find out anything about the realities of their everyday lives, at work and outside work? It is possible to do some detective work on a numerical sample whose size (unfortunately for any girls hoping to work as compositors in Edinburgh, but conveniently for the historian) could only decrease. The names of 844 women still in the trade at the end of the year 1910 are listed in the *Register of Employees* produced by the Edinburgh Typographical Society in 1911: this covered all the chief book-printing houses in the city, and since the total tallies with other estimates it can safely be assumed to cover most of the Edinburgh 'compesses' of the day.[1]

What are our sources? The *Register* gives us the basic 1910 sample. But it does not tell us very much: all the compositors, men and women, are simply listed by name and by printing-office. From subsequent editions (1911(2) and 1913) we can at least tell when a compositor had changed offices or left the trade altogether. For approximately 38.5 per cent of the 844 women in the sample, this is the only information available. Of the other 61.5 per cent it has been possible to discover at least something of their personal histories. Some data came from the trade-union records – particularly those of the Women's Section of the ETS created after 1910 – and from cross-checking in the *Scottish Typographical Journal*.[2] The names of those who left the trade were usually printed in the *Journal* or noted in the minutes, sometimes with details. Since the great majority of the women who left in the 15 years after 1910 did so to get married, an obvious place to look was the registration records.[3] Marriage certificates provide such data as the age, address and occupation of the bride, the groom and their parents. Although by no means all the marriages could be traced, I was able to find records for about 160 women, roughly one-fifth of the total sample. Deaths (although for only about 2 per cent of the sample) provided similar information. Union records and the *Journal* also from time to time (though all too rarely) yield details of everyday life: applications from widows to re-enter the trade; accounts of social outings or retiral parties. Lastly it was possible to have the first-

hand testimony of some of the compositors themselves and their relatives. I was able to trace only four survivors, all over ninety (all of whom have since died) but their first-hand evidence was all the more precious.[4]

It would be presumptuous to call what follows a collective biography and it would certainly be unwise to claim any great statistical value for such findings as there are. The gaps in the evidence are simply too great, and it is sometimes hard to interpret. But by piecing together all these different kinds of information, it should be possible, if only very imperfectly, to bring out of the shadows the central actors in the whole story, the women in the composing rooms.

A GENERATION

To begin at the beginning: when were they born? We know the latest possible year. Since no apprentices were taken after 1910, and since the age at which girls normally left school and began working was fourteen (give or take a few months), the youngest women in the sample were born in 1896. In fact, of the 202 cases where a date of birth is known (see Table 8),[5] only 4 were born in that year (as compared with 18 born in 1895). The reason must be that since the dispute over women had reached a critical phase by the end of 1909, very few girl apprentices were taken on after that. Two of the survivors assured me they were among the last girls to be admitted to the trade.

As for the earliest date of birth, it is theoretically possible that it could be 1855, since the first recruits to the trade, some of whom were still working in the 1900s, were aged 18 in 1873. The earliest known date of birth in the sample is in fact 1867 (two cases). It can be assumed then that by 1910 the age range ran from 14 to 43 for certain, and there will most likely have been a few women in their late forties or early fifties. But the distribution was far from equal between these limits. As we have already seen, recruitment of girl apprentices increased during the 1890s and especially the 1900s. From the ages of the 202 known cases, we can calculate that there was a definite upturn in recruiting in 1902 (girls born in 1888) reaching a peak in 1904 (girls born in 1890). Then, consistently with a downturn in trade, the numbers fall a little, to peak once more in 1908–9 (girls born in 1894–5). It is impossible not to connect this finding both with the introduction of machines and with the increasing alarm among the men. Extrapolating from the known dates of birth, it is possible that as many as 75 per cent of the women employed in 1910 were then aged between 14 and 23, the remaining 25 per cent being between 24 and 43 or older. So in everything that follows, it should be borne in mind that the sample under discussion is – possibly more than might have been expected – a group close together in age, which could almost be regarded as a generation. The opportunities in life of these women would reflect their generation's place in history. To take just one in-

TABLE 8. *Women compositors: distribution of ages and presumed year of beginning apprenticeship where date of birth is known*

Year of birth	Year of apprenticeship	Age in 1910	Number of women
1867	1881	42	2
......
1870	1884	40	1
1871	1885	39	3
......
1874	1888	36	2
1875	1889	35	3
1876	1890	34	3
1877
1878	1892	32	1
1879	1893	31	6
1880	1894	30	2
1881	1895	29	3
1882	1896	28	1
1883	1897	27	6
1884	1898	26	5
1885	1899	25	8
1886	1900	24	5
1887	1901	23	11
1888	1902	22	15
1889	1903	21	18
1890	1904	20	23
1891	1905	19	15
1892	1906	18	14
1893	1907	17	12
1894	1908	16	24
1895	1909	15	15
1896	1910	14	4
TOTAL			202

Source: Registration and retirement records. The younger age-groups are probably over-represented in this table, which is based on the known dates of birth of 202 out of the 844 women in the sample – 25 per cent – since many of the dates are derived from marriage records. All the same the table is probably fairly accurate about the years when larger numbers of girls were recruited into the trade: the late 1890s; and the early 1900s, with peak years in 1904 and 1908, followed by a rapid decline in 1909 and 1910. Of the 202 cases recorded here, 46 are presumed to have been apprenticed before 1900 (and thus to have been 25 or over in 1910); 156 must have come in after 1900 and thus were under 25 in 1910: proportions of 25 per cent and 75 per cent approximately, which may reflect the age distribution in the whole sample.

stance, most of them were of an age to lose brothers, fathers, husbands or the chance of marriage during the Great War.

What were their social origins? The normal way of classifying a child is by his or her father's profession, and this is essentially all we have to go on in this case. We know the occupations of 161 fathers of women compositors, from their marriage certificates. The registration records only give the occupation of the bride's mother in rare cases, illegitimacy for instance. Women's social identity was assumed by the recording authorities at the time, and still is in most historical and sociological analysis, to depend on that of their fathers and husbands. Their own occupations and those of their mothers are allowed no analytical weight. (Common sense reminds us that given the distribution of women in employment in Edinburgh, most of the mothers probably were or had been employed in some form of domestic service or in the clothing industry; but in what proportions?) Bearing in mind then that we have only half the story, we do have some indication of the social origins of about one-fifth of the sample, enough to be regarded as reasonably representative.

Edinburgh, as described in Chapter 1, was a city of small trades, with little large-scale industry at the turn of the century. It was also increasingly a city of white-collar and service workers, but it is the first category – manual workers in small manufacturing enterprises – that is best represented among the 161 fathers. Their occupations cover at least 76 distinct trades, but within this variety, certain patterns can be identified. As usual, the word 'skill' is a problem. The usual criterion for skilled work is the serving of an apprenticeship. Thus a compositor, joiner, tailor or tinsmith for instance would normally be identified as skilled, a docker as unskilled. But there are disputed categories (such as coalmining). In what follows, the branch or sector has been used as a category in the first classification of father's occupations, with skill as a secondary and more arguable subdivision. (See Table 9.)

Whether skilled or unskilled, the vast majority of fathers of brides in the sample were engaged in manual trades (110 of the 161), and most of them could safely be assumed to be skilled workers. Nineteen fathers were in woodworking trades, all of them in conventional skilled trades: joiners, upholsterers etc. Seventeen fathers were themselves in the printing trade – mostly compositors, with a sprinkling of bookbinders and machinemen – again all skilled. Seventeen were in the building trade; mostly in skilled trades such as mason, painter or bricklayer. A further 17 were in miscellaneous craft trades, such as tailors, bootmakers, potters and so on. Fifteen were in metalworking; most of them were well paid and skilled, as tinsmiths etc. And 14 were in trades of a newer kind in which apprenticeships were served: plumber, fitter or engineer. Only 11 fathers, outside these sectors, were in heavy or what

TABLE 9. *Occupations of 161 fathers of women compositors of 1910*

A. Printing trades	
Compositor	10
Bookbinder	5
Marbler	1
Litho printer	1
TOTAL	17

B. Wood trades	
Joiner	7
Upholsterer	5
Sawyer	3
Cooper	3
French polisher	1
TOTAL	19

C. Building trades	
Housepainter	7
Mason	6
Bricklayer	1
Plasterer	1
Causeway layer	1
General labourer	1
TOTAL	17

D. Metal trades	
Blacksmith	4
Tin/silversmith	3
Brassworker	2
Gilder	2
Sheetmetal worker	1
Ironmoulder	1
Core filer	1
Wire drawer	1
TOTAL	15

E. Miscellaneous skilled, traditional	
Tailor	7
Baker	4
Boot repairer	2
Shirtmaker	1
Glass engraver	1
Jeweller	1
Earthenware maker	1
TOTAL	17

F. 'New' skilled	
Engineer	4
Plumber	3
Loco fitter	3
Gas Fitter	2
Riveter	2
TOTAL	14

G. Factory, heavy, semi-skilled (not in previous categories)	
Rubber worker	3
Coal miner	2
Gardener	2
Dustman	2
Docker	1
Laundry porter	1
TOTAL	11

H. Railway workers	
Marshalling etc.	3
Driver	1
Guard	1
Signalman	1
Foreman	1
Stoker	1
TOTAL	8

I. Transport, other	
Vanman	2
Conductor	2
Coachman	2
Pilot	1
TOTAL	7

J. Warehouse, Janitor, other service	
Warehouseman	5
Lodgekeeper	2
Watchman	2
Janitor	1
Gamekeeper	1
Footman	1
Waiter	1
Cinema attendant	1
TOTAL	14

K. Shopkeepers, assistants	
Draper	3
Grocer	2
Chemist	2
Coalmerchant	2
Bookseller	1
General dealer	1
Publican	1
Fruiterer	1
Dairyman	1
Pawnbroker	1
TOTAL	15

L. Clerks, officials, white-collar	
Clerks	2
Auctioneer	1
Inspector (works, telegraph)	2
Borough engineer's assistant	1
Meterman	1
TOTAL	7

Source: Registration of marriages of women compositors, General Register Office for Scotland, Edinburgh.

might be termed semi-skilled or unskilled jobs: docker, coalminer, dust-man, general labourer, worker in rubber factory.

Of the remaining 51 fathers, 15 worked either on the railway in some capacity (as signalman, guard, driver etc.) or in other forms of transport, old and new (coachman, bus conductor). Fifteen were tradesmen (grocer, pawnbroker, draper etc.), though it is not always clear whether these were small shopkeepers or employed by someone else. It might be argued *a contrario* that the term 'shop assistant, draper's assistant etc.' which is recorded for some of the bridegrooms, suggests that 'grocer' does indeed refer to a shopkeeper. Another miscellaneous group of 14 were in low-paid service jobs (janitor, lodge-keeper, waiter, picture-house attendant). Finally, only 7 of the whole sample could really be described as white-collar employees (clerk, inspector of works etc.)

The general picture seems quite clear: the families whose daughters entered the printing trade were overwhelmingly ones where the father was in a manual trade, usually as a skilled worker. It must be borne in mind that this distribution, while likely to be typical of the 1910 sample as a whole, does reflect that sample's age structure: the information comes from marriages logged very largely between 1910 and 1920 and obvi-ously tells us more about the families that sent their daughter to the trade in the 1900s than about the earlier decades. The few references and scraps of information we have about the very early recruits suggests that these may have included more girls of middle-class origin and certainly some from orphanages and boarding-schools – girls sometimes from middle-class families fallen on hard times.

By 1910 however, it seems to have been fairly standard practice for the daughters of skilled manual workers to try to get into printing. It must be pure speculation as to whether such a father advised his daughter to do so, but he would at least be well aware of the value of a skilled calling. The largest *single* occupational group among the fathers is indeed com-positors (10) and these men's daughters were doing exactly the same as their sons: following their father into a trade. For fathers in say, metal-working or joinery, there was no chance at all of their daughters follow-ing in their footsteps, but it made sense for them to seize the chance offered by the printing trade.

It is less evident that such a strategy would appeal to the daughter of a tradesman, who might after all be able to serve in her father's shop, or to the daughter of a white-collar worker, to whom the printing trade might appear to be a step down in the world in some respects: inky and dirty, even if requiring literacy. This no doubt explains the low number of fathers in these categories. The comparatively high number of transport and particularly railway workers may reflect the increased opportunities for such work in late nineteenth-century Edinburgh (none of the bride-grooms, belonging to a younger generation, worked on the railways: if in transport they were in more modern motorized jobs like van-driver: see

Table 10 below). And of course the main printing-offices were still near the town centre and the main railway station.

This raises the question of locality: most data on where our compositors lived come from the registration records. Many brides came from the registration districts (formerly parishes) in the crowded town centre – Canongate, St George's, St Andrew's, St Bernard's – and there was also a sizeable contingent from Leith. As might be expected, very few came from middle-class suburbs like Newington, Morningside or the West End, practically none from the squares of the New Town, and very few from outlying villages or districts. Their homes were mostly in the traditional working-class districts of the city, whether the tenements of the Old Town and South Side, or the lower-built streets north of the New Town between Edinburgh and the port of Leith.[6]

FAMILY, CHILDHOOD, UPBRINGING, SCHOOLING

There is very little direct evidence about the family life of the 1910 sample itself, but at this point it may be permissible to draw on another source, very close in time, and relating to working-class families in the town centre. The *Report on the Physical Condition of Fourteen Hundred School Children in the City, together with some account of their home and surroundings*, was published in 1906 by the City of Edinburgh Charity Organization Society (hereafter CECOS). Based on interviews carried out by 'lady volunteers' in the winter of 1904–5, it surveyed an area of tenement houses in 'one of the poorer parts of the city' (in fact North Canongate) and one in which 'the less prosperous working class was heavily represented', although as the survey put it, 'there was an admixture of children of the substantially comfortable and thoroughly respectable working class'. The extent to which the exercise represented a venture into 'the policing of families' by well-intentioned outsiders can be appreciated by the method of collecting information. Apart from interviews with the families, the survey might collect information about them from 'the Benefit Society, the Church, the Club, the Schoolmaster, Pawnbroker, Factor [rent-collector], the Doctor and the Police' (family 768). The survey was as concerned with the moral as well as the physical welfare of the subjects, and was particularly preoccupied with drink.

All this has to be borne in mind when considering the survey as a source, but it also contains a great deal of 'objective' evidence about size of family, size of dwelling, wages, etc. Its interest for us is that out of the 781 families surveyed, 'printing and cognate occupations' represented 'more than any single trade'. Selecting only fathers and daughters described as 'compositors' or 'printers', 52 families had a printer father and 38 families had at least one daughter described as 'printer' or 'compositor' (7 families had two daughters so described). As usual the term 'printer' is to be treated with caution, but other evidence, wages for instance, usually indicates that 'compositor' is meant.

The girls in these 38 families may not be quite typical of the 1910 sample, since the 1906 survey was skewed towards the 'less prosperous' working class; the occupations of their fathers were overwhelmingly manual (no tradesmen for instance). No fewer than 5 fathers from the 38 families were compositors, and otherwise a range of 20 different trades, was covered: from blacksmith to lamplighter. Only one, an insurance collector, had a white-collar job. Bearing in mind the bias of the Canongate survey, it is nevertheless possible to use data from the 38 families with compositor daughters to suggest something of the family background from which a number of our women compositors came. The memories of the four surviving compositors (none of them from Canongate as it happens) can provide some useful comparisons.

The most immediately striking point is family size. Almost all the 38 families were what would today be regarded as large, but was fairly normal for working-class families in Edwardian Britain.[7] Of the 38, 11 families had 4 children or less, 21 had between 5 and 7, and 6 had 8 or over. (Several families had moreover lost one or more children in infancy or youth, often from TB.) Of the surviving compositors I interviewed, one was from a family of 9 children, another from one of 8, one had at least three sisters, and the last was one of only two, whose father had died young. The survivors were mostly younger sisters, but the striking thing about the teenage girl compositors traced through the CECOS *Report*, was that they tended to be the eldest children of large families. 5 of the 38 families consisted of a widowed mother with respectively 3, 5, 5, 6, and 8 children to support, and in each case the eldest girl or girls were compositors. In 16 other families the girl compositor was the oldest child. Although one should not read too much into this, given that the families in the survey had at least one child in primary (board) school by definition, and therefore the oldest were sometimes the only ones of an age to be working, it can safely be said that the openings for girls in the printing trade must have been a godsend for low-income families with several children. A girl could be earning 10s a week by the time she was 18: better pay than most of the other teenage working girls in the CECOS *Report*, who were usually in low-paid service (as domestics or laundry-workers) or low-paid factory workers (machinists, paper-bag makers).[8]

Unlike the registration records, the CECOS *Report* does give details of mothers' work both inside and outside the home. The great majority of mothers were not in paid work, hardly surprisingly since so many of them had large families of young children. But in the 781 families surveyed, 262 mothers are nevertheless described as wage-earners, 153 on a regular basis. Most of these were either widows or deserted wives, or as the survey put it 'from drinking families'. In other words, they were compelled by need to seek extra income. It is assumed by the survey, and accepted by most historians of the period that married women with children did not go out to work unless they had to. But there was a great

deal of casual working: mostly in cleaning jobs or 'taking in washing', which the CECOS survey recognizes, though possibly underestimating it.[9] Such work was often not perceived as 'work' at all. One of the survivors told me that her mother 'never worked', but it later emerged that she did go out to clean offices.

In the 38 families with compositor daughters, there was evidence of dire poverty in some cases, but the mother was rarely described as working regularly. More often she 'took in lodgers' or washing, or did charring on a casual basis. One mother (the widow of a lamplighter) was a machinist at a printer's (bookbinding?), and in this case at least it may have been the mother who introduced her daughter to the trade. More often the mothers of these large families were being what the survey described as 'good' or 'bad' managers, trying to hold things together. Typical comments were 'weary-looking, but hardworking and doing her best' (a tailor's wife with seven children); or 'how she manages to keep the house so tidy is a marvel, she is dying of pthisis'. It is reasonable to assume that the daughters, particularly the elder ones, of such families will have been brought up to share in household chores.[10] The survey remarked of girls under 14 that 'they are often found to save expense by that unremunerative and often heavy task of helping mother about the house', and 'small girls are naturally useful as nurses' for their younger brothers and sisters.[11]

In the Canongate families, conditions were cramped. Fifty-five per cent of the 781 families lived in houses consisting of two rooms on a tenement staircase. Although few of them (only 20) were officially designated as 'overcrowded', bringing up large families in such circumstances was not easy, and activities such as reading would have been particularly difficult. (In 1911, 41 per cent of the population lived in two-room dwellings, and 71 per cent in three rooms or less.)[12] The CECOS surveyors tended to dwell on whether the houses were clean, well-kept and so forth. But they also noted whether there was reading matter in the house. It might perhaps be assumed that families sending girls to be compositors would be those where there was some interest in books, but the evidence is very fragmentary. In one family, where the eldest of the 6 children was a girl compositor, 'they are all determined characters and all read a good deal of fiction'. A younger sister, still at school is described as 'very bright'. In another family, the surveyor noticed that the eldest girl, a compositor aged 18 'reads novelettes and the *People's Friend*'. In another family, where both father and daughter were in the trade, there were plenty of books around the house, but the children were 'not good scholars' whatever that meant. The father in one family, himself a compositor with both a son and daughter following his trade, was described as 'a first-class workman, clever, thoughtful and well-read . . . he is in the Trade Union' and also attended Labour Party meetings

(indicating incidentally that it was not necessarily a sign of disaffection from the union for a comp to send his daughter to the trade). But in many of the families no particular mention is made of reading habits.

It is hard at this distance to work out whether the family played a great part in the daughter's choice of trade, though common sense suggests that this was probably so. Wherever we have any hard information, it suggests several forces might have been at work, not least the school. A former male compositor, apprenticed between the wars, told me that in his school, near Nelson's printworks in Parkside, the foreman used to come to the top class every year and recruit 'the brightest boys'. It seems likely that once the board schools were well established for both sexes, by the 1880s, the same thing will have been true of girls. One employer as we have already noted, thought board school girls better at reading and spelling than the boys in 1902. This may have been one way in which a girl could emulate the 'lad o' pairts' and improve herself through education.[13]

The few cases where we know how a girl entered the trade show a mixture of influences. For Jean Henderson, who entered the trade in the 1890s, it was perhaps, her daughter thinks, the orphanage with its 'feminist' matron that urged her to take up what in later life she felt to be an intellectual calling. Jean's own mother, who had been a domestic servant, wanted her daughter to go into service too, and certainly did not push her into printing. Jean Henderson had been a quick pupil at school; so was one of the 1910 survivors whom I interviewed, Ethel Brechin. She went to Canonmills School, then Broughton Higher grade, and had always been good at reading and spelling. In her case there were other reasons too. The youngest of a large family, who lived right in the book-printing district with Morrison & Gibb, Clark's and Neill's within walking distance, she had two elder sisters already in the trade. Even so, her choice was not automatic. First she tried dressmaking, which she liked and was good at, but after 'six months with not a penny pay', her father, a footman at the Caledonian Club, said she wasn't 'even getting the shoe leather'. After a brief spell in a florist's shop, she entered Morrison & Gibb in November 1909, aged 15, and worked there more or less all her life. Another survivor, who had no fewer than three sisters already in the trade, did not automatically follow them either. She too had been to Canonmills and Broughton school (though she says she was 'not very clever') and first of all went to work at a draper's shop in the West End, a job for which she remained still nostalgic. Alone of the survivors, she had no great affection for the printing trade, which she entered ('my big mistake') when she went to 'chum along' a friend. Another survivor, who was brought up in Leith, where she went to Bell's School, owed her introduction to printing to a neighbour 'a Miss Taylor', who told her widowed mother that young Jenny would ʋe 'just suited' to the printing trade, and herself took her up for interview. She was asked

to read a passage, told 'You'll do', and started immediately as a reading girl.

What other openings were there for these girls? Dressmaking or working in a shop were possibilities. Shop assistants in this period were expected to be of 'respectable' appearance and speech. It may have been harder for girls from the Canongate to find such jobs (the survivors were all from slightly more prosperous backgrounds). The teenage girls and young women recorded in the CECOS *Report* were more likely to be doing industrial or domestic work. Quite a few were in the printing and paper trades as folders, envelope makers, envelope stampers etc. Others were pantry maids, laundry workers, and some were in factory work as machinists or 'chocolate coverers'. Their pay varied, but very few girls in these occupations ever earned as much as the 12s–13s a week, which as we have seen is what a girl compositor could be earning by the time she was about 20, with the (limited but real) possibility of earning more later.

It will have been noticed that it was common for more than one child in a family to enter the same trade, and our sample very strikingly demonstrates the importance of sisterhood. Two of the survivors had several elder sisters working as compositors. A third had two sisters in the trade, but working in less well-paid jobs as auxiliaries. She was the highest earner. In the sample as a whole, out of every 100 women, there would be as many as 10 pairs of sisters, i.e. about 20 individuals. And cases of three or more sisters working are not uncommon. In this calculation, I assumed that if two women worked in the same office and had the same surname (provided it was not a very common one) but different Christian names, then they were sisters. For instance, Agnes, Jemima and Maria Steele were all working in Morrison & Gibb in 1911. Very often there is some independent evidence (witnesses to marriage, mention in trade union records) to confirm the sisterhood. But I have not counted as sisters any women with very common surnames – in descending order, Brown, Henderson, Thomson, Reid, Robertson, Wilson, Scott, Anderson, Walker, Grant, Miller, Munro, Smith and Stewart – unless there was independent evidence. So the number of sisters is almost certainly an underestimate.

Although it was quite usual for sons to follow fathers into the printing trade, the presence of so many sisters suggests that composing was quickly recognized as a good opening for a girl. As we have seen from the memories of two of the survivors, younger sisters not initially interested in the trade might end up following their sisters' example. One survivor recalled that having made up her mind to do this, she asked her elder sister to put in a word for her. But her sister refused, so the younger one had to go and ask for herself.

DAILY EXPERIENCE

Once at work, what was life like for the young apprentice? We have already noted that she would have started as a reading girl, at 4s or 5s a week, before learning the lay of the type case and eventually starting work setting type. Though soon earning more than an apprentice boy of her age, she was unlikely to keep much of her wages for herself in the early years. The Canongate sample is not necessarily typical, but in almost all these families, all children, boys or girls, gave a substantial part of their earnings to their parents, never less than half and usually more. (By way of indication of what this represented in the family budget, it has been estimated that weekly expenditure on food in working-class families at the time was about 3s per head.)[14]

Most girls lived quite near their work, and normally walked there, either taking a sandwich for lunch or coming home. Jean Henderson, who worked until her marriage (at the age of 29) in 1912, walked to work in Rose Street, and later to Canonmills, from her home in the Pleasance which was about a mile away. It was normal practice to live at home with one's parents until marriage (and women who did not marry usually continued to live with parents, often supporting them into old age, see below).

At work, women compositors were usually, though not invariably, segregated from men in some way. In some offices there was a 'Girls' Case-Room', as the wage-books in Constable's show. The description of Clark's in 1906 refers to the separate composing-rooms for women, disposed differently from the men's to combat 'chatter'.[15] Former women compositors remembered working mainly with other women but all referred to the men who 'carried the formes for us', or 'carried away the type to put in galleys', though one remarked 'my immediate boss was a woman'. They all remembered their main work as straight setting, but also did corrections on the stone. Miss Brechin, on being asked about this, suddenly recalled how cold the stone was, and how she got chilblains on her fingers in winter. She had for a while become a Monotype operator, on one of the 'women's machines', and also remembers 'trying to do imposition' and doing a little display work in one mainly jobbing firm where she worked for a short time. Many of the women who remained in the trade until their senior years eventually became readers, with higher pay and status than they had ever enjoyed before. Some changed firms. Although workers tended to stay with one firm most of the time, fluctuations in trade meant that it was by no means unknown to move about on a short-term basis. Miss Brechin for instance, although working at Morrison & Gibb most of her life, had also had spells at Clark's, Constable's, Oliver & Boyd and Simpson's Label.[16]

What was very noticeable about three of the four survivors and about Jean Henderson as recalled by her daughter, was immense enthusiasm for the work. 'I would have worked weekends if they'd have let me',

Miss Brechin told me. 'I loved my work, we all did', another survivor said. What was so attractive about it? Partly it was a matter of company – despite what the description of Clark's says about 'chatter', former compositors all remember being allowed to talk – 'after all, we were on piece work', as one pointed out. It was the company that Joanna Martin missed the most when she left to get married: 'all the girls helped each other, and if you hadn't the right kind of type, someone helped you'. Since they were often working on stories or novels, they would call out to each other 'What are they doing now?', if the next chapter was being set by someone else. Most of my informants retained very happy memories of the atmosphere of the composing-room, possibly a little coloured by the passage of time; but there does seem to have been a good deal of good humour and fun. 'We had plenty of laughs' was an expression used by two former compositors, one a man, the other a woman. One thing must be remembered about their experience as part of a group: they would all have started work when there were large numbers of young girls in the composing-room, whose atmosphere would have reflected this, differing from that of the men's composing-room where the spread of ages was much greater. As time went on, after 1910, and the numbers of women dwindled, those who were left grew old together. By the 1920s and 1930s, not to mention the years after the Second World War, the women formed an ageing group of unmarried women and widows, once more having little in common with the men at work, who by now would be younger and probably married. In both cases, their separate experience may well have created a special atmosphere, although my informants all stressed that they got on perfectly well with the men at work.

The content of the work seems to have been another source of enjoyment. It was 'really fascinating'. 'You learnt a lot', according to one woman who had worked on the *Encyclopaedia Britannica*, which was her most vivid memory, as well it might be. Others remembered setting Greek, Latin, other foreign languages and mathematics (subjects of which they knew nothing, but which were a matter of professional pride). The one author whom everyone remembered best was George Bernard Shaw, popular editions of whose plays were running off the presses in the early years of the century. 'The flower girl' (*Pygmalion*) was the first book that came to mind for one very elderly survivor.[17] As compositors, one might be working from manuscripts (in 'difficult hands') or from earlier editions going to reprint. But – in common with many workers in manufacturing industry at the same time – none of the survivors I spoke to ever remembers having handled the end-product of her work, in this case the completed book. Not all of them were even keen readers outside working hours, and they preferred relaxing in other ways.

Jean Henderson, about whom her daughter was able to give me many details, was perhaps unusual in her great thirst for reading. The daugh-

ter of a sailor who was lost at sea, she was sent to the Dean Orphanage where she received a solid education and showed promise. For her, the trade of compositor was more an intellectual calling, not so much a craft, and she found her work fascinating, reading as she went. It was also a way of moving up in the world. She stayed in work until she was 29, walking out for five years with her fiancé, an engineer's blacksmith who was himself a great reader, while they saved up to marry. Her daughter remembers her nursing a baby with one hand and holding a book in the other. She remained serious about reading all her life, taking pains with her five children's education and recommending that they read good books, 'not some of the trash she had seen at Morrison & Gibb'. She and her husband bought second-hand books regularly, and she would always look in the back to see where they had been printed. Working-class intellectuals have often come from the ranks of printers in the past, but it is rare to find one such who like Jean Henderson was a woman.

If, like her, many compositors, male and female, remembered printing offices as quite sociable places to work, they also recalled the organized social activities which are regularly reported in the *Scottish Typographical Circular* and *Journal*. It had long been traditional for offices to hold an annual dinner for staff in the winter and an outing or picnic in summer. The dinners had always been all-male affairs, with formal suits and speeches, and long continued to be. The picnics were originally for the printers 'and their families', but once large numbers of young women were employed, they seem to have taken on a more youthful atmosphere, and became good opportunities for courtship. The STC in the winter of 1904 reprinted a humorous story from the Clark's in-house journal ('Brandon Backchat and Clarkite Clippings') about the rivalry between two suitors (a stab worker and a linesman) for the right to accompany Miss Minion Thinspace, 'the goddess of the case-room', to Peebles on the annual picnic. The regular reports on outings always mention the jolly atmosphere 'which even the weather could not dampen'.[18]

But apart from such outings, much of the organized sociability surrounding the printing-offices was, as we have already noted, segregated. In Robert Gray's detailed analysis of the leisure activities, in the wider sense, of the Edinburgh 'labour aristocracy' including male printers towards the end of the century, almost all the indices he has used – the bowls club, flower show, reading-room, Volunteer Rifles – were all-male organizations. Male printers had their own organizations, usually based on their place of work and often devoted to sport. There were football and cricket teams which had fixtures against other offices, or arranged 'married vs unmarried' matches. There was also an ETS male-voice choir and a lecture society, the Typographia. From all these activities women were not so much excluded as absent by definition.[19]

It is sometimes argued that studies of working-class leisure have

concentrated on male activities simply because leisure, a fairly new notion in any case, was very much a male affair in this period. Women and girls were not expected to go off after work and sing in choirs or play games – they were expected to be at home catching up on household chores. While this seems to have been as true among Edinburgh printers as anywhere else, there are plenty of indications that it was possible, for girls or unmarried women at any rate, to join societies or practise hobbies. From the CECOS *Report* it seems that church-related activities were often the main focus of outings for girls. Children of both sexes went to Sunday School (one of my informants when I asked her about this said, 'Oh yes, everyone went to Sunday School'). And many families were described as 'regular at Church', though occasionally the surveyor adds 'except the father'. But quite a number of the teenage girl compositors in the sample were described as 'regular attenders at the Mission', something rarely or never remarked of their brothers. One girl aged 16 was described as 'going to the Good Templars three times a week'. In several families, the teenage compositor daughter went to the Band of Hope. In one family the 16-year-old compositor daughter went to Band of Hope and Bible class and was said to have 'guided' her mother away from drink. The CECOS surveyors make it clear that the drinking problem which most concerned them and was undoubtedly of serious proportions in their sample, was by no means confined to men (indeed their condemnations of drinking mothers are particularly sharp) but one can certainly detect a mainly female temperance counter-current in the survey, apparently connected to religious observance.[20] (A male informant remembered during the inter-war period 'a lady keyboard operator [who] used to get out her Bible and have a wee read', at idle moments.)

Less note was taken by the CECOS *Report* of other ways of spending leisure, but a few mentions indicate that girls might for instance go to sewing classes, sing in choirs, and in one case learn 'skirt dancing'. In one family the daughters 'attended dances' regularly, but these can hardly have been like the dance-halls of the inter-war period. (Then, the dancing craze swept Edinburgh as everywhere else, and Miss Brechin for instance became an enthusiastic ballroom dancer for several years, winning prizes and championships.) In the pre-war period, music and dancing were nevertheless activities in which girls or women showed particular interest. This is reflected in the social events for women compositors organized by the printing firms, usually with women only present, when a programme of events was performed by talented compositors. A correspondent sent me the programme for the Annual Social of the Female Caseroom at the Ballantyne Press, held in Swan's Tea Rooms in April 1906. The chair was taken by Mrs R. W. Hanson (the boss's wife) and tea was served at 8 o'clock. The committee of six (nearly all their names turn up in the 1910 sample) organized a programme which included songs such as 'The Old Countree', and 'Flight of Ages',

Programme for the Annual Social of the Female Caseroom,
Ballantyne Press, Friday 13th April 1906
in Swan's Tea Rooms, Nicholson Street, Edinburgh

Pianoforte selection Miss Thomson
DANCE ... Waltz
Song – 'Down the Vale' Miss McKenzie
Violin Selection Miss Hanson
DANCE .. Quadrille
Song – 'Sing me to Sleep' Miss Mason
Song – 'Flight of Ages' Miss Waugh
DANCE Miss J. Chisholm

Interval Refreshments

Song – 'There let me rest' Miss Wilson
Violin Selection Miss G. Hanson
DANCE ... Pas de Quatre
Song – 'The Old Countree' Miss Tinlin
DANCE ... The Lancers
Song ... Miss Forrest
DANCE .. Waltz
Song – 'Song of the Thrush' Miss Young

AULD LANG SYNE

(From the original programme, courtesy of Miss D. Mathewson)

sung by Misses Forrest and Waugh; the opportunity to dance quadrilles and waltzes; and a pianoforte selection by Miss Thomson, who was, like most of the other performers, a compositor. It was noticeable however that two items (violin solos) were played by 'Miss Hanson' (the daughter of the head of the firm?). Violin lessons were probably beyond the reach of most working-class girls.

It was considered quite an innovation when, after the First World War, the 'progressive officials' of R. & R. Clark decided on 'a combined "Annual"' in 1921, 'instead of one section having a smoker all on their own and the other a high tea and gossip', as the *STJ* put it. 'A mixed company sat down to tea . . . presided over by the Father [of the chapel] – the Mother was too busy waiting on the guests to sit down, much less preside.' (!) A whist drive was followed by a concert and the evening was voted 'a great success'.[21]

Life was not all work and no play for women any more than for men; even if they had chores to do at home, the women compositors – who

were almost by definition young and/or unmarried – had the chance to escape duty for pleasure from time to time. One of two of the survivors recalled playing golf and walking on the Pentlands. The fact remains that men's leisure-time activities are much more visible to history, more organized and perhaps to some extent seen as more legitimate. Certainly leisure is one of the harder areas of the everyday life of our sample to investigate.

THE GREAT WAR

The printers' picnic that had been arranged for a Saturday at the beginning of August 1914 had to be cancelled because of the outbreak of war. The very large majority of our sample, having been born between about 1885 and 1895 were in that special, and it might be said tragic, generation who were young adults during the Great War, then spent their middle years living through the Depression and the Second World War. A certain number became war brides and in some cases war widows in 1914–18, while others lost fathers, brothers and sweethearts or themselves remained unmarried. (Nationally, of single women in their late twenties in 1921, 50 per cent never married.) The war was a dislocating experience for the group in other ways too, disrupting families, interrupting working careers, sometimes precipitating emigration.

To take marriage first: of the 54 marriages recorded among the sample during the war years of which details could be traced, 25 were to serving soldiers, mostly local men, a few from colonial forces stationed in Edinburgh. One might possibly have expected the average age of marriage in our sample to fall a little in wartime, but it does not in the recorded cases. Although many of the group would still be under 25 in the years 1914–18, there are only 16 brides under 25 during the period, whereas in 1911–12 alone there were 15 brides under 25.[22] (One must of course bear in mind that these figures represent only the retrievable fragments of the marriage pattern for the whole sample.) Eight of the sample are known to have married soldiers from overseas – almost all from Canada – and eventually emigrated. It is impossible to estimate the number who were widowed (Scottish losses were heavy in France). But it seems all too likely that the 21 married women who applied to rejoin the trade and the union in 1919–20 were war widows, although we only know this for sure of three of them. Normally, married women only applied for re-admission to the union and thus to the trade (which was not granted automatically) when their husbands had either died or were severely incapacitated.

It was not only those who married colonial soldiers who emigrated. At least 17 women compositors emigrated permanently (12) or temporarily (5) in the years immediately preceding or following the Great War. Again, this was partly a matter of generation. Those who did not follow soldier-husbands often emigrated with their parents. The local Edin-

burgh press in 1910–14 had almost a whole page devoted to news from
Canada, where so many Scots had relatives. In the immediate aftermath
of the war, a number of families left for Canada.

For those who did not marry or emigrate, the war might bring change
of a different kind. At least 72 of our sample left the printing trade during
the war years, according to the records mostly in 1916–17, although it
seems likely that some had already left, since the city's book trade went
into immediate depression on the outbreak of war. Thus as early as 1915,
'Juvenus' writing in the *Scottish Typographical Journal* reported that there
were 'many girls out of work who went to the GPO for Christmas work'
(i.e. Christmas 1914). Until conscription was introduced for men, there
was much unemployment in the trade. The same article reports that
'Woman is now of importance: she is motor mechanic, dispatch carrier,
munitions manufacturer . . . Quite a number of our own Edinburgh
members are "on war service"'.[23] I have been able to trace very few
records of women actually doing what is normally regarded as 'war
work' (one went to be a nurse, 'a few' went to work in munitions, one to
the RAF, one to 'the services', undefined). But quite large numbers of
women compositors left work in order to replace men in other jobs. One
major recruiter was the Post Office. At least 24 of the sample (and
probably many more) went to work there, either as clerks or sorters. In
several of the marriages at the time, the bride's temporary occupation is
listed. Thus one of Miss Brechin's sisters is described as a 'postwoman'
on her marriage certificate. 'Juvenus' remarked that a 'girls' chapel' was
being set up in the GPO of members of the Edinburgh Typographical
Society on temporary secondment. Some women went to work in in-
surance offices, again probably as clerks, a few found themselves in
railway offices, and one worked in the offices of the *Scotsman*. Quite a
large group apparently went to work as compositors in the south of
England, if that is the right interpretation to put on the mention 'gone to
Colchester' which is recorded against the names of some women in the
trade-union membership registers which are the chief source for this
information.[24]

MARRIAGE, CHILDREN, RESPONSIBILITIES

By 1921, most of those in the sample who were going to marry had
already done so: there are records of 13 marriages in 1916, 17 in 1917, 12
in 1918, 13 in 1919, 16 in 1920 and 15 in 1921. Although the records are
much more reliable for the later years, the absolute number of marriages
declined steadily with the age of the sample. Can anything sensible be
said about the marriages of our women compositors in terms of social
equality or mobility? Robert Gray has analysed marriage patterns in late
nineteenth-century Edinburgh and concludes that by the end of the
period, patterns of segregated intermarriage as between the families of
'skilled' and 'unskilled' workers were tending to break down.[25] It does

TABLE 10. *Occupations of 166 husbands of women compositors of 1910*

A. Printing trades

Compositor or machineman	42
Bookbinder	1
Printing-ink maker	1
TOTAL	44

B. Wood trades

Joiner	6
Upholsterer	1
TOTAL	7

C. Building trades

Housepainter	2
Mason	1
Plasterer	1
TOTAL	4

D. Metal trades

Blacksmith	2
Tinsmith	1
Brassmaker	2
Ironmoulder	1
Steelworker	1
TOTAL	7

E. Miscellaneous skilled (traditional)

Tailor	2
Glass bottlemaker	1
Glazier	1
Miller	1
Marble cutter	1
Jeweller	1
Baker	1
Master butcher	1
Confectioner	1
TOTAL	10

F. 'New' skilled

Engineer	7
Riveter	1
Fitter	1
Plumber	1
Electrician	3
Gasman	2
Telephone linesman	1
TOTAL	16

G. Factory, heavy or semi-skilled not in previous categories

Rubber worker	2
Coal miner	4
Docker	1
Porter	4
Brewer's labourer/cellarman	2
Shipyard worker	1
Waterproof coat maker	1
TOTAL	15

H. Railway workers —

I. Other transport

Car conductor	1
Chauffeur/driver	6
TOTAL	7

J. Warehouse, janitor, service

Warehouseman	1
Footman	1
Bowling green keeper	1
TOTAL	3

K. Shopkeepers or assistants

Shop assistants (various)	8
Tea salesman	1
Jeweller's salesman	2
Commercial traveller	3
Pub manager	1
Restaurateur	1
Pharmacist	1
TOTAL	17

L. Clerks etc.

Clerks (various)	16
Analyst	1
TOTAL	17

L. Armed services

TOTAL	11

M. Miscellaneous

Police constable	1
Prison warder	1
Minister of religion	1
Schoolteacher	1
Farmer	2
Livestock agent	1
Performer	1
TOTAL	8

Source: Registration of marriages of women compositors, General Register Office for Scotland, Edinburgh. There are more husbands than fathers, since the fathers of sisters are counted only once.

seem that the social profile of the bridegrooms of our 'compesses' displays several significant differences from that of their fathers, though one has to be careful about interpreting them. The differences may reflect generational change or changing times in the Edinburgh labour market – or mere chance acquaintance in the vertical village formed by the typical Edinburgh tenement – as much as social mobility on the part of the brides.

On the whole, the sons-in-law were in better-paid jobs than their fathers-in-law, though only just (see Table 10). The 166 husbands whose occupations are recorded do not cover quite such a range of trades as the fathers – 64 as opposed to 76 – but that is hardly surprising since they are much more concentrated in a number of particular trades. Top of the list – and there are obvious reasons for this – comes the printing trade. No fewer than 42 of the recorded marriages are between two compositors. Work-place acquaintance can safely be assumed to explain most of these weddings – though as it happens, two of the surviving women compositors, one who married a compositor from another printing office, and one whose husband worked at Bartholomew's the map-printers, told me that they had met their future husbands at social gatherings unconnected with work. The second largest group among the husbands is made up of clerks (16 in all). A further 11 are listed as serving soldiers or seamen (some of the other bridegrooms were in the services at the time of marriage, but since their civilian occupations were also recorded they have been classified differently). All these marriages took place during the Great War and it is a matter of generation more than anything else if the groom was a serviceman. The only other occupational group that runs to double figures is made up of shop assistants (11). The relatively modern professions of engineer and chauffeur or driver account for 7 and 6 respectively, while the skilled traditional trades so common among the bride's fathers are here all down to single figures: 7 in wood, 7 in metal, 4 in building, 3 in plumbing and fitting. There are no railway workers among the bridegrooms, but there are 4 factory workers and 4 coal-miners. After this comes a scatter of individuals, but interestingly a different scatter from that of the fathers. Where among the fathers there had been one representative each of gamekeeper, watchman, pilot, none of these trades was represented among the husbands: instead there were one each of policeman, teacher, minister of religion, prison warder and two farmers: occupations entirely absent from the list of fathers.

Without wanting to draw too hard and fast conclusions from a very partial sample, some differences between our compositors' husbands and their fathers are obvious. Thus only about 70 or 80 of the brides were marrying skilled manual workers; and 42 of these were in the printing trade, massively skewing the figures. Nor can one pass over the fact that clerks and shop assistants bulk larger among husbands than among fathers. In the sample as a whole, it could be argued, there was a

tendency for the brides to be marrying husbands either with white-collar jobs, or in trades slightly better paid than their fathers. (Among traditional skilled workers, printers came fairly near the top of the pay scale.) The special circumstances of the Great War undoubtedly played some part in bringing about change: for instance several soldiers from Canada or Australia who married women from Edinburgh were from better-off families than their brides. And the fact that women compositors were drafted into the Post Office brought them into contact with male clerks there, at least before conscription.

One should also bear in mind the 'vertical class mixture' of the Edinburgh tenement. There are many cases where bride and groom have the same postal address at the time of marriage – something that does *not* indicate premarital living together, quite unusual among the respectable working class of Edinburgh at the time. It merely tells us that the young people were neighbours sharing 'a common stair'. Thus Janet D., the daughter of a cooper, and James R., a chauffeur and the son of a flourmill warehouseman, were living at the same street number when they married in 1911. In such cases, neighbourhood rather than milieu may have brought people together. Sometimes both came together: very few of our sample lived as far out of town as the mining village of Gilmerton, but one woman compositor who did was the daughter of a miner and in due course she married a miner herself.

Some of the marriages could certainly be described as taking place within the traditional milieu of the skilled working class: thus Flora H., daughter of a blacksmith, married the son of a cabinet maker (bride and groom were both compositors). The two children of a boot-closer, Katie and Andrew S., both became compositors. Andrew married Chrissie K., daughter of a shoemaker also a compositor, while Katie married an electrical engineer, son of an engineer.[26] Georgina L., daughter of a tailor's cutter, married William T., a machineman and son of a bookbinder. Such 'mainstream' marriages, though frequent in the sample cannot however be regarded as typical; the variety at this unstable moment in the century was so great. Thus Maggie C., the daughter of an upholsterer, is a 'mainstream' bride, but her husband is less easily classifiable. A sorting clerk at the GPO, he came from a less settled and respectable background, being the illegitimate son of a domestic servant. Bride and groom presumably met in the Post Office during the war. Perhaps least typical of all was Annie J., also the daughter of an upholsterer: aged 31, after 16 years in the trade, she married James T., minister of religion. (In this case, what looked like a move into the middle class was in fact a prelude to much financial worry.)

Although quite a few of the sample married, like Annie J., comparatively late in life, most of the marriages were contracted while the bride was still in her twenties. Those who did marry all left the trade, except for a few cases where the husband was a serving soldier abroad during the

war. ('The war brides among us must labour on till the boys come home'.)[27] Did women mind leaving their work to get married? Some must have. One survivor, as I have already noted, said that she did mind, mainly because she missed the company, but that her husband would not hear of her carrying on. All the survivors who married said the same thing: that their husbands 'would not have let' them continue to work. It does indeed seem that the taboo on wives working was still operating among the generation that came to maturity at the time of the Great War. Jean Henderson, despite being so fond of her work, never for a moment contemplated carrying on after marriage. She and her husband moved further away from the town centre, to a spot where they could see the fields, and settled down to have five children.

For most of the brides, their farewell party (usually accompanied by a small presentation of wedding presents), was the last they saw of printing office life. But for some, particularly in a generation whose men fought in the trenches, marriage was a short interval before widowhood. Left alone, often with children to support, former women compositors could do no better than ask for their old jobs back.

The traditional justification for lower wages for women was always that they were not responsible for the livelihood of a household. Time and again, witnesses told parliamentary commissions that women workers were either girls living at home with their parents and contributing to a multi-income household, or that if married, they were earning 'pocket money'. Women living alone, or as the sole wage-earner in an all-female household, or widows with children were invisible, though statistically by no means insignificant. The gaps in our data do not make it possible to say anything of statistical value, merely to point out that the evidence fragmentarily available suggests that it was by no means exceptional for women to be sole breadwinner in a household, usually in three precise sets of circumstances: in widowhood, with or without children; after marriage when the husband was away, unemployed or chronically sick; when unmarried, either living alone or – more frequently in our sample at any rate – caring for and responsible for an elderly parent or sick sibling.

If a woman had left the trade in Edinburgh to get married, she was entitled under the official interpretation of the 1910 agreement, to re-apply for a job and a union card in certain circumstances, notably widowhood. In all a total of 45 women are recorded as having re-applied for union membership between 1919 and 1934 (20 of them in the first two years, 1919 and 1920) and this is probably an underestimate. Most of them were widows and were re-admitted without problems. Married women whose husbands were incapacitated were also treated sympathetically. Thus Mrs B., who had left to get married in 1912, and had 4 children, applied for re-admission in 1919 since her husband was in an asylum. She was successful, but it was not always enough to be in

difficulties to get the union committee's approval, especially in times of unemployment. If a woman's husband was able-bodied, permission was rarely granted. Mrs M.'s husband, a coal-miner, had been out of work for nine months when she applied unsuccessfully for her union card. And the wife of the congregational minister fared no better when she explained that 'owing to falling church membership', the church no longer paid a living wage. Her husband had opened a bookshop to support her and their two children, but it was 'imperative for her to work' at her old job as reader, 'to tide them over for a year or two'. Despite her long years in the trade, her request was turned down.

We do not know exactly how many of those who re-applied were supporting children, who are mentioned only occasionally in the sources. Thus a note might reach the union committee asking for exemption from the quarterly meeting (to avoid a fine) such as the one from Mrs K. who in 1922 said 'I wish to be exempt from Society meetings as I have to attend to my children in the evenings'. Connie B. was married in 1917 at the age of 28 and left the trade. Her husband, also a compositor, died six years later leaving her with three young children, and she was obliged to go back to work (at Macdonalds in London Road, not in her previous job at Morrison & Gibb) until she was over 50, by which time her children were all supporting themselves. She came from a large family, and it must be supposed that her mother or one of her sisters helped to care for the children while she was at work.

Children were not the only dependents of working women. Probably more numerous than the widowed mothers in our sample were the single daughters, living with elderly and ailing parents, usually mothers, whom they supported. The reader may remember Mr Fraser of Neill's telling the parliamentary commission, 'their mother is always ill'. It is impossible to put figures on this phenomenon, which has to be guessed at from fragmentary glimpses of life after work: excuses for failure to attend a meeting and so on. But we know that at least 23 per cent of our sample never married, and carried on working till retirement. As daughters earning good wages, they tended in their later years to become the sole breadwinners in households containing elderly mothers and, in a surprisingly large number of cases, handicapped or ailing sisters. Sometimes a mother might have some income or savings of her own to support the family. Thus Lizzie F. was able to take a few years out of work to nurse her mother, an auctioneer's widow, before returning to work after her mother's death. Mary Alston, one of the mainstays of the women's union in the 1920s, had to care during this time for a sick sister, who was in and out of a nursing home; much later, in the 1940s, she had to give up work for a while to care for her mother. Similar cases are scattered through the records. Jessie B. retired early in the 1940s, 'owing to sickness at home'. Nettie B. was absent from work a great deal in the 1920s, 'owing to sickness of mother'. Flora D. left work then returned,

'owing to changed domestic circumstances', a phrase which usually meant the death of a parent. Chrissie J. (unmarried), had 'domestic duties every evening'. Rena M., an active union member, nevertheless asked to be replaced on the committee in 1929 because of her mother's illness. Grace M. was herself ill for three months with exhaustion after the death of an ailing mother in 1945. Alice P. had been supporting a bedridden sister for years when she herself died in 1952. And so it goes on: cases which are obviously only the tip of the iceberg since they relate to repeated absence caused by serious illness of a relative.

A DWINDLING BAND

Very few women left the trade before retiring age for reasons other than marriage, ill-health, or care of a relative. As jobs went, printing was clearly the best option they had. (One of the very few to leave for other employment was Emily Picken, who had been offered a post as matron of a children's home. This was obviously an exceptional case.)

It was the 200 or so unmarried or widowed women, who made up rather more than 25 per cent of the original sample, who remained as a solid phalanx of women compositors in the 1920s and 1930s. By this time, the trade was completely unionized, and the existence of the women's section of the union gave the group a certain coherence and identity; so much so that to avoid overloading the present chapter, the union's creation and activity is discussed in Chapter 7. But other things bound the experience of this group together as well. The work had changed in the post-war period, and women were less likely to be employed now at setting pages of books. Mary Alston, arguing the case for a pay rise, pointed out in a speech as early as 1922 that

> It may be that prior to 1914, women were employed in book composing only, but we must not forget the introduction of monotypes diverted hand labour to other channels correcting, making up and so forth, and in every large office today, not to speak of the small ones, we find women compositors setting, making up, doing author's corrections and in some offices making ready for machine.[28]

Thus the women who stayed at work sometimes acquired the skills that made them 'fully' trained in the trade. They never acquired equal pay, but they did increase their wages, and continued to earn what were, for women, good rates of pay. A number of them ended as proof-readers earning as much or almost as much as men. Some, through failing health or eyesight, were obliged to go down a couple of rungs on the ladder however, and there are an increasing number of cases in the 1940s of former compositors working as copy-holders for lower pay.

It was the unfortunate experience of the age-groups best represented in the sample to pass their middle years during some of the blackest

periods of the twentieth century. After its partial recovery in the middle
1920s, the Edinburgh printing trade was hit by the depression. Although
the impact was perhaps less calamitous than in Scotland's heavy indus-
try, the blows dealt by the collapse of orders in the 1930s would eventu-
ally lead to the permanent eclipse of Edinburgh as a printing capital. In
the short term, the depression brought deepening unemployment
among both men and women. It seems to have been at its worst among
the women, according to the weekly out-of-work register, in 1934–6,
when 10–15 per cent of the membership was regularly signing on. By the
late 1930s, the position had improved somewhat, but unemployment
soared again during the first two years of the Second World War, when
about a quarter of the membership found itself unemployed.[29] For these
single women in their 40s and 50s, it was not immediately easy to find
war work, for instance in munitions factories, nor were they necessarily
eager to do so. They were also hampered from leaving Edinburgh to
work in printing on war contracts elsewhere by the dilution agreements
of 1934. However by 1941, almost the entire membership had either
found war work or was employed in the surviving Edinburgh printing
offices, and by then only 2 members were listed as out of work. Un-
employment might depend on the individual's capacity. The only sur-
vivor I interviewed who had not married and who had always worked,
told me that she had only once been unemployed, for a period of 6
months, when she got a temporary job selling insurance. Otherwise, she
went from firm to firm, wherever there was work, and usually managed
to find some. (Her niece told me that she had been particularly good at
her job.)

By the end of the Second World War, the youngest members of the
group were 50 years old, and the numbers began to dwindle fast,
through death or retirement. The union discontinued its 'social even-
ings' in 1951, but carried on holding occasional events or tea-parties
which served as reunions for increasing numbers of retired compositors.
Those who remained at work were likely to find themselves increasingly
isolated: Miss Brechin told me that she was the very last woman to work
in Morrison & Gibb. It is probably a fair assumption that towards the end
they were increasingly marginal to the operation of the office. An inform-
ant from Aberdeen, where the last women were still working up until the
1950s, told me that these elderly women sometimes had little to do, were
regarded rather as passengers and had to put up with rather disparaging
remarks, but were kept on until retirement age by the firm, which felt it
had obligations towards them. Some women were proof-readers, but
otherwise, being excluded from machine typesetting, they were left with
odd jobs to do round the office. Quietly and with hardly anyone to
notice, the last women compositors in both Edinburgh and Aberdeen
slipped out of the case-rooms and into retirement. A very, very few of
them may still be alive today, with their memories.

The rise and fall of the employment of women compositors coincided with the rise and fall of Edinburgh as a centre of book-printing. It also coincided with the rise and consolidation of the labour movement in Britain; and that is a story from which women were for many years absent or in which they featured very much as a minority. We left our particular section of this story back in 1910, when the male trade-union movement had succeeded in stopping the future recruitment of women. It did not look as if women would ever be part of the Edinburgh Typographical Society; but in fact, the women compositors did finally gain first admission to the men's union as a subordinate section and finally control (within limits) of their own affairs. Our 1910 sample did serve its apprenticeship in trade-union organization, and this episode provides the last chapter in the story. It is no mere epilogue, but a striking demonstration that it was possible for men and women to co-operate in the printing trade.

7

IN THE UNION AT LAST:
THE EDINBURGH WOMEN'S BRANCH

A good deal of the literature about women and trade unions in Britain in the early twentieth century inevitably dwells on the problems of organization, and is largely concerned with separate women's unions, since women were usually working in different occupations from men. We have already seen how early attempts to organize the Edinburgh women compositors had fallen through to the usual refrain that women were apathetic, hard to organize and so on. Looking at the records of the women's section of the Edinburgh Typographical Society, successfully set up after the 1910 affair, can be illuminating both about the potential for success and about the real problems such an enterprise faced. Central to the question are the relations between the women and their male colleagues and the degree of mutual understanding they showed. What can also not be dodged is that – once again – a power relationship is at work here. But that relationship was not fixed and stable, and it can be instructive to see how the women's branch gradually acquired the confidence to defend itself as it saw fit, within a context not of its own choosing.

THE 'FEMALE SECTION': CREATION AND EARLY RECRUITMENT
In the early days after the 1910 agreement, it looked as if women were unlikely to be admitted to the dignified ranks of the Edinburgh Typographical Society. J. T. Yule, the hammer of the women compositors, was among those who did not regard the battle as over in 1910 and strenuously opposed any talk of admitting women to the men's union. 'Let them quit [the trade] unwept, unorganised, unsung,' he wrote.[1] But he was soon (perhaps surprisingly) in a minority. Most of the women who had supported the men had originally enrolled in the (unskilled) Warehousemen's Union. It is not clear who made the first move to bring them out of this union and into the STA via the Edinburgh branch. It may have been some of the women themselves. At any rate the ETS official Robert Allan, writing to the *Scottish Typographical Journal* in May 1911, said that during the 1910 dispute,

> We appealed to the women compositors to throw in their lot with the men. The majority of the women workers responded to the appeal . . . unquestionably now the women consider it desirable to be affiliated to the Typographical and that too is the opinion of the majority of the ETS.[2]

It might be thought a little cynical to wonder whether the prospect of fighting the employers again at the end of the five year ban had something to do with the ETS's change of strategy, if it were not that this was specifically mentioned at the time. At any rate, a vote of principle was taken at the May 1911 delegate meeting of the STA, at which a majority declared in favour of 'organising the women compositors'. The Edinburgh delegation voted 6 to 1 in favour. In July 1912, the decision was formally taken by the men to form a Women Compositors' Section (1,966 votes for, 618 against: a larger majority than the previous year). Perhaps the continued dissidence of the breakaway 'We Women' movement spurred the men to action. Although little evidence survives of its activity, it seems that for the two intervening years the breakaway group had continued to exist, with some 250 members paying their subscriptions, and it may have been worry about this division among the women that prompted the STA's decision. The hatchet seems to have been buried at about this date, however, and a male writer announced with relief that 'the girls affected', that is the 'We Women' group, 'we are pleased to report, are gradually coming back and binding up in union membership along *with their own class* and fellows' [my italics].[3]

The new women's section seems to have existed unofficially long before the STA vote of 1912, the terms of which were that the section 'be transferred to be under the wing of the Edinburgh Case Branch'. There is in existence a Contributions book of the women's section, with entries dating from as early as January 1911. Seventy names are listed for this date, the great majority being women employed at Morrison & Gibb (who, it will be remembered, had backed the men the year before). There are a few names from Turnbull & Spears, Clark's and Oliver & Boyd, but none from Neill's, which was one of the last firms to be fully unionized. If this was a women's initiative, no records survive to prove it, but the existence of the list seems to show a reluctance to join the Warehousemen's union.

How many of the 800 or more women in the trade joined the Female Section (as it was called)[4] as soon as it was formally open to them to do so? It is hard to give a clear answer. The contributions book for 1912 for instance has 204 names on the register, but only 104 of them are recorded as having paid their subscriptions. In February 1913 (the first meeting of the section committee for which minutes exist), the statement of membership claims only 154 members, but by autumn of the same year, the numbers had risen to 220, and in 1914 a burst of recruitment brought this up to 356 by October. The war years, as we have seen, brought disruption to the trade, with many compositors working temporarily outside printing, but it was claimed in early 1916 that 'less than 100 of the girls actually in the trade' were now outside the society. A retrospective survey dating from 1922 claimed that unionization was virtually

complete by 1917: 'To begin in 1912 and to be able to say within five years that 96% of the women compositors of Edinburgh were organised is no mean achievement'.[5] By 1920, all women compositors in Edinburgh and in those other Scottish towns where they were still employed, were paid-up members of the STA. By this time, there was virtually a closed shop in the trade. One surviving woman compositor – not an over-keen union member – said 'well you had to be in the union, you couldn't not'.

By the middle 1920s, the absolute number of women members had declined from its peak, inevitably as the numbers working in the trade fell. The figure given to the committee for January 1925 was 274: so if unionization was practically complete, some 570 of the 844 women present in 1910 must already have left the trade by this date. Because of the greater number of young women recruited in the 1900s, the numbers remained fairly stable at the 200–250 level for the next few years. Membership stopped being regularly reported, but can be guessed at from ballot figures. Thus in February 1932, 181 members voted in a ballot; in 1933, 152 voted, and on this occasion it was remarked that 'about a quarter of the members did not trouble to vote'. In 1934, 175 voted; in 1939, only 97 did so, but again 'a large number did not trouble to vote'. By the end of the Second World War, numbers had fallen to a very low level. Eighty-six members turned out for a tea in 1949, but that included some who were superannuated. The committee's minute book ends in 1955, and there does not seem to be a successor. By this date the youngest women would have been in their sixties, and there cannot have been more than a handful still working.[6]

'GIVING THE GIRLS CONTROL OF THEIR OWN BUSINESS': GETTING STARTED

What exactly did 'organising the women' mean? Very much what it said: that the women's section was set up under the authority of the Edinburgh Caseroom Branch, that is the male compositors. The women did, it is true, elect their own committee, but at first every meeting was chaired by a man, generally the secretary of the men's branch or his deputy. Thus at the earliest recorded meeting of the women's committee in February 1913, William Hampton took the chair, all the others present being women. Hampton was in fact held in much affection and esteem by these early committees, who credited him with the initiative for setting up the section in the face of opposition from some of the men. They showed their gratitude on several occasions: verbal tributes, votes that he be exempted from war service, contributions to his retirement present, a set of golf clubs. One should also mention here the role of the pseudonymous Juvenus, who wrote a column for the *Journal* for several years, exhorting the women's section to greater effort, encouraging and scolding by turns, always in the direction of increasing union member-

ship among the women compositors. The fiction was always maintained that 'Juvenus' was a woman (use of the pronoun 'we' when talking about women compositors for instance), but the style and content indicate that the column was written by a man. Sarah Gillespie confirms this without revealing his identity. The dates of Juvenus's absence (from December 1917) do not match those of W. G. Hampton (called up in that year) but it is not impossible that Juvenus was another official in the branch.[7]

It was perhaps inevitable that the first steps of the new section should have been taken under the watchful eye of the men's branch officials. Autonomous organization of women workers generally only took place in all-women trades and then often with help from experienced outside organizers (we have already seen how Margaret Irwin, Clementina Black and Ellen Smyth had all been called on in the past). The men's attitude was that women had everything to learn, and this is hard to deny, although one may be irritated by the condescending terms generally used by the *Journal*:

> If she [woman] is a difficult subject to educate in the ways of social organization, the more the pity, the harder the struggle and all the more need . . . for training her to honestly take her place and stand – where her heart and inclinations lie – at your side as a helpmeet, not against you as a tool in the hands of that class that lives by bleeding both.[8]

Unless firmly taken in hand, it is implied, women were putty in the hands of employers. The officials of the ETS, however, managed to be helpful without being too patronizing in these early days, to judge from their action as reported in the minutes taken by the women's secretary.

It was after all true that for women with little or no experience of formal organizations inside or outside the labour movement, even the procedure of committee meetings had to be learnt from scratch: all the codes of practice, from drawing up agendas to writing minutes, drafting regulations, handling accounts and so on. The very vocabulary of trade unionism was a foreign tongue to them. To a seasoned trade unionist for instance, the language of the 'We Women' memorial of 1910 (cf. p. 81) might sound naïve and would certainly indicate that it had been drafted outside union circles. Produced by the women themselves, possibly with help from middle-class suffragists, its tone is very different from that of the men's memorial: 'it seems a great hardship that women should be debarred [from the machines] . . .' it complains, and goes on, 'We ask you . . . to delay any decision hurtful to the interests of women compositors'. This is the language of an injured party rather than the language of unalienable rights.

When they formed their branch within the ETS, then, the women of the Edinburgh Female Section were adopting the rules and customs of a pre-existing culture created for an all-male membership, rather than devising their own ways of doing things. There are a few, but only a few,

indications of a different vocabulary used by women ('chumship' for 'companionship' for instance). In the early meetings we find them conscientiously learning to handle finance and keep records. In later years it was the niceties and finer points of procedures at different levels that had to be mastered. A man continued to take the chair at committee meetings for four or five years, and there is no echo of this being questioned or resented. But it is surely no accident that when for the first time, in 1917, the men's branch secretary was not available, and the chair was taken by a woman, this immediately led to the proposal – unanimously voted and accepted without demur by the men – that the section should from now on have a woman president.[9] This was one way of coming of age, even if initially it was forced upon the section: 'Deprived of our chairman and organiser by his being called up, we have had to rely on our own resources, but with the ever ready assistance of the male officials we have "warstled through"', as they said. Even so, a man was invited to take the chair on one occasion as late as 1924, because, it was explained, 'no committee member has any experience of delegate meeting procedure', which was then under discussion.

The problem was not merely one of knowing the ropes. It was also simply one of finding the time and determination to come to meetings or serve on committees. All meetings were held in the evening after work (from 7.45 to 9.45 p.m.) To those who lived far from the committee rooms in the High Street, it meant a late-night walk or bus-ride home, something that before the First World War at any rate, unaccompanied women preferred to avoid. Low attendance at the mandatory quarterly general meetings can be explained partly by such reasons, but also by what are usually known in the minutes as 'domestic duties'. As we have seen, a number of women had responsibilities at home. Widowed mothers, single daughters living at home with elderly parents, elder sisters of large families: all faced calls on their time against which the new duty of a union meeting might seem to have little claim. Men had no such restraint on going out in the evening – they were not wholly responsible for evening meals or the care of the young – and the union meeting fitted the role expected of them, including the visit to the pub afterwards, a place out of bounds to respectable women of any class in Edinburgh at the time (and indeed for many years later). The women's committee was always having to rule on requests to be exempted from meetings (a small fine was levied for non-attendance) and having to decide what sort of age or distance limit was fair (being over 50 years of age or living over a mile and a half from the city centre were permitted excuses in the 1920s). But as the minutes laconically remarked, domestic duties were 'always a problem' in the women's section, so they took each case on its merits.

Ordinary members always seem to have been reluctant to turn up in large numbers to general meetings. In 1923, the new secretary, a woman of determined views, took her fellow-members to task over it: 'the

attendance at quarterly branch meetings has recently ranged from 4 to 17, a truly noble record and one which certainly shows the burning interest which we as a section have in the affairs of the trade'.[10] (They certainly are very low figures!) She, like the men, blamed apathy among the women, but it has to be remarked that one had to be very keen to turn out on an Edinburgh winter night for a meeting that on the whole was dealing with very routine matters, and rarely with anything to a woman's advantage, when in almost every household there were contrary pressures.

If ordinary members found it hard to get to meetings, committee members had even greater problems. Their meetings were held monthly, and although most members managed to turn up, several had to resign extra offices because of late working, living too far away, or 'the usual domestic circumstances'. The secretary and treasurer in particular had to make themselves available to the membership once or twice a week in the evenings, in addition to committee meetings. The 1916 rule book clearly states that they must 'attend at the Society room every alternate Monday between the hours of 7.30 and 9.0 for the purpose of receiving contributions, and every Friday night from 8 to 8.30 to pay out-of-work allowances'.[11] This was standard practice in the men's branch, but was undoubtedly a burden for women, something which does not seem to have been taken into account when the women's section was set up. It is hardly surprising that it proved difficult at first to find secretaries and treasurers. In the early years there was a fairly rapid turnover of office holders as newcomers found it hard to commit themselves to this level of activity. Only one or two members of the first committee stayed more than a year (Miss Boaz and Miss Calder were the exceptions).[12] Gradually, more committed or at any rate more willing officials began to emerge, and when they did, the committee clearly tried to keep them in office as long as possible. The section therefore came to rely on the goodwill and expertise of a certain number of individuals who really kept the show on the road. Their names regularly recur as office holders and committee members and although we rarely know more about them than this, they deserve to be rescued from anonymity.

Perhaps the most striking figure, both in commitment and eventually expertise in union matters was Mary Alston. One of the youngest compositors in 1910, since she was still working in the 1950s, she had evidently made her mark by 1917: in that year Juvenus welcomed her election to the post of treasurer, commenting that 'her good work down by Brandon and progressive way of putting things at general meetings made me desirable of seeing the section make use of her ability'.[13] She quickly graduated to secretary and held the post for three years, developing the ability to hold her own at mixed as well as at all-women meetings. It was she who handled the negotiations to get a woman delegate on the STA executive council, and when she relinquished the

post of secretary, it was in fact to take up the new appointment herself. Here she had to argue the case for women's issues, which by all accounts she did forcefully. The *STA Annual Report* for 1922 (when she had been on the council for a year) contained an unusual tribute: 'the female representative's colleagues on the Executive Council highly appreciate her business acumen in dealing with Association affairs generally'. All the survivors whom I interviewed remembered her well, and one told me that once when a man from the executive committee came to explain some question to a women's meeting, he 'got in an awful tangle'. Whereupon Mary Alston stood up and explained it so that everyone could understand. 'Oh, she was better than the man!' There survives in the minute book a pencilled set of notes for a speech at the executive council in 1922, when it fell to Mary Alston's lot to argue that women compositors in Aberdeen (of whom there were about 40) be paid at 70 per cent of the male rate, not 62.3 per cent as proposed. Her marshalling of the figures and arguments is precise and clear, and her style forthright, and she successfully negotiated the rise. One should not underestimate the courage and competence needed to be the only woman on the Council. Despite having her share of domestic commitments (an ailing sister and later an elderly mother) Mary Alston carried on for many years in this and other posts, taking over again as secretary of the women's section for another spell from 1935 to 1940, before home duties obliged her to leave work for a while during the war. After her mother's death, she returned to work until the 1950s.

Mary Alston, who worked most of her life in Constable's, was remembered as a 'character' there by a former male compositor who described her as a 'very competent reader – a blue stocking intellectual in my opinon'.[14] Another such, who also devoted herself to the women's section was Margaret Rendall; she was an impressive and imposing figure as can be judged from the photograph printed by the *Journal* in September 1922 (see Plate 7). She succeeded Mary Alston as secretary in 1921 and held the post for the next five years, working closely with her predecessor. She must have been a few years older than Mary Alston, but her death was even so very premature. She resigned from her post for health reasons in 1926 and died suddenly in 1928, after only a few days off work from Clark's where she worked as a reader. The tributes to her after her death indicate that she too was an intellectual: 'her outlook was wide, she had read much, was a student of languages, science and books and keenly interested in progressive thought'.[15]

Between them, these two secretaries steered the committee through the important years 1917–26, after the work of recruitment was accomplished and before the decline caused by falling numbers. Any union branch will have its outstanding individuals, and it is clear even from the laconic records that Mary Alston and Margaret Rendall were important forces in these early years. But there were a number of other

long-serving committee members, who created a core of committed and efficient office-holders. The sad thing was that there were no younger members to relieve them, so towards the end of the section's existence, the same people were having to administer a shrinking constituency. Among those who should be mentioned are Maria Goodfellow, who was treasurer for 5 years 1921–6, and her successor Christina Collie, who held the post for no fewer than 20 years. Mary Graham was secretary during a difficult period in the war years. Annie Tweedie served for many years on the committee in various capacities, and Elizabeth Bagley (a widow), was secretary from 1928 until her second marriage in 1935.

RELATIONS WITH THE MEN'S SECTION AND WITH THE STA
Once the women's section had been set up, the most complicated aspect of the committee's work was handling relations with the men's section, the main body of the ETS, or 'the Typographical', as it had always been known. In the early years, the 'Female Section' was treated very much as a marginal adjunct to the ETS, while the *Scottish Typographical Journal*, the official voice of the STA, treated it as a separate entity. No records of its membership or reports of its affairs appeared in the *Journal*'s official column of 'Branch News', although there was of course, the regular Juvenus column in chatty style. (The section's progress is however regularly noted in the *STA Annual Reports* from 1912.) In Edinburgh itself, apart from the officials such as William Hampton who had regular dealings with the women's committee, there seems to have been some wariness on the part of the men, at least at first.

The coming of the war was probably what hastened better relations with the men. As we have seen, initially the war brought problems for the printing trade, which like other 'luxury' trades lost orders and laid off workers, both men and women. But by 1916, after conscription had been introduced for men, there was a nationwide shortage of compositors, and Edinburgh women were being tempted to move outside Edinburgh to work at male rates. This the union was prepared to accept; but more worrying were attempts to lure women to other centres by offering wages pitched somewhere between the Edinburgh rate and the full male rate. The men's union sought the co-operation of the women's committee on this question (for a fuller discussion on equal pay, see below) and the women's comparative importance during the war may have helped to change the status of the women's branch, which was definitely higher by the time of the armistice. Other factors may have been a greater determination on the part of the women's committee, now led by Mary Alston, and the general precariousness of the trade: several firms (including Ballantyne & Hanson's) closed down during the war and never re-opened their doors.[16]

In October 1918, a special meeting took place between the Executive Council of the STA and the committee of the Edinburgh women's sec-

tion, to consider several questions, including whether the section should have a say in STA affairs. (It had always been represented in theory by the Edinburgh men's branch.) The Executive Council argued that since women did not earn the same wages as men, and therefore paid lower union dues, this was not possible. But eventually a compromise was reached, and it was agreed that the women might have a voice on 'Protective' matters, which concerned them as much as men. Shortly afterwards, the women's section was admitted to the Edinburgh Trades Council as a separate branch, a further step towards recognition.

More talks in 1919 centred on the question of a women's representative having a seat on the Executive Council of the STA. This was partly sparked off by the STA's decision to create an Auxiliary Section for the semi-skilled workers in the printing trade, many of whom were women.[17] The women's section at first proposed that with the probable influx of many new women members of the union via the Auxiliary section, a new post be created on the Executive Council to represent *all* women members. Such a proposal would have meant one post to represent both skilled and unskilled workers, and it is (perhaps) an indication that the women compositors were prepared to sink hierarchical differences in the interests of practical questions facing women as a group defined by their sex. But the Executive Council (in its usual terminology) refused the idea of 'the representation of females as females' and eventually the more 'correct' solution was adopted: the creation of 2 new seats on the Council, one for the women compositors and one for the auxiliary workers. (The point to remember here is that there were both men and women in the auxiliary branch: it seems likely that their Council representative was a man, although I have not been able to confirm this; Mary Alston is generally referred to as the 'only woman on the EC'.) The groups were to be represented at delegate meetings in relation to their numerical strength. In July 1920, a delegate meeting ratified the decision, and the following year, Mary Alston, in her retiring speech as secretary, was able to refer to this as a 'crowning victory' in the 'emancipation of the branch'. The women compositors in Edinburgh and Aberdeen were now to appoint one of their number to represent them on the council. Mary Alston having been chosen, 'I was privileged', she reported, 'to reply to the toast of "the Ladies", the first time we were officially recognised by the Association'.[18]

Strains and tensions inevitably persisted under the surface however. As Mary Alston was well aware, the 'crowning victory' had come only when the numerical strength of the women's section was beginning to decline quite sharply, that is when it no longer posed a threat to the men. In her report back from Executive Council to the women's committee, on the question of women returning to the trade after the war, she said that the Council had expressed itself 'entirely satisfied and greatly pleased with our decreasing numbers'. (This must be a rare statement in the

annals of trade union history – celebrating a *drop* in the membership.) In 1916 the end of the five-year ban on women compositors had come and gone, and there had been no serious attempt to start recruiting girls as apprentices, or indeed boys in any numbers, given the new reduced position of the Edinburgh printing industry. Women compositors might no longer pose quite the same threat as in the past, but even in 1922, the Edinburgh branch's contribution to the *Annual Report* of the STA warned that 'Edinburgh employers have still got a considerable advantage in the service of a highly skilled body of women compositors' (at least now the women were recognized as skilled!).

Those remaining in the trade realized that from now on they could indeed expect to have to protect their own interests without outside help. Their period of apprenticeship within the union movement had ended, but there was a risk now that the women compositors would be written off as unimportant, because their numbers were falling. A potentially risky decision had to be taken very soon. The STA Executive Council proposed to the Edinburgh male and female branches that they should now amalgamate. The proposal was that the women should send two representatives to sit on the main committee of the ETS; that section routine proceed as hitherto: that the women's committee should handle day-to-day matters, such as contributions and benefits; and that joint general meetings be held on matters concerning both men and women. One immediate consequence would be that women, although paid only 70 per cent of the male wage, would have to pay full contributions to the Administrative and Protective fund. Mary Alston explained to the committee that her expenses as a member of the Council (about 15 trips to Glasgow a year) were entirely paid by the men's section contributions, and indeed that the informal arrangements made so far were not strictly legal. The committee felt that the sacrifice was worth it in order to have a say in Association affairs 'in a period of stress'. But they were now alert enough to the possible dangers of agreeing to the change to insist on some conditions. They were particularly anxious about equal pay (which is discussed below) and it was agreed that no move to raise women's wages would be initiated by the Edinburgh branch without the consent of a 75 per cent majority of the women's section in a ballot. This and the contributions question having been settled, amalgamation went ahead in July 1922. Margaret Rendall, to whom it fell on this occasion to express the views of the women's section, said that she hoped that 'work so well begun and so genially carried out [should] never fall to the ground, but go on to ever greater usefulness under the new constitution'.[19]

It is difficult to say exactly how relations between the men and women really stood at this stage. For the rank-and-file male members of the ETS, it must be assumed that the women compositors' mere existence continued to be perceived as a nuisance, and a source of underpaid labour which they were not sorry to see dry up. That did not necessarily mean

any hostility at personal level, as my surviving informants, both men and women, all stressed. As for the male officials of the Edinburgh branch, while they made no concessions on main issues, they seem to have treated with respect the women's section as it emerged with a firmer grasp of its role, and with such leaders as Mary Alston, who could clearly hold her own in any company. The tone of the Edinburgh branch reports included in the *STA Annual Reports* in fact seems to be one of genuine warmth. The women had after all shown a great deal of solidarity with the men during and since the war, even though their interests did not coincide. The women representatives on the local committee were said to be 'valuable executive members' and 'we have reason to be proud of our women of Edinburgh' (1922). Their finances in particular were singled out for praise on several occasions. But how was the women's continued presence viewed by the STA leadership in Glasgow?

The most intriguing incident in which the rights of the women members of the STA were at issue was the proposed amalgamation between the STA and the Typographical Association (of England) something which came up in 1925. The TA and STA delegates who met in Manchester that year decided that amalgamation was both 'possible and desirable'. But after negotiations had reached an advanced stage, they broke down over an unexpected question: the right of women compositors in Scotland to take work outside their area, provided it was paid at the full male rate. This had always been the understanding within the STA since the 1910 agreement: that lower wages were allowed within Edinburgh (and Aberdeen) but that any women working outside those areas had to be paid at the full male rate (or the office would be blacked). There had been a number of women in this fortunate position in Scotland, particularly during the war, though by the mid-1920s few of them were left. In 1925, the total of women compositors working in Scotland was about 300, almost all in Edinburgh. When the question was broached by the Scottish negotiators, their English counterparts replied: 'We think it best to be honest and straight with you and tell you quite frankly that it is quite impossible for us to accept the proposal that your female compositors can be permitted to work in our area, even at full male rate of wages'. The executive council of the English Typographical Association went on to confirm this, adding as a gloss that 'female compositors must be confined to Scotland and means sought whereby female compositors shall be eliminated in Scotland'. The STA, after further protracted negotiations, decided to ballot its members. No doubt national pride was a factor, and perhaps there were other reasons: for instance the problem of reconciling the different arrangements for sick and pension funds. It should also be remembered that the STA was in dispute with the Printing and Kindred Trades Federation at the time, over its recruitment of semi-skilled workers to the Auxiliary section. But

the STA leadership clearly posed the question as a matter of its women members' rights. The note accompanying the ballot paper pointed out that 'members must clearly understand that according to the decision of the (English) Typographical Association, if Amalgamation is agreed upon, no female compositor member employed anywhere in Scotland, at and from the date of Amalgamation, will be allowed to accept a situation under any circumstances within the area of the TA'. The leaders went on to say that they were in favour of amalgamation on general grounds but were 'of the opinion that no scheme of amalgamation, however tempting, should be agreed upon unless it allows our female compositor members the same freedom, terms and conditions as are laid down for our male members'. Both William Hampton, the secretary of the Edinburgh branch, and Margaret Rendall, secretary of the women's section, recommended a 'no' vote. Other branches did the same and the negative ballot result meant that negotiations were broken off.[20] There may be other, underlying reasons for Scottish reticence on this occasion. After all, none of the various attempts to amalgamate before the formation of the NGA in 1952 came to anything. But officially and for the record, the reason for the breakdown was the question of the women compositors.

Viewed historically, relations between men and women within the STA and the Edinburgh branch had developed considerably after 1910. The men's union had been obliged to reckon with two groups of women: those who had supported the men in 1910, and those who had formed their own movement. Either way, it was probably felt that they could no longer be ignored. The women's section as originally set up was under the wing of the main Edinburgh branch. No outside organizers were called in. Regular contact at official level between the women's committee and the men perceptibly reduced tension, which was gradually replaced by mutual respect and understanding. This may not always have been reflected in the membership at large, but in the union leadership at least, harmony turned out to be quite achievable. It may therefore well be the case (though it is impossible to prove) that the 1925 vote against amalgamating with the English compositors, genuinely reflected willingness to defend the rights of women who had finally been accepted as 'comrades'.

DEFENDING WOMEN'S INTERESTS: THE GRIT IN THE MACHINE
All the same, the interests of the women compositors were not and never could be identical with those of the men. Sometimes it was a question that could be resolved without reference to the men, such as 'dowries' and 'returners'. Sometimes there was potential conflict, as in the question of equal pay and composing machines. A brief survey of how these issues were handled shows both the power and the limitations of the women's branch.

To begin with the first category, there were some questions specific to the women's section – and most specific of all was the 'marriage dowry'. Certain employers had been in the habit, as we know from the Clark's account books, of paying a modest sum of money to a woman on her leaving the trade to get married. Inevitably this came to be known as the 'dowry', and when the rule book of the women's section was drawn up, it was duly incorporated into the list of benefits for members. So in addition to the out-of-work benefit, the strike benefit, the sickness and funeral benefit, there was a marriage dowry benefit of five shillings per year of membership, with a maximum of £5. (The men's equivalent was their pension fund.) The reasoning behind this was that most women would leave the trade to marry; and indeed probably as many as three-quarters of them did so. But for that substantial minority of women who never married, the dowry came to seem an unfair use of their sub-scriptions, while during the war, brides who went on working, or war widows who returned to work, did not know where they stood.

In April 1918, Miss Crawford moved at a general meeting that the marriage dowry be abolished and the out-of-work allowance increased. Most of the women at the meeting said they were not ready to make such a change. 'Meg' who had temporarily replaced Juvenus as the *Journal's* correspondent on the women's section, and who may really have been a woman, commented sarcastically on the 'arduous task of making heaven on earth for a man'; those present seemed to think that 'marriage was woman's chief end . . . it looked as if every member was a prospective bride and regarded the abolition of this benefit as a personal loss. Frankly I was disappointed in you'.[21] The only change introduced that year was some clarification for recent brides: those already married before joining the union could not claim a dowry; if a member married a man in the forces and went on working during the war, she could go on contribu-ting and draw her accumulated dowry when she eventually left the trade; if the same brides should be widowed, they were entitled to all dowry accumulated until their widowhood. This sorted out an immedi-ate problem, but left the benefit tied to marriage rather than need, let alone retirement. It was specifically earmarked for helping the bride embark on married life.

But the 'unfairness' of the system to the unmarried could not persist much longer once the question had been raised. By autumn 1918, when the general rate of contributions went up, the women's committe re-solved that because the present arrangements were unfair to the un-married, in future, 'every member leaving the trade should be given a retiring allowance of 5s for every year of membership'. The circum-stances of the war made it necessary to specify that anyone who took the grant and returned to the trade within 13 weeks should pay it back.

As can be seen, the dowry question coincided chronologically with another question facing the section: the return of married women or

widows to the trade. Perhaps understandably, the male compositors frowned on this: just as the numbers of women were falling, they started to come back. But it was a convention of the 1910 agreement that any women who needed her job back might apply for it and for a union card. Normally the request for a card was automatically granted to widows. But there were some difficult cases, such as women married to men who were disabled or unemployed, in the years after the war. The women's committee had to face several difficult decisions and regularly came down on the side of the unemployed within the trade, rather than the married woman with an unemployed husband. It was not that there was an absolute rule; but their priority, as usual expressed in terms of 'fairness', was the welfare of the unemployed compositor (usually male): 'the committee felt it would be most unfair to allow such introduction of labour [i.e. of married women], at a time when there was so much unemployment.'[22] They were prepared to relax their unofficial marriage bar, however, when trade picked up again. There still remained the problem of a woman who had re-entered the trade when her husband was unemployed and who kept her job when he returned to work; feeling within the women's committee – virtually all of whom were unmarried – was often mixed. This is an example of a kind of division which did not occur on the men's committee.

Much more controversial and likely to lead to conflict are the two main issues in the second category: the machine question and equal pay. The machine question arose directly out of the 1910 dispute: almost all the Monotype machines in use then were worked by women, and continued to be so. Only new machines were to be 'given' to men. If a woman operator left, her machine went to another woman.

There is no detailed record of the number of machines owned or acquired by Edinburgh printers between 1910 to 1914, but most likely master printers went on buying machines until the outbreak of war. During wartime, the shortage of men meant that while some women had to work men's machines for the duration, no men worked on women's machines. The question began to cause problems only after the war when, as things returned to normal, surviving firms began to replace their antiquated Monotypes, bought in the 1900s, with new machines. The secretary of the women's committee reported that:

> several of the Monotype machines operated by female labour were being replaced by new machines, and that though opinions to the contrary were expressed by members of the male branch, the [women's] section interpreted the 1910 agreement to apply to additional machines, not replacements.

When it was suggested that the matter be referred to the EC, the section stuck to its guns and said 'there was no dubiety in the members' minds as to the justice of their decision and they meant to abide by it'. Nevertheless, the male branch committee also discussed it (this was

before the two branches had merged). At first they accepted the women's point, but later for unstated reasons (presumably pressure from the membership) they went back on their decision, and the whole question was referred to a subcommittee with equal representation. The women's delegates were Mary Alston, Chrissie Kilgour, Jessie Dalgleish and Miss Mason, and they must have argued their case firmly. Despite the context, in which a particularly hard case was invoked, the subcommittee decided in the women's favour. (Morrison & Gibb had started two disabled ex-soldiers at Monotypes and said that women would have to be displaced if these two young men were to be engaged.) 'New' was to be interpreted as 'additional', so women could continue to work at replacement machines. And it was firmly stated that 'all machines being worked by girls [sic] in 1910 should continue to belong to the girls to that number, that is so long as those girls are and continue to be members of the ETS, except where a machine is transferred from one office to another'.[23]

This decision implied the right of 'girls' to receive training if the number of qualified Monotype operators was to be maintained. It was not until 1923 however that women were admitted to keyboard training classes at Heriot-Watt College. Perhaps until then there had been no shortage of women monotypists. At any rate Margaret Rendall reported in 1923 that

> it is a pleasure to announce that the section is sharing in the Monotype instruction at Heriot-Watt College. Eight girls took advantage of the offer and a special class has been formed for them on Saturdays. This is really an opportunity to be grateful for in view of the congested condition of the class and plant, we might easily have been crowded out.

The instructor later reported that the eight had done 'exceedingly well' and he hoped they would be allowed to practise at work. For training was only part of the problem: without knowing when one might be called upon to take over a machine, a trained operator could let her skill grow rusty if she was doing nothing but hand-setting. In 1925, Margaret Rendall wrote to the union training committee pointing out that when firms were approached about this, 'a little was done but not enough'. She reminded the committee that the women who attended classes 'did so on their own initiative and at their own expense', and that 'their good work and excellent certificates' had been recognized:

> We submit to you gentlemen that such a recognised nucleus of potential operators is desirable and indeed necessary, in order to fill any vacancies which might arise through illness or marriage and thus to keep the female mechanical section up to proper numerical strength.[24]

At the same time, she politely asked Turnbull & Spears if Miss McLean, a qualified machinist, could have some practice (a man having

been given a women's machine in her absence), 'otherwise girls will not spend time and money attending the class and in the near future these will result in a serious shortage of qualified female operators'. The employer replied that Miss McLean 'would not be overlooked', but 'at the same time you quite understand that regular routine of business must take first place.'

On this issue of course, everything else took first place: nobody else but the women concerned had any interest in helping them to keep up to strength. It was in the men's interests to seize the chance to take over machines, pleading the excuse that no woman in the firm was qualified, while for an employer, a woman whose command was not yet perfect might not look a good investment. It was a battle where eternal vigilance could only at best maintain the troops in the field; winning was out of the question. By the 1930s, the motivation on the part of the women to train as monotypists without prospect of a job was clearly a problem. They were all growing older, failing eyesight and speed no doubt played a part too, and employers could always refuse to take an outsider on a vacant machine. In 1937, William Hampton tried and failed to get Morrison & Gibb to take a woman from another firm to work a woman's machine. Morrison & Gibb's reaction was a far cry from the employers' preference for women in 1910, but the circumstances had quite changed. A woman was still paid less than a man, but it was by now in the employers' interests to have amicable dealings with their male work-force: the union was stronger, while the remaining women were not seen as being worth the trouble of defending. By 1938, the women's section committee realized that 'it was useless to try and claim any vacant Monotype machine unless a fully qualified female was idle at the time'. The battle was gradually being lost; but it is worth remarking that despite the feeling among the men generally, the union leadership seems to have applied the rules loyally and to have lent assistance to the women as long as it remained practicable to do so.

The second major issue confronting women compositors was pay. It is not possible here to do justice to the complex moves on pay in the compositors' trade during the period 1910–40, in particular to the various negotiations, awards and war bonuses during the First World War. Two things stand out: to the men, the Edinburgh women compositors constituted a problem and an anomaly for as long as they continued to exist, and there was bound to be unease about their position; secondly the women themselves were extremely reluctant to talk about equal pay, let alone campaign for it.

To begin with, had anything changed in the extent to which women were doing work comparable to men's? We have seen that in the pre-1910 days, women hand-setters were often confined to the 'easier', more continuous work, and that they themselves regarded this as sufficient justification for unequal pay. But there were already in 1910

exceptions to the rule, namely Monotype operators and proof-readers.
For a while the earliest Monotype operators had been doing a job for
which there was no qualified man, but doing it well below the male rate
for handsetting. Once men came forward to claim the machines after
1910, there can be little doubt that a man and a woman operating a
keyboard were doing exactly the same job. Nevertheless, the women
continued to be paid at not much more than half the male rate. By 1915,
the male minimum rate was 37s, the female rate 21s; keyboarders of
either sex got 3s 6d extra. Women Monotype operators could not, by the
1910 agreement, increase their number, and we have seen that by the
1920s they were having difficulty keeping up to strength. Women proof-
readers, the other category doing exactly the same work as men, did see
their numbers increase. (Indeed this was the case even in England.) For
the ordinary hand-compositors – as were still the great majority of
women – the differential remained as it always had been, but the work
had changed. In a retrospective speech quoted above, Mary Alston
pointed out that patterns of work were no longer the same as before 1914:
women were now much more likely to be doing correcting, making up
and even imposition. Machines had removed the need to have rows of
women doing straight setting in bookwork. Increasingly, there was little
difference in practice between the work handled by men and women
compositors.[25]

In the first years after 1910, there is no trace of any independent
pressure from the women on the question of pay differentials. Signifi-
cantly, the first time their voices are heard is over the payment of
differential war bonuses to men and women in 1917. It was proposed
that men should get 3s extra, women 1s 6d. The women argued that this
was nothing to do with skill, status or equal pay, but was intended to
compensate for the rise in the cost of living: they pointed out that 'their
bread, groceries, coal, clothing etc. was just of the same poor quality and
inflated prices as those supplied to the stronger sex'; but they lost that
battle, and the war bonuses were always differential.[26]

If they were prepared to protest over this issue, the women were on
the contrary most reluctant to raise the question of equal pay. Perhaps
they were still inhibited to some extent by the notion of 'fairness' a word
that continually crops up in their discourse. If they could all agree that
there was something inherently 'unfair' in the differential war bonus,
they were not prepared to argue that the different wage rates were
necessarily unfair. There might be discussion about exactly what a 'fair
wage' was. But there is no doubt that they found pay a very awkward
question.

In the early days of the women's section, and during the First World
War, one finds them far more likely simply to support the men's position
on pay than to take an independent line, although they were the losers
on three separate occasions. The first time, over the matter of women

being tempted out of the city to work in printing at rates somewhere between the 21s women were paid in Edinburgh and the 37s of the full male rate, the union leadership sought and obtained the co-operation of the women's committee. The ETS's efforts to stop women moving out of Edinburgh even ran to offering to pay unemployed women 21s a week out of union funds until they found a job in the city, but 'this matter [was] to be kept as quiet as possible amongst members of the committee'.[27] The committee co-operated loyally, though we do not know how successful it was as a tactic.

The second issue arising during the war was the end of the ban on recruitment in July 1916. On that occasion, the women's committee sent a letter to the secretary of the STA stating that 'We the members of the Edinburgh Typographical Society Female Section resolve to resist any attempt to introduce female learners into our trade until the rates paid male labour are conceded to our section'. This may look like a call for equal pay, but it was in fact nothing of the sort, and must be interpreted as the result of pressure from the Edinburgh men to get the women to support them in resisting any move on the part of employers to start recruiting women again. There is in fact no evidence that any such move was made, such were the circumstances in 1916, but yet again, the women were expressing solidarity with the men. There is no sign of any protest on the lines of the 'We Women' movement on this occasion.

Thirdly, when there was a move by employers to get the electoral rolls printed by women, at women's rates, the women again supported the men's opposition. Refusing to replace the men at less than the male rate, the women nevertheless said: 'in view of the desirability of retaining the contract for Edinburgh, they were willing to allow the Voters' Rolls to be done by Male Labour only and will place no obstacle in the way of Master Printers substituting male for female labour', in other words, they were prepared to forego their own chance of getting the work in the interests of solidarity with their male colleagues. (In the event, there were not enough men available anyway, and a compromise was reached, whereby women were paid higher, but not full rates.)[28]

On all these occasions, the women bowed to the arguments of the men. They were throughout subjected to a chorus from employers telling them that they were not up to the male rate anyway. How accurate this was is impossible to say. One senses the frustration of Mary Alston, who in a confidential minute written during the electoral rolls affair said, 'as regards monotype operators, they [the employers] are obdurate. It seems that in addition to their "lack of stamina" [women] are not so accurate as the men.' She herself, evidently disbelieving, wanted to try an experiment, whereby women would receive the male piece-work rate on the machines, confident as she was that their work would be as good as the men's; but in the event this was never put to the test.[29]

It has to be said however that many women compositors seem to have internalized the judgement that they could not do as well as men. In a series of votes taken by the women's section in 1918, this was stated several times. 'The unanimous feeling of the meeting was that women comps cannot earn the male standard of wages' (June 1918); 'Women comps could not claim men's wages because they were not able to earn them' (November 1918); 'unanimous that women comps cannot earn the male standard of wages' (December 1918); 'Women comps cannot claim men's wages because they are not able to earn them on account of physical inability' (January 1919).

This litany of voices does not necessarily mean that women accepted that the status quo was 'fair'. In 1914, they were earning little more than 50 per cent of men's wages. The rate crept up irregularly during the war, reducing the differential slightly. Once the war was over and a major reassessment of the wage scale was under way in 1920, the women confessed themselves 'perplexed what to do about the new proposed grading system, as the female compositors are in a peculiar position, in that her wages are "not fair"'. Their feeling, evidently arrived at after some heart-searching, was that women's work was equivalent to 85 per cent of men's. This was well in advance of what they were actually earning at the time and of the figure eventually agreed between union and employers in November 1920: that is that the women's rate should be 70 per cent of the men's. This figure was to remain the norm for much of the inter-war period. Thus when the men's stab wage was fixed at 66s in 1920, women were earning about 43s. A further rise left men earning 88s and women 61s to 63s. (These large and irregular rises of course merely reflected inflation, not an improved standard of living.) When wage cuts were imposed during the troubled years 1922–3, the women's wage was by the same token cut by 70 per cent of the men's cut.

There was no support among the women for equal pay during any of these talks. They might regard 70 per cent as too low, but the furthest they were prepared to go was to urge in May 1920 'that when wages are stabilised, the female compositors must be paid 85% of the standard male wage, plus 12½% for operators and readers'.[30] Miss Davidson proposed that they stand out for the full male wage, but nobody could even be found to second her proposal at the special general meeting. According to Mary Alston, 85 per cent represented a judgement by the women on 'how much physical disability depreciated our work and it was felt that [this percentage] meant justice to employers and fair competition with male operatives'.

Given this history, it is easier to understand why, when the merger with the male branch of the ETS was proposed in 1922, the women were so anxious not to be outvoted on the matter of equal pay. In a word, they feared that if they claimed more than what they themselves regarded as a 'fair' wage, they would start to lose their jobs. The joint committee

drawing up proposals for amalgamation suggested the safety clause as follows:

> No wage movement to raise the Women's Rate shall be initiated by the Branch except with the consent of the majority of the section members present at a special meeting called to discuss such a movement and no attempt made to secure the Male Rate for Women shall be undertaken except with the consent obtained by ballot of a majority of 75% of those voting. A special meeting of the section may be called by a requisition to the Branch Secretary signed by 40 women members.[31]

At the special women's meeting called to discuss the amalgamation terms, doubt was expressed that this clause was not strong enough to safeguard against some outflanking manoeuvre on the part of the men. In other words, the membership of the women's section was genuinely afraid of equal pay, and this was an issue on which they felt more strongly than any other, since they were convinced – rightly or wrongly – that it would threaten their jobs. It also indicates that they did not entirely trust the men's branch. In fact the women were given assurances by the men's committee on this occasion, and no move was ever made by the men to demand equal pay for them. By the time of the Second World War, those women still in the trade were getting 85 per cent of the male rate. But the attitude of the women confirms what Jane Lewis says about the widespread fear among women in all walks of life at this time that if equal pay was introduced, they would lose their jobs.[32] The women compositors in Edinburgh, who as much as any workers in the country were entitled to it, had long ago for the most part accepted that they were not worth the men's rate.

If equal pay was not on the agenda, improved pay was. When Sarah Gillespie says that 'recognition of the female compositors led to a gradual improvement in their position and a reduction of the disparity between the male and female rates of pay',[33] she is echoing the STA Reports. It may seem a slightly bland summary of bargaining which was sometimes fraught with problems. But it is true that almost as soon as the women's section was formed, it succeeded in bringing into line six offices which had not been paying even the standard rate agreed by the employers themselves for their women compositors. The section also contributed to the improvement of women's pay outside Edinburgh. Within the city, the problem was more intractable, but it was certainly in the interests of both men and women that the women's pay be increased; the improved unity within the Edinburgh Typographical Society undoubtedly played its part in the negotiations which led to women's officially being paid 70 per cent of the male rate, in the period between the wars. This was admittedly an improvement on the pre-war position, but once this percentage had been fixed, no further efforts to improve the ratio appear to have been made. It was only during the Second World War, in

circumstances not of the Association's choosing, that further increases
for women narrowed the gap from 30 per cent to 15 per cent. By this time
in any case, the number of women compositors had fallen very low.
They never did get equal pay, and it must be assumed that their own
deep-seated fears were at least in part to blame. One of the surest signs
that the columnist 'Juvenus' was a man not a woman, is that he cham-
pioned the cause of equal pay.

What, in the end, can be concluded from the experience of trade-union
membership of the women compositors after 1910? On the positive side,
it proved that if an attempt was made in good faith to incorporate women
into the trade union, with co-operation and advice from the men's
branch (something which had never been attempted seriously before),
there was no reason why women could not be found to learn the ropes
and take control of committees. Several individuals, of whom Mary
Alston is the most obvious, were born organizers, who clearly enjoyed
their work and combined a command of administration with a human
warmth evident from some of the (only too rare) letters that have sur-
vived. It also showed that the women were well able to take control of
their own affairs after the initial 'apprenticeship' period, and that their
relations with the men's committees and the leadership of the STA
generally were relaxed and friendly. This could have been a successful
episode in trade union history.

On the negative side however, the experience was vitiated by the
circumstances of its creation. Since no more women were effectively to
be recruited into the compositors' trade, the section can be seen as more
like a winding-up operation than the new departure it so nearly could
have been. It would hardly be an exaggeration to say that objectively it
represented an operation of control and absorption by the men's branch,
in order to avoid any repetition of the 'We Women' movement. Soli-
darity within the union had the effect of stifling any independent moves
to open the trade up (on whatever terms) to women after 1916. Whatever
the degree of cordiality between men and women, the satisfaction ex-
pressed by the men that the women's numbers were falling tells its own
story.

Sadly then, the positive experience so painfully acquired of adminis-
tering the women's section could not be passed on to a younger gener-
ation. The undeniable lack of enthusiasm – especially in later years –
among the membership at large, reflects this dead-end situation. To
overcome all the usual physical and to some extent psychological and
historical obstacles standing in the way of women's developing trade-
union consciousness, the branch would have needed to be able to look
forward to some future horizon. Instead it found itself forced to fight a
defensive rearguard action on behalf of an ageing membership increas-
ingly cut off from the male work-force. In view of this, one should not

shake one's head over its lack of combativity, but rather recognize its considerable achievements. The signs are perfectly readable in its history that there was a potentially viable skilled women workers' movement here. But it had been directed along a road leading nowhere.

CONCLUSION

This book has looked in very close detail at a minority of a minority: the 800 or so women compositors out of a total work-force of about 2,000 compositors of both sexes, themselves only a section of the skilled workers in late Victorian and Edwardian Edinburgh. What is more, it has explored one of history's 'blind alleys' as E. P. Thompson has called them: the printing trade reverted to the *status quo ante* as far as women were concerned. That need not mean it has nothing to tell us. In a Scottish context, there is so little hard information about women workers, outside one or two well-defined groups, that it serves some purpose simply to provide the empirical detail to fill in one more corner of the historical landscape. But landscapes, especially with figures, are dynamically balanced. To put something or someone in is to alter the relation of the parts to the whole. Can this reasonably be claimed here?

Emmanuel Le Roy Ladurie suggests that historians can be divided into parachutists (who see the grand sweep) and truffle-hunters (who pursue information on the ground). Is it possible to move up from truffle-hunting to an intermediate position, so that the investigation of a micro-subject, like women compositors in Edinburgh, can shed some light on the bigger debates which their history provokes? I would like to think that one can generalize up from a precise example concerning women, since it has been more common to generalize down from assumptions about what women did in the past, based on inadequate knowledge. Several of the debates have been touched on in the preceding pages. The aim of this conclusion is to sum up briefly, and I hope not too abstractly, how this short study relates to these questions. The debates are inter-connected, but for convenience sake, I shall group them under four rather artificially separate headings: skill and the work process; the rewards of labour; class identification; and the writing of history. Gender is the prism through which each is viewed.

THE WORK PROCESS: WHEN IS A SKILL NOT A SKILL?
Composing type, like tailoring or dressmaking at the turn of the century, was a trade that could not be learnt in a hurry. It took training, practice and time for abilities to be safely acquired. Traditionally the learning period was known as an apprenticeship. So like tailors (but unlike dressmakers) compositors were firmly in the category of 'the skilled

worker'. Not all apprenticeships led to complete mastery of the craft, and not all compositors could handle all the processes, but a time-served journeyman was sure of his place in the trade.

There was no such thing as 'time-served journeywoman' in printing: the term never seems to surface in all the reams of documents about the women compositors. Although they were doing work which no un-skilled person had ever done before, although they were doing work identical with that of a certain proportion of the men, the label 'skilled' was one which the women had to do without.

What was a skill? To the employers, it was something they had had to reckon with in the past: a trump card held by the men, but also recog-nized by the masters. They hoped however that its importance would be reduced, when ways were devised of breaking down work processes into specialized tasks. When asked, they often denied that many of their journeymen 'really were' skilled, by which they meant competent at a wide variety of tasks. The concept of skill to them was on the way to becoming a restrictive practice.

To the journeymen, the notion of skill had two parts. In the first place there was traditional craft pride and satisfaction with a job well done. It was this aspect of the trade that suffered most as work patterns changed. The second component was becoming all important: to put it crudely, skill was becoming a bargaining counter, a meal ticket, a status symbol, a means of craft control, something visible to the outside world. The printing trade was a classic example of a calling restricted to those who had 'served their time', undergone the rites of passage, been accepted into the confraternity and, in theory at least, become good craftsmen. In practice, the craft might be imperfectly learnt (or taught), and as Gray has pointed out, in Edinburgh the 'casualization' of much of the work-force produced a vulnerable group of men, less secure in either their skill or their employment than in the past. But they still had something denied to the women compositors, the trappings of skill.

When women came into the trade, they simply learnt the work, from day one, but it was stripped of all the other things a boy apprentice learnt as he swept the floor: all the rituals, all the language, all the battle lore between master and man (how to tell 'lean' from 'fat' for instance). As a result, women were not aware of any difference between 'learning the job' and 'acquiring a skill', with its heavy symbolic weight. Since more-over both their employers and their male colleagues daily told them they were *not* skilled, it would have been hard for them to acquire the idea that they were. It would be hard too to find any examples of women outside the printing trade who could claim to be skilled. What was more, the age structure of the female work-force was such that comparatively few older women remained as a 'critical mass' of experienced workers who might have had the confidence to claim the skilled label. Boy apprentices joined as it were a moving staircase of generations, progressing up it in their

turn. Girls had comparatively few elders as role models, and the interplay of generations was interrupted by marriage.

Consequently their view of the work process was fragmented and their appreciation of the socially constructed side of 'skill' very imperfect. In their case, craft pride was replaced by delight in the job, a sort of liberation from the various kinds of drudgery that passed for women's employment at the time. It was for them an adult activity, one that engaged brain as well as hand, a previously unopened door, but not a political weapon. By all but one of the Edinburgh survivors I talked to, the strongest feeling to be conveyed was this fascination: 'I loved my work'; 'I would have worked weekends if they'd let me'.

Without a social definition of skill, distinctions between different categories of work were less forceful. So setting in foreign languages, or particularly small type, or mathematical and scientific work for instance – all matters on which Edinburgh's printing reputation was founded – were not seen by women (as they would be by men) as specially significant. The same was true even when a skill was invented before their eyes. The 'We Women' group did actually claim the label 'skilled' but even they did not appear to recognize that the coming of the Monotype had created a new skill which, by a historical accident, was in the hands of women operators. A traditional seven-year apprenticeship was very largely irrelevant to the keyboard. But neither masters, men nor women put it that way. The answer to the question is quite simple: a skill was not a skill when practised by a woman[1]. Anyone who thinks that things have changed should read Swasti Mitter's devastating analysis of the contemporary division of labour.[2]

THE REWARDS OF LABOUR: WHY NOT EQUAL PAY?

As with skill so with pay. When one looks back over the Edinburgh story, it may seem tempting to think that there could have been a different outcome. What if men and women had joined forces to oblige the employers to grant equal pay for equal work (whether keyboarding, proof-reading, simple typesetting or typesetting with extras)? Would the firms really have gone out of business? Would the women have lost their jobs?

What may seem obvious is not always reasonable, and nothing is quite what it seems in the argument over equal pay. The men called for it, on the assumption, rightly or wrongly but sincerely held, that women were not doing equal work, and that the masters would not find it worth keeping them. The masters were against it, ostensibly on the shifting and contradictory grounds that women would not be 'economic' at equal rates, because they were not doing 'the whole job'; but really because women were prepared to accept lower rates. Paradoxically they were supported in their view by the men. The women were against equal pay too, believing the arguments put forward by masters and men, and

concluding that they would indeed be ousted from a trade they had only just entered.

On a larger canvas, the low pay of women in the printing trade simply reflected the low pay of women's occupations generally. As a result, it looked remarkably like *high* pay to girls entering the trade. It is an unfortunate fact about gender and pay bargaining that male unions did not on the whole campaign against low rates of pay for women in trades where they did not compete with men. Until they did, there was not much hope of progress on this front: a crucial point underlying the whole wage structure.

A rather different question is that of quitting work on marriage. Both men and women were caught in a set of social expectations from which it was hard to break loose. The 'family wage' was a very theoretical notion, given wage rates in Scotland at the time, but Scottish women mostly did give up at least regular employment after marriage, either voluntarily or because their husbands insisted on it, or both. Uncertainty about length of career provided (as it still does today) an excuse for employers to put women in a different category. But there was theoretically no reason why a woman should not earn the same wage as a man at an equivalent stage in his career while she remained unmarried. (Many men, after all, changed employers often in the printing trade or left the trade altogether.) Nor were men the only breadwinners: our sample contained plenty of examples of women who had to maintain themselves and others on their wages.

To return to the question, could it all have ended differently? Although all the parties took up contradictory positions, in a sense the men and a section of the women *did* in 1910 join together to beat the masters. But this was at the cost of future women's jobs, as other women pointed out, and it certainly did not achieve equal pay. The root of the problem was that women were forced into an artificial choice between class solidarity and sex solidarity.

CLASS IDENTITY AND SOLIDARITY *vs* WOMEN'S RIGHTS
Writers of women's history have long had to contend with the deeply rooted and widely held view that the working class is essentially identified with working men. *A fortiori*, and admittedly with more reason, the so-called labour aristocracy is perceived as male. Was there ever a female labour aristocrat? Not in most of the literature, but women compositors, if anyone, should qualify for such a description. In practice job segregation was (and is) so regular that even if women were (and are) doing skilled work, it has rarely counted as such.

Having no reference group so to speak, skilled women workers wherever they were (and it is certain that they were not confined to the printing trade) had no tradition of trade-union consciousness, *as a gendered group*, remotely comparable to that of their male equivalents. There

was no 'critical mass' of experience, something that I am convinced was essential for group identity. On the other hand they were well aware that they belonged in the working class, and were bound by ties of kinship, marriage or friendship to the men of their class and the men alongside them at work.

Historically, the cause of skilled women workers was championed only by middle-class reformers, of both sexes but in particular by women in the suffrage and rights movements. This reinforced the notion that women's rights were essentially a middle-class cause foisted on to working women from outside and deeply prejudicial to 'the working class', that is of course the male working class. Emily Faithfull appeared as a sworn enemy to the male compositors; the suffrage groups who counselled the women resisters in 1910 were identified with the bosses. As a result, the women compositors were faced with a dilemma men never had to face: they were told to choose between the interests of their class and those of their sex. Men's rights and interests were never perceived as clashing with those of their class; and yet they were certainly not identical with the interests of working-class women. In fact it could be equally argued that there was a degree of male solidarity between masters and men, across class lines, expressed in the low estimate and condescending discourse they both applied to women.

There is plenty of evidence that when faced with the challenge 'my sex or my class', women staunchly defended 'the working class', that is they showed solidarity with men. Macdonald quotes the case of a woman in bookbinding: her employer wanted her to varnish books 'and offered her 5s a book: she has a steady hand and could have done it quite well . . . following a delicate zigzag with a paintbrush. She refused indignantly and said "I know my place and I'm not going to take men's jobs from them"'.[3] The trouble was that it was women who had everything to gain and men everything to lose if women were ever going to do other than unskilled jobs.

It was a paradox in this case as in that of the Edinburgh women, that the employers – for their own reasons – offered women the chance to 'better themselves' or to break into a male preserve. Some very eloquent pleading on behalf of women's rights is to be heard from the master printers during negotiations in 1910. But to agree with the masters was to set oneself against the men. The 'We Women' group were torn in two directions as their articles and speeches show: they did not want to seem to be taking the bosses' side. Employers' rhetoric about women's rights sorted ill with paying women at half-rates, as all the women involved well knew. The strain showed itself in their suggested compromise of 'fair pay': an embryonic attempt to make the division of labour one by task rather than by sex. But at the end of the day they could not prevail against what the union defined as the interests of 'their own class'. A

majority of the women supported the men's case, and the resisters were obliged to buckle under.

Although their interests separated the men from the women compositors, class solidarity[4] was in practice a very firm cement. There was hostility, yes, from the membership of the men's union to the employment of women as a group, but everyday relations at work were friendly; individual men were the fathers or brothers of women compositors; many marriages were made in the composing-room. Outside work, a shared if not identical culture and background united men and women print workers, and cut them off sharply from the middle-class Edinburgh where women's rights were debated. When, after 1910, a women's section of the union was finally created, it showed that it was possible in certain circumstances to find common ground and work together: could it be that 'women's rights' and 'working-class solidarity' were after all compatible? But the conflict had already been resolved in the men's favour by then, and unity came too late to affect the main issue: exclusion of women from the trade on grounds of sex. The friendly union officials were delighted to hear that the numbers of women in the trade were falling. Class solidarity concealed the fact that the rights of some members of the working class had prevailed over those of others. The women's loss of opportunity was not perceived (by men or indeed by women) as some kind of loss for 'the working class'. Rather the labour movement claimed it as a great victory.

GENDER AND HISTORY

The women's story is one of exclusion and loss; at the same time it represents a kind of breakthrough. The breakthrough was short-lived, it is true, and vitiated by the circumstances of its introduction, but it should not be forgotten simply because it led nowhere. If we were to stick to simple linear models of progress, we should never get anywhere in women's history. The usual periodization of social change often breaks down when looked at from the point of view of gender. There have been times when social organization has allowed greater independence to women, followed by the reverse. This story shows how an idea first suggested by vanguard feminists did at least get a run for its money. Women did succeed in penetrating a skilled trade from which they had been firmly excluded. Working-class girls in Edinburgh briefly had the chance to get their hands on work which was more of a calling and better paid than anything else they could aspire to. But what to them was well-paid work looked to a man like cheap labour; and like other people hired as a cheap work-force (apprentices, strike-breakers, immigrants at various times) they could not possibly be viewed with equanimity by the dominant male trade-union movement. Hence the clash between a men's labour movement, which was historically buoyant during these

years, and a women's movement only just beginning to feel its way and whose time had not yet come.

It is important not to view this clash as too much of a one-sided affair, with women the innocent victims and men, whether employers or unionists, as the oppressors. It is possible for historians with a bad conscience about mentioning women (and in Scotland the bad conscience is understandable) to fall into the trap of representing women only as oppressed victims – burying them with full honours so to speak. Thus the 'women of Scotland' are described as 'truly the country's most oppressed group'; or we are told that socialist working-class culture 'involved the virtual subordination of women . . . with the exception of a few outstanding individuals' or participants in the Glasgow rent strikes.[5] It is surely more interesting, and in the end more accurate (though it means a lot more work), to try to see relations between the sexes as more complex than a simple oppressor/victim model. Both men and women were trapped to some extent; both men and women negotiated tolerable compromises from time to time. Both men and women could be equally blind to the advantages of co-operation.

On the other hand, I do not want to take refuge in neutralism. There *was* an unequal power relationship at work in this story. But it was not simply some timeless and immutable oppression of women by men. It was a power relationship socially constructed over time. The women in question were nearly all young, inexperienced and without the benefit of an accumulated tradition. Most of them were expected to give all their out-of-work time to domestic duties. Their early efforts at organization reflected all these things, as well as taking place outside the mainstream of the union movement. The men involved were either employers, with the power of hiring and firing, and with the benefit of an unusually strong Master Printers' Association; or they were the men of the union, with a full range of age and experience, a particularly strong craft and trade tradition, and with the backing of the established labour movement in public and of a domestic support system in private.

Although it is a lot easier said than done, it is the historian's duty to explore this kind of relation rather than to take refuge with all-purpose explanations like 'women's apathy', the 'difficulty of organizing women', or indeed 'oppression' and 'subordination'. Spirit and comradeship, rebelliousness and leadership were all at various times shown by the women in this story, while it was equally possible for the men at various times to be apathetic and divided. The outcome was as it was, not because of the moral qualities or defects of the people most concerned, but because the kind of collective action necessary to produce anything different could hardly emerge from a working class or a labour movement divided, consciously or unconsciously, by gender, and in a society where marriage and employment were alternatives for half the population but a combination for the other half. When I was researching

this book, the daughter of a former woman compositor wrote to me, telling me about her mother. Her letter ended: '[The women] were comparatively well paid. When [my mother] told *her* mother she was getting married, her mother's comment was that if she had been earning that kind of money, she would not look at any man!'

NOTES

NOTES TO INTRODUCTION

1. *Encyclopaedia Britannica*, 11th edn., 1911, preface. The actual distribution of the work was as follows: John Clay, six volumes; Richard Clay & Sons, four volumes; R. & R. Clark of Edinburgh, nine volumes; Ballantyne & Hanson of Edinburgh, three volumes; Morrison & Gibb of Edinburgh, one volume; nine further volumes were split between Richard Clay and R. & R. Clark, and one volume is unattributed.

2. Cynthia Cockburn, *Brothers: Male Dominance and Technological Change* (Pluto, London, 1983); see esp. ch. 6 for a brief history of the Edinburgh case.

3. Angela John, *By the Sweat of their Brow: Women Workers at Victorian Coal Mines* (Croom Helm, London, 1980).

4. For some clear and readable recent accounts by a number of historians of what they now understand by 'women's history', see the symposium 'What is Women's History?' in *History Today*, July 1985. My own position is closest to that of Anna Davin.

5. T. C. Smout, *A Century of the Scottish People 1830–1950* (Collins, London, 1986), 292.

6. Rosalind Marshall, *Virgins and Viragoes, A History of Women in Scotland 1080–1980* (Collins, London, 1983). J. D. Young, *Women and Popular Struggles: A History of Working-Class Women in Britain 1560–1984* (Mainstream, Edinburgh, 1985).

7. Glasgow Women's Studies Group, *Uncharted Lives: Extracts from Scottish Women's Experience 1850–1982* (Pressgang, Glasgow, 1983). Esther Breitenbach and Eleanor Gordon are editing a two-volume collective work on Scottish women c. 1850–1914 to be published by Edinburgh University Press, volume 1 forthcoming 1989.

8. Esther Breitenbach, *Women Workers in Scotland* (Pressgang, Glasgow, 1982); Eveline Hunter, *Scottish Women's Place: A Practical Guide and Critical Comment on Women's Rights in Scotland* (EUSPB, Edinburgh, 1978); Elspeth King, *The Scottish Women's Suffrage Movement* (People's Palace, Glasgow, 1978).

9. Eleanor Gordon, 'Women Workers and the Labour Movement in Scotland 1850–1914' (Ph.D. thesis, Glasgow University, 1985), to be published by Oxford University Press, forthcoming.

10. Lynn Jamieson, 'The Development of "the Modern Family"': The case of Urban Scotland in the early Twentieth Century' (Ph.D. thesis, Edinburgh University, 1983); see her chapters in *Uncharted Lives*, and in, Jane Lewis (ed.), *Labour and Love: Women's Experience of Home and Family 1850–1940* (Blackwell,

Oxford, 1986). Details of oral history projects can be found in *By Word of Mouth*, the newsletter of the Scottish Oral History Group.

11. Smout, *A Century*, 292. For some brief but pertinent remarks in a longer historical context, see Rosalind Mitchison, *Life in Scotland* (Batsford, London, 1978).

12. On England, see Felicity Hunt's chapter on the London bookbinding and printing trades in, Angela John (ed.), *Unequal Opportunities: Women's Employment in England 1800–1918* (Blackwell, Oxford, 1986) and references, esp. to her MA thesis. On France, see Madeleine Rebérioux, *Les Ouvriers du Livre et leur Fédération 1881–1981* (Temps Actuels, Paris, 1981) and Charles Sowerwine, 'The Emma Couriau Affair', *Journal of Modern History*, 1983. There is much more to be said about the other women in the printing trade. Because this book has concentrated on the particularly acute example of the compositors, it has neglected the women in Edinburgh who worked at semi-skilled jobs in printing, or who had a claim to be skilled bookbinders. Archive material exists for a more general survey.

13. See Cynthia Cockburn, *Brothers*, and also her article and several others in *Waged Work: A Reader*, edited by *Feminist Review* (Virago, London, 1986) and references; Jonathan Zeitlin, 'Craft Regulation and the Division of Labour: Engineers and Compositors in Britain 1890–1914' (Ph.D., Warwick, 1981).

NOTES TO CHAPTER 1

1. A recent short account will be found in, Lorne McCall, 'Edinburgh Printing History' in, *Scottish Book Collector*, 6 (June–July 1988), 8–12, providing details of the founding of several of the main firms.

2. Population figures from T. C. Smout, *A Century of the Scottish People 1830–1950* (Collins, London, 1986), 41. For descriptions of urban life in Edinburgh and Glasgow, see ibid., ch. 2, 'The Tenement City'. On servants, Robert Q. Gray, *The Labour Aristocracy in Victorian Edinburgh*, (OUP, Oxford, 1976), 21–3. Gray gives a full account of the industrial structure of Edinburgh in ch. 2.

3. Smout, *A Century*, 112.

4. Ian MacDougall (ed.), *Minutes of the Edinburgh Trades Council 1859–1873* (Scottish History Society, Edinburgh, 1968), introduction, xvi.

5. Gray, *Labour Aristocracy*, 22. As Gray points out, there are difficulties about the term 'printer', used in the census to mean not only compositors and pressmen but semi- and unskilled workers in the trade.

6. *Minutes of the Edinburgh Trades Council*, xvi.

7. Sarah C. Gillespie, *A Hundred Years of Progress, 1853–1952: The record of the Scottish Typographical Association* (Maclehose, Glasgow, 1953) 11; James Glass Bertram, *Some Memories of Books, Authors and Events* (Constable, Westminster, 1893), 90.

8. R. D. McLeod, *The Scottish Publishing Houses* (W. & R. Holmes, Edinburgh and Glasgow, 1953), 7; for brief histories of individ-

ual firms see ibid., 10–22; on the Scottish Enlightenment's early days, when the emphasis was on philosophy and science, see e.g. Nicholas Phillipson and Rosalind Mitchison (eds.), *Scotland in the Age of Improvement* (EUP, Edinburgh, 1970); David Daiches, Peter Jones and Jean Jones (eds.), *A Hotbed of Genius* (EUP, Edinburgh, 1986); and on the later literary phase, the age of Ballantyne, Constable and the great days of Scottish publishing, see David Daiches (ed.), *A Companion to Scottish Culture* (Edward Arnold, London, 1981) 229–301.

9. Anon., *The Ballantyne Press and its Founders* (Ballantyne, Hanson & Co., Edinburgh, 1909), 1–2.

10. David Keir, *The House of Collins: The Story of a Scottish Family of Publishers from 1789 to the Present Day* (Collins, London, 1952), quotes Lockhart as saying in 1819: 'Instead of Scottish authors sending their works to be published by London booksellers, there is nothing more common nowadays than to hear of English authors sending down their books to Edinburgh, than which Memphis or Palmyra could scarcely have appeared a more absurd place of publication to any English author thirty years ago,' 162.

11. Gillespie, *A Hundred Years*, 11; Bruce Lenman, *An Economic History of Modern Scotland 1660–1976* (Batsford, London, 1977) 107, 168.

12. David Bremner, *The Industries of Scotland* (A. & C. Black, Edinburgh, 1869, reprinted 1969), 500; see 493 ff. for the printing trades in mid-century.

13. B. W. E. Alford, 'Business enterprise and the growth of the commercial letterpress printing industry 1850–1914', *Business History*, vii, 1 (Jan. 1965), 4.

14. Gray, *Labour Aristocracy*, 54 ff., 'Cycles in the Printing Industry'; cf. Marjorie Plant, *The English Book Trade: An Economic History of the Making and Sale of Books* (Allen & Unwin, London, 3rd edn., 1974), who suggests that the trade was healthy even during the great depression of the 1880s.

15. Anthony Keith, *Edinburgh of Today* (William Hodge & Co., Edinburgh and Glasgow, 1908), 10.

16. *Scottish Typographical Circular* (1888), 710.

17. Colin Clair, *A History of Printing in Britain* (Cassell, London, 1965), 249; Alford, 'Business Enterprise', 10; John Child, *Industrial Relations in the British Printing Industry* (Allen & Unwin, London, 1967), 160. P. M. Handover, in *Printing in London from 1476 to Modern Times* (Allen & Unwin, London, 1960) refers to the decline of book printing in London because of the 'chilly draught from the competition of Scottish printing. It was the low wages and small overheads of R. & R. Clark of Edinburgh and Maclehose of Glasgow and others that forced the book printers to desert London in the second half of the nineteenth century,' 221. So far as I know, Maclehose's competitiveness had nothing to do with employing women as compositors. A few women were employed as typesetters in Glasgow in the 1900s but only in firms blacklisted by the STA; see J. Ramsay Macdonald (ed.), *Women in the Printing Trades: A Sociological Study* (King, Westminster, 1904), 172 ff. Women were however employed in significant numbers for a while in Perth, Dundee and most notably Aberdeen. On the employment of women

compositors in the 1890s in what later became the Aberdeen University Press, see Alexander Keith, *Aberdeen University Press: An Account of the Press from its Foundation in 1840 until its Occupation of New Premises in 1963* (AUP, Aberdeen, 1963) 25 ff. See also Gillespie, *A Hundred Years*, 107 ff. and 203 ff. The last women compositors were still in the firm in the 1950s, as remembered by John Davidson, now Assistant Secretary (Production) in the Edinburgh University Press.

18. Child, *Industrial Relations*, 160.
19. *Scotsman*, 14 Aug. 1986, 15. On Edinburgh printing in the twentieth century, see C. Oakley, *Scottish Industry Today* (Moray, Edinburgh and London, 1937), ch. 6, esp. 137; C. Oakley (ed.), *Scottish Industry: An Account of what Scotland makes and where she makes it* (Scottish Council of Development and Industry, 1953) section 7, 238: 'reference to imprints will frequently occasion surprise at the range of books produced north of the Tweed'; D. Keir (ed.), *The Third Statistical Account of Scotland: The City of Edinburgh* (Collins, Glasgow, 1966), 686–9.
20. *The Ballantyne Press*, 143.
21. Ibid., 157.
22. Some details in the *Third Statistical Account*, 686–9.
23. Cynthia Cockburn, *Brothers: Male Dominance and Technological Change* (Pluto, London, 1983), 46.
24. On the processes referred to in this and the following paragraphs, see Cockburn, *Brothers*, 46 ff.; Gray, *Labour Aristocracy*, 33–4; and for more details, John Southward, *Practical Printing: A Handbook of the Art of Typography* (London, 1882).
25. Gray, *Labour Aristocracy*, 34.
26. *The Ballantyne Press*, 145–6.
27. For details see Gillespie, *A Hundred Years*, 62–6.
28. On wage-rates generally in Scotland, see Smout, *A Century*, 110 ff., and R. H. Campbell, *The Rise and Fall of Scottish Industry* (John Donald, Edinburgh, 1980), 80, 84, 190, 193. On wages in the printing trade and comparisons within Edinburgh, see Gray, *Labour Aristocracy*, ch. 14. Cf. John Burnett, *Useful Toil: Autobiographies of Working People from the 1820s to the 1920s* (Allen Lane, London, 1974), 253–80, for similar evidence that the skilled handicrafts of mid-century had 'sunk relatively in importance and remuneration' by 1906.
29. For details see Gillespie, *A Hundred Years*, 72–6: 'Piece and Stab: The Edinburgh System'; and see Chapter 4.
30. The 'labour aristocracy' debate is discussed by Gray at length in his book on Edinburgh of that title and also in his *The Aristocracy of Labour in Nineteenth-Century Britain, c. 1850–1914* (Studies in Economic and Social History, Macmillan, London, 1981). The major problem about this debate from a feminist point of view is the difficulty of relating it to women: see Chapter 4 and Conclusion below.
31. Cockburn, *Brothers*, 17, quoting from *The Country Journal or the Craftsman*, 24 May 1740. Cockburn discusses the male rituals of printing offices at length. See also Gillespie, *A Hundred Years*, ch. 2. For further details of union organization in Edinburgh, see Chapter 5.
32. Several reports on the first girls to complete apprenticeships

appeared in the NGA journal, *Print*, in the autumn of 1978, with specific mention of the problem of initiation rites.

33. S. Kinnear, *Reminiscences of an Aristocratic Edinburgh Printing Office* (Edinburgh, 1890, copy in Edinburgh City Library), 17.
34. On the tramping system, see e.g. J. W. Rounsfell, *On the Road: Journeys of a Tramping Printer* (A. Whitehead (ed.), Caliban Books, Horsham, 1982), and Gillespie, *A Hundred Years*, 25.
35. Kinnear, *Reminiscences*, 17.
36. On the family wage, see Angela John (ed.), *Unequal Opportunities: Women's Employment in England 1800–1918* (Blackwell, Oxford, 1986), 24 and note 78 on the literature.
37. J. Begg (ed.), *Happy Homes for Working Men and How To Get Them* (Edinburgh, 1866), 163.
38. C. Dorrington, *Printing Office Characters* (1881), quoted in, Plant, *English Book Trade*, 401.
39. The social and cultural world of the male skilled workers of Edinburgh is fully discussed by Gray in chs. 5–7 of *Labour Aristocracy*.
40. 'A Famous Printery: R. & R. Clark Ltd.', *The British Printer*, IX (1896), 113–18.

NOTES TO CHAPTER 2

1. On women's work in the nineteenth century see e.g. Sally Alexander, 'Women's Work in Nineteenth-Century London' in, Juliet Mitchell and Ann Oakley (eds.), *The Rights and Wrongs of Women* (Penguin, Harmondsworth, 1976) which remains a classic introduction to the topic. See also Angela John's introduction to the collection she has edited, *Unequal Opportunities: Women's Employment in England 1800–1914* (Blackwell, Oxford, 1986); further theoretical essays using mostly present-day material are to be found in *Waged Work: A Reader*, articles from *Feminist Review* (Virago, London, 1986). On Scotland, which is not covered by any of this literature, see Glasgow Women's Studies Group, *Uncharted Lives: Extracts from Scottish Women's Experiences 1850–1982* (Pressgang, Glasgow, 1983) especially the chapter by Eleanor Gordon, whose thesis 'Women and the Labour Movement in Scotland' (Ph.D., Glasgow, 1985; to be published by OUP) is a fund of information not found elsewhere. An overview, running up to the present day is provided by Esther Breitenbach, *Women Workers in Scotland* (Pressgang, Glasgow, 1982).
2. Figures, based on the census, from Gordon, 'Women and the Labour Movement', ch. 1.
3. On Dundee, see T. C. Smout, *A Century of the Scottish People 1830–1950* (Collins, London, 1986), ch. 4; W. M. Walker, *Juteopolis: Dundee and its Textile Workers 1885–1929* (Edinburgh, 1979) and Gordon, 'Women and the Labour Movement', chs. 4 and 5. See ibid., 43–5 and Smout, *A Century*, ch. 5, for the impact on wages in general of the high male wages in heavy industry in the west of Scotland in the late nineteenth and early twentieth centuries.

4. *Census*, Scotland, 1911, City of Edinburgh.

5. Cf. *Scottish Typographical Circular* (Aug. 1860): women are advised to become 'domestic servants, who are both scarce and dear'. The *STC* was still reporting similar injunctions in 1910.

6. Gordon, 'Women and the Labour Movement', 30.

7. 'The only areas where women were making significant inroads into "traditional" men's work were in clerical work, printing and tailoring, where women were in fact displacing men', Gordon, 'Women and the Labour Movement', 29.

8. Anne Phillips and Barbara Taylor, 'Sex and Skill: Notes towards a Feminist Economics', *Feminist Review*, 6 (1980), reproduced in *Waged Work*.

9. *Census*, Scotland, 1911, City of Edinburgh. On de-skilling in the bookbinding trade, where there are significant differences from, as well as some similarities with, what happened in printing, see Felicity Hunt, 'Opportunities Lost and Gained: Mechanization and Women's Work in the London Bookbinding and Printing Trades', in, John, *Unequal Opportunities*, 71–93.

10. In 1861, the mean age at marriage of women in Scotland was 25.6; of men 28.6. Cf. Smout, *A Century*, 179.

11. Gordon, 'Women and the Labour Movement', appendix 2; in Dundee, 23.4% of married women were in paid employment, compared to 5.1% in Edinburgh. Of the 31,485 married women recorded as employed in Scotland in 1911, 5,938 were in the jute mills, 2,609 in domestic service, 2,133 were charwomen and 1,138 were laundry workers.

12. *STC* (Aug. 1860), 244 is the only near-contemporary reference located for this experiment, which is there described as an 'utter failure', though it apparently lasted some ten or twelve years. It is also referred to in Barbara Bradby and Anne Black, 'Women Compositors and the Factory Acts', *Economic Journal* (1899) 261. This article also suggests that Emily Faithfull actually started a women's printing office in Edinburgh in 1857, before setting up the Victoria Press, and Sheila Lewenhak, *Women and Trade Unions* (Ernest Benn, London, 1977), 61 says the same, but I have been unable to find any mention of this in contemporary sources, and it may have been a misunderstanding.

13. *STC* (July 1895), 409–10.

14. For biographical details and a full account of the Victoria Press see William E. Fredeman, 'Emily Faithfull and the Victoria Press', *The Library*, xxix, 2 (June 1974), 139–64, and references. Details of the Langham Place Circle will be found in most of the literature on the nineteenth-century women's movement in England; see, in particular, Ray Strachey, *The Cause* (1928, reissued by Virago).

15. Gladstone was Chancellor of the Exchequer when he said: 'We all know that women are peculiarly adapted, from their small fingers, to the delicate handling of type.' They are 'admirably suited for that particular trade', but have been 'excluded from it by the combination of the printers', quoted in *STC* (Apr. 1860), 213. Napoleon is quoted in Madeleine Rebérioux (ed.), *Les Ouvriers du Livre et leur Fédération* (Temps Actuels, Paris, 1981), 25.

16. *Scotsman*, 4 Oct. 1869, report of Miss Faithfull's lecture.

17. *Transactions of the NAPSS* (1860), 819. (The *Transactions* were printed by the Victoria Press.)

18. See Fredeman, 'Emily Faithfull', and W. Wilfred Head, *The Victoria Press: Its History and Vindication* (1869); *The Printer's Register* (6 Oct. 1869).

19. *Scotsman*, 4 Oct. 1860, is the source for the debate referred to here. It contains details omitted from the published *Transactions of the NAPSS* conference.

20. Edinburgh Society for the Promotion of the Employment of Women, *Annual Report, 1862–3*, by Phoebe Blyth. Cf. *Scotsman*, 27 Oct. and 7 Nov. 1860. The letter printed on 27 October said that the Edinburgh Society was not anxious to 'thrust' women into printing. Much research has till to be done on the suffrage and women's rights movement in Scotland, one aspect of which is the activity of the 'progressive' Edinburgh families like the McLarens and Stevensons. Duncan McLaren (1800–86) was Liberal MP for Edinburgh from 1865–81, and a well-known figure. His third wife, Priscilla, was a member of the reforming Bright family of Liverpool. Her most famous brother, John, was opposed to women's rights, but another brother, Jacob, was an active supporter. Priscilla Bright McLaren and her daughter were keen promoters of the movement in Edinburgh. Sarah Siddons Mair (1846–1941) was the founder of the Ladies Edinburgh Debating Society in the 1860s (it lasted 70 years). The Stevenson sisters (Flora Stevenson was the first woman member of a School Board in Edinburgh) were also active supporters of ESPEW.

21. *Scotsman*, 19 and 26 Jan. 1861; cf. Sarah C. Gillespie, *A Hundred Years of Progress, 1853–1952: The Record of the Scottish Typographical Association* (Maclehose, Glasgow, 1953), 102.

22. *STC* (October and November 1860, July 1865).

23. *STC* (July 1895), obituary of Emily Faithfull.

24. 'To the Three Kingdoms', in *Rose, Shamrock and Thistle* (November 1863: full run of the journal in National Library of Scotland).

25. *STC* (May 1862), 138; Gillespie, *A Hundred Years*, 104.

26. *Rose, Shamrock and Thistle* (Nov. 1863). Emily Faithfull began producing the *Victoria Magazine* in London a year later. The reference is to a printer's devil – the errand boy, or in this case girl.

27. *Scotsman*, 13 and 14 June 1865.

28. *Transactions of the NAPSS* (1860), 821. The choice of girls brought up in institutions highlights the great ambiguity about class in the whole enterprise: such girls were culturally middle class yet often from the very poorest families originally.

29. *STC* (May 1862), 139.

30. Quoted with approval by the *STC* (Apr. 1860).

31. *STC* (May 1862).

32. Taylorization: the introduction of scientifically organized industrial production by the use of machinery and a specialized workforce, of which the first famous example was the Ford assembly line. Named after the US engineer, F. Taylor (1856–1915).

33. Felicity Hunt, 'The London Trade in the Printing and Binding of Books: An Experience in Exclusion, Dilution and De-skilling for Women Workers', in *Women's Studies International Forum*, 6. 5 (1983), gives details of the London experience. On the Women's

Printing Society, see Hunt, 'Opportunities Lost and Gained', in, John, *Unequal Opportunities*, 79–81.

NOTES TO CHAPTER 3

1. Commentators at the turn of the century tended to attribute the defeat of the strike to the employment of women: Barbara Bradby and Anne Black, 'Women Compositors and the Factory Acts', *Economic Journal* (1899), 262; the team which produced *Women in the Printing Trades: A Sociological Study* (ed.) J. Ramsay Macdonald (King, London, 1904), refers to the 'extensive employment' of women during the strike, and also regards it as the reason for the STA's 'defeat' (p. 45); Barbara Drake, in *Women in Trade Unions* (Allen & Unwin, London, 1921), 33, actually uses the term 'strike-breakers'. Cynthia Cockburn commendably uses more neutral terms but does not go into detail. See her *Brothers: Male Dominance and Technological Change* (Pluto, London, 1983).

2. I. MacDougall (ed.), *Minutes of the Edinburgh Trades Council, 1859–1873* (Edinburgh, Scottish History Society, 1968), xix. On Scottish trade unions in general, among the many published works see for instance I. MacDougall (ed.), *Essays in Scottish Labour History* (Donald, Edinburgh, 1978) and *Labour in Scotland: A Pictorial History* (Mainstream, Edinburgh, 1985); introduction to, W. Knox (ed.), *Scottish Labour Leaders 1918–39* (Mainstream, Edinburgh, 1984); T. Dickson (ed.), *Capital and Class in Scotland* (John Donald, Edinburgh, 1982); and Eleanor Gordon, 'Women and the Labour Movement in Scotland' (Ph.D., Glasgow, 1985), ch. 2: 'The Mid-Victorian Trade Union Movement'.

3. Sarah C. Gillespie, *A Hundred Years of Progress, 1853–1953: The Record of the Scottish Typographical Association* (Maclehose, Glasgow, 1953), ch. 3 *passim*. Gillespie's official history of the STA contains a wealth of information, thematically rather than chronologically presented (unfortunately without many footnotes). The author had access to a full run of the *Scottish Typographical Circular* (now impossible to find in any single collection) as well as to union records.

4. Gillespie, *A Hundred Years*, 45–6.

5. Ibid., 42.

6. MacDougall, *Minutes*, xx, based on Minute Books of ETS, 1861 and 1869.

7. Gillespie, *A Hundred Years*, 27.

8. Ibid., 23–4 for the Interlocutor; on the mixed system, see ibid., 24 and 73–6. On fat and lean see below, Chapter 4. The en is a unit of typographic measurement based on the width of the letter 'n'.

9. Ibid., *passim*, but especially ch. 8, 'The Apprentice Question'.

10. Ibid., 37–9.

11. Ibid., 63–4.

12. Partly because of the extension of the franchise by the 1867 Reform Act, which meant printing enlarged electoral rolls (always welcomed in the printing trade). Cf. Gillespie, *A Hundred Years*, 51.

13. *Scottish Typographical Circular* (Dec. 1872). On the men's demands in detail, see, Gillespie, *A Hundred Years*, 117–20.
14. *STC* (December 1872).
15. Minute Book, strike committee, 13 Feb 1873 (in, NLS, manuscripts, Acc 4068, nos. 39 and 40).
16. *Edinburgh Evening Courant*, 14 Feb. 1873.
17. *STC* (Dec. 1872).
18. *STC* (Jan. 1873).
19. MacDougall, *Minutes*, 349.
20. The *Reformer*, 14 Feb. 1873.
21. Minute Book, strike committee: the text of the letter was printed in the *Reformer* on 14 Feb. 1873.
22. *Scotsman*, 20 Feb. 1873.
23. Minute Book, strike committee, 23 Jan. 1873; cf. Macdonald (ed.), *Women in the Printing Trades*, 45. A *retrospective* reference appeared in the *STC* in March 1873: 'several of the largest firms were carrying out their threat of employing women', 152.
24. The men began producing and printing a newsletter, first entitled *Out on Strike* (one or two issues survive in the NLS), later *The Craftsman*, which led to the setting up of the co-operative printing company.
25. *Edinburgh Evening Courant*, 8 Feb. 1873.
26. *Scotsman*, 8 Feb. 1873.
27. Macdonald (ed.), *Women in the Printing Trades*, 45.
28. *STA, A Fifty Years Record* (1904), 62, refers to the 'indescribables' and 'unreliables' of 'London and Liverpool' as the strike-breakers both in the 1872 strike and the *Scotsman* dispute a year before.
29. On the 'charity hospitals' or boarding schools, see, Olive G. Checkland, *Philanthropy in Victorian Scotland: Social Welfare and the Voluntary Principle* (John Donald, Edinburgh, 1980), 16–17 and 108ff. 'At the time of the Education Act of 1872, there were 23 hospitals where boys (and a few girls) were boarded (usually between the ages of 8 and 14), educated and subsequently apprenticed.' These were supposed to be for the 'puire fatherless bairnes' of 'decayed burgesses', rather than for the working class. The so-called 'monastic system' of boarding children in these schools was just breaking down in the 1870s, but some of the first recruits to the printing trade may have been middleclass boarders.
30. Macdonald (ed.), *Women in the Printing Trades*, 45.
31. On the Dean orphanage, see Checkland, *Philanthropy*, 17; interview with Jean Henderson's daughter, January 1986; on the age of the first recruits, letter from Alex Ross to STA headquarters, Letter Book, ETS, 1879 (NLS, Acc 4068).
32. *Edinburgh Daily Review*, 23 Jan. 1873.
33. *STC* (June 1873), 190.
34. Minute Book, ETS, 27 Sept. 1873 (NLS, Acc 4068).
35. Ibid., Feb. 1874, and *Register of Employees*, 1911.
36. *STC* (Sept. 1904).
37. Gillespie, *A Hundred Years*, 123–5.
38. *STC* (Sept. 1904), 346.
39. *STC* (Sept. 1873), 234.
40. *Scottish Typographical Journal*, the successor to the *STC* (1922), 237.

41. *Out on Strike*, 1 Sept. 1873, letter to the editor.
42. *STC* (Nov. 1873), 251.
43. Gillespie, *A Hundred Years*, 105.
44. *STC* (July 1879).
45. *STC* (Mar. 1882).
46. C. M. Bowerman's evidence to the *Royal Commission on Labour*, vol xxxiv (PP 1893–4), para. 23083, evidence from printing trade, put it at 100 to 150. Amy Linnett in the *Economic Journal*, vol. i. 1 (1892) suggested 200.
47. Bradby and Black, 'Women compositors and the Factory Acts', 261–6; see also Macdonald (ed.), *Women in the Printing Trades*, and Felicity Hunt, 'The London Trade in the Printing and Binding of Books: An Experiment in Exclusion, Dilution and Deskilling for Women Workers', *Women's Studies International Forum*, 6. 5. (1983). She points out that some firms had a 'fair house' in London and an 'unfair' one, i.e. employing women, in the Home Counties.
48. *Fair Wages Committee*, xxxiv (PP 1908), paras. 238–40 and 246.
49. *RCL*, xxxvii, part i (1893–4), 290. On Margaret Irwin, see below, Chapter 4, note 34.
50. On Aberdeen, see Gillespie, *A Hundred Years*, 105 and other index references.
51. Gillespie, *A Hundred Years*, 105–7.
52. *FWC*, Mr Fraser's evidence (cf. note 48), para 4623.
53. *STC* (July 1879, Nov. 1888, Sept. 1904): Irwin to *RCL*, xxxvii, part i (PP 1893–4), 290; Bradby and Black, 'Women compositors and the Factory Acts', 262; *FWC* (1908), para. 2925; ETS Minute Book, 12 Feb. 1908; *Register of Employees in Edinburgh Printing Houses* (1911); Alex Ross's estimate of 'over 200' to the *RCL* in 1893–4 seems to be an understatement; Margaret Irwin says 300, which is closer to *STC* reports.
54. ETS Letter Book, NLS MS Acc 4068 (121), letter of 20 June 1879 by Alex Ross, who was extremely bitter about the men who acted as 'tutors of those petticoated underlings', but thought the problem 'at present insoluble', because of low union membership.
55. *STC* (Jan. 1902), 398.
56. *RCL*, 1893–4; Margaret Irwin's report (see note 52), employer no. 209.

NOTES TO CHAPTER 4

1. Speech to meeting of STA delegates, 1885, reported in *Scottish Typographical Circular* (Sept. 1885). John Battersby was secretary from 1874 to 1889.
2. The literature is too large for more than a few indications. The 'labour process' debate associated with Harry Braverman's book, *Labour and Monopoly Capital: the Degradation of Work in the Twentieth Century* (Monthly Review Press, London and New York, 1974) is discussed in Anne Phillips and Barbara Taylor, 'Sex and Skill: Notes towards a Feminist Economics', *Feminist Review*, 6 (1980). See also John Benson (ed.), *The Working Class in England 1875–1914* (Croom Helm, London, 1985) and in particu-

lar Jonathan Zeitlin, 'Craft Control and the Division of Labour: Engineers and Compositors in Britain, 1890–1930' in *Cambridge Journal of Economics* (1979), 263–74, as well as his thesis on the same subject (Ph.D., Warwick University, 1981).
3. *STC* (Feb. 1875).
4. *STC* (June 1875), 477.
5. J. Ramsay Macdonald (ed.), *Women in the Printing Trades: A Sociological Study* (King, London, 1904), 57; *Fair Wages Committee* (PP 1908) xxxiv, para. 4587, evidence of William Fraser, managing director of Neill & Co.; ibid., para. 2929, evidence of George Simpson, committee member of Edinburgh Typographical Society; interview with survivor, Edinburgh, January 1986. Much evidence in this chapter comes from the testimony before two parliamentary commissions, the *Fair Wages Committee* of 1908 and the *Royal Commission of Labour* of 1893–4, i.e. the verbatim accounts of both employers and trade-union representatives. On both occasions, the Edinburgh printing trade was discussed at some length. The *parti pris* of the witnesses has to be allowed for, but their evidence (including its contradictions) gives a much better picture of the situation than the coded articles or repetitive complaints of the *STC*.
6. *FWC* (1908), para. 4616, Fraser's evidence.
7. Ibid., para. 4618, evidence of Thomas E. Naylor, general secretary of London Society of Compositors.
8. Ibid., para. 2903, evidence of John Templeton, secretary of the STA.
9. Macdonald, *Women in the Printing Trades*, 174.
10. *FWC* (1908), para. 4616, Fraser's evidence.
11. 'Turtle' to *STC* (Dec. 1904), 421.
12. Barbara Bradby and Anne Black, 'Women Compositors and the Factory Acts', *Economic Journal*, 1899, 265.
13. Quoted by Macdonald, *Women in the Printing Trades*, 63 and 174.
14. *Edinburgh Evening Despatch*, 30 Aug. 1910. Cf. T. C. Smout, *A Century of the Scottish People 1830–1950* (Collins, London, 1986), 178.
15. On wages in general see Sarah Gillespie, *A Hundred Years of Progress, 1853–1952: The Record of the Scottish Typographical Association* (Maclehose, Glasgow, 1953), ch. 13, 153–78.
16. Oliver & Boyd: National Library of Scotland, MSS, Acc 5000 (47): printing wage-book 1903–12; T. & A. Constable, National Library of Scotland, MSS: Dep 307 (184–6): wage-book 'Girls' Room'. See also, Margaret Irwin, 'Women's Industries in Scotland', *Proceedings of Philosophical Society of Glasgow*, xxvii (1895–6), 70–91, who gives women's wages as starting at 4s, rising to 9s, 12s and 'in rare cases' to 18s, while the stab wage for men in Scotland could be between 30s and 37s 6d.
17. *Royal Commission on Labour* (PP 1893–4), xxxvii, pt. i, 290–1, Margaret Irwin's report on the printing industry.
18. *FWC* (1908), para. 4615, Fraser's evidence: 'we have a fixed rate for an apprentice. She begins at 3s 6d and she rises to 7s after 3 years: after that she is paid so much per 1000 letters lifted. Then after that, if she wishes to go on time, we take her average wages and give her that sum, which is gradually increased by a shilling or so every second year'.
19. *RCL* (1893–4), Irwin's report, evidence from firm 209.

20. *RCL* (1893–4), para. 23187, evidence from Alexander Ross for Scottish Typographical Association.
21. Quoted by Macdonald, *Women in the Printing Trades*, 173.
22. *FWC* (1908) 248, Naylor's evidence.
23. 'A famous printery, R. & R. Clark's of Edinburgh', *British Printer* (1896).
24. Ibid. (my italics).
25. Macdonald, *Women in the Printing Trades*, 45 and 174.
26. Letter from Mr A. Simpson, Feb. 1986.
27. *RCL* (1893–4), Irwin's report, 291.
28. Ibid., 290.
29. *RCL* (1893–4), para. 23186, Ross's evidence, and Macdonald, *Women in the Printing Trades*, 45.
30. *RCL* (1893–4), Irwin report, 290.
31. *FWC* (1908), para. 4489, evidence of Stanley Straker, chairman of London Master Printers' Association.
32. Macdonald, *Women in the Printing Trades*, 173.
33. *FWC* (1908), para. 4586, Fraser's evidence (my italics).
34. *FWC* (1908), para. 4674, Fraser's evidence, and para. 2929, Templeton's evidence.
35. *RCL* (1893–4), Irwin's report, 290, evidence from J. Battersby.
36. *FWC* (1908), para. 2970, Templeton's evidence.
37. Ibid., para. 2899, Templeton's evidence.
38. Macdonald, *Women in the Printing Trades*, 173.
39. *RCL* (1893–4), para. 23189, Ross's evidence.
40. *FWC* (1908), para. 4483, Straker's evidence.
41. *STC* (Feb. 1886).
42. Macdonald, *Women in the Printing Trades*, 46.
43. *FWC* (1908), paras. 4586, 4590, Fraser's evidence.
44. Macdonald, *Women in the Printing Trades*, 50.
45. *FWC* (1908), para. 4675, Fraser's evidence.
46. Ibid., para 4483, Straker's evidence.
47. *RCL* (1893–4), Irwin's report, 290, statement of firm 209.
48. *FWC* (1908), para. 4607, Fraser's evidence.
49. Both in *RCL* (1893–4), Irwin's report, 291.
50. *FWC* (1908), para. 4607, Fraser's evidence.
51. Macdonald, *Women in the Printing Trades*, 174.
52. Ibid.; also quoted in, Sally Alexander, 'Women's Work in Nineteenth-Century London', in, J. Mitchell and A. Oakley (eds.), *The Rights and Wrongs of Women* (Penguin, Harmondsworth, 1976), 410.
53. *STC* (Feb. and May 1886).

NOTES TO CHAPTER 5

1. Jonathan Zeitlin, 'Craft control and the Division of Labour: Engineers and Compositors in Britain 1890–1930', *Cambridge Journal of Economics* (1979), 263–74.
2. Ibid., 267–8.
3. *Royal Commission on Labour* 1893–4, para. 23285, testimony of Alex Ross, secretary of ETS.
4. John Child, *Industrial Relations in the British Printing Industry* (Allen & Unwin, London, 1967), 60.

5. J. Ramsay Macdonald (ed.), *Women in the Printing Trades: A Sociological Study* (King, London, 1904), 28 note and 39 note.
6. National Library of Scotland, MS collection, Acc 4068, 124 (1), Misc. Corr.
7. NLS MS, Acc 4068, 124 (1), minutes of talks between employers and unions, April 1910.
8. *Edinburgh Evening News*, 29 Aug. 1910.
9. *Scottish Typographical Circular*, Mar. 1882.
10. *STC*, Oct. 1904, 'Phoenix'.
11. Scottish Typographical Association, *Annual Reports* (1905), 129.
12. *Fair Wages Committee* (PP 1908), para. 2933, testimony of George Simpson of ETS.
13. The classic first-hand account of tramping is J. W. Rounsfell's series of articles written at the turn of the century and re-issued as *On the Road: Journeys of a Tramping Printer* (Caliban, Horsham, 1982). In his introduction, Andrew Whitehead charts the rise and fall of tramping and points out that the relief system was seriously restricted in 1903 and came to an end in 1913. Tramping was not an option readily open to women. But it should be noted that both men and women compositors from Edinburgh were prepared to move away in search of work; indeed it was claimed during 1910 by English unionists that Edinburgh women comps were coming to work in England.
14. *The House of Neill* (Bicentenary edition, Edinburgh, 1949), 24. Cf. Sarah Gillespie, *A Hundred Years of Progress, 1853–1952: The Record of the Scottish Typographical Association* (Maclehose, Glasgow, 1953), 111.
15. Ibid., 114.
16. Cf. Cynthia Cockburn, *Brothers: Male Dominance and Technological Change* (Pluto, London, 1983), 26–31 and 46–50.
17. NLS MS, Acc 4068 (8), minute book ETS executive committee 1906–12, letter received from master printers, Jan. 1910.
18. Cockburn, *Brothers*, 155; Marjorie Plant, *The English Book Trade: An Economic History of the Making and Sale of Books* (Allen & Unwin, London, 3rd edn. 1974), 285.
19. NLS MS, Acc 4068 124 (1), minutes of talks between employers and unions, April 1910.
20. NLS MS, Acc 4068 (8), minute book of ETS, Jan. 1907.
21. NLS MS, Acc 4068 124 (1), minutes of talks. (The brief existence in Edinburgh of a branch of the Glasgow printers William Collins is not mentioned anywhere else: apparently attracted by the possibility of employing women comps, the branch seems to have closed once the exclusion of women had become a reality.)
22. NLS MS, Acc 4068 (8), minute book of ETS, 18 July 1907, letter received from William Fraser of Neill's: the master printers 'are seriously alarmed at the fact that novel printing and work of that description is already leaving Edinburgh, as they find it impossible to compete with the houses in the neighbourhood of London'.
23. See Introduction, 1–2.
24. *Fair Wage Committee* (1908), para. 4593, Fraser's evidence.
25. For the Memorial, see the *Scottish Typographical Journal* (Jan. and Feb. 1910); Gillespie, *A Hundred Years*, 203; NLS MS, Acc 4068, minute book of ETS, Nov. and Dec. 1909.
26. Cf. Cockburn, *Brothers, passim*, and, Felicity Hunt, 'Oppor-

tunities Lost and Gained: Mechanization and Women's Work in the London Bookbinding and Printing Trades', in Angela John (ed.), *Unequal Opportunities: Women's Employment in England 1800–1918* (Blackwell, Oxford, 1986).

27. NLS MS, Acc 4068 124 (1), minutes of talks, Apr. 1910.
28. Amelia McLean, letter to *Edinburgh Evening News*, 27 Aug. 1910.
29. *Edinburgh Evening News* editorial, 29 Aug. 1910.
30. *Royal Commission on Labour* (1893–4), para. 23269, Alex Ross's testimony.
31. Gillespie, *A Hundred Years*, 106; Cockburn, *Brothers*, 34.
32. *STC* (Dec. 1904). Clementina Black (1855–1923) was a well-known figure in the movement for women's trade-union organizations at the turn of the century, taking a leading role in e.g. the Anti-Sweating League and the Women's Industrial Council. See, Ellen Mappen, *Helping Women at Work: The Women's Industrial Council 1889–1914* (Hutchinson, London, 1985).
33. *STC* (Aug. 1886), 383.
34. Margaret Irwin (d.1904), the secretary of the Scottish Council of Women's Trades, carried out many investigations into women's industrial work; while on 'cordial terms with the trade union movement', Eleanor Gordon writes, she remained firmly within a philanthropic tradition. Regrettably little is known about her life.
35. *STC* (July and Aug. 1898); STA *AR* (1898), 28, and (1889), 29.
36. Cf. discussion of this topic in Eleanor Gordon, 'Women Workers and the Labour Movement in Scotland' (Ph.D., Glasgow, 1985).
37. *Fair Wage Committee* (1908), para. 6035, Margaret Irwin's testimony. See, Macdonald, *Women in the Printing Trades*, 28, 53.
38. *Fair Wage Committee* (1908), para. 6221, Margaret Irwin's testimony.
39. *STC* (Apr. 1904), 267.
40. The Glasgow printers rightly pointed out in reply that the structure of the trade was quite different in the two cities: 'What the average printer in Glasgow would do with the ladies I cannot fathom, for while they may be taught to sling plain dig [i.e. bookwork: straight setting], I am not aware that the lady jobber has yet come along. The very nature of commercial work, which constitutes the general run of Glasgow work, precludes her employment,' *STC* (May 1904), quoted in, Cockburn, *Brothers*, 154.
41. *STJ* (1908). On the 'female question' in general, see the sections in, Gillespie, *A Hundred Years*, 101–7, 203–8. On the Printing and Kindred Trades Federation, ibid., 128–30.
42. ETS, minute book, Feb. 1910.
43. C. M. Bowerman (1851–1947), Secretary of LSC, president of TUC 1901, MP for Deptford 1906–31.
44. NLS MS, Acc 4068 (8) minute book for ETS, 19 June 1910.
45. NLS MS, Acc 4068 124 (1), minutes of talks, Apr. 1910.
46. The voting figures are in Acc 4068 (8), minute book of the ETS, 22 Dec. 1909 and 18 May, 1910.
47. NLS MS, Acc 4068 (8), ETS minute book, 3 Aug. 1910.
48. Ibid., 10 Aug. 1910. It was clear from the minutes of the talks held on 26 Aug. 1910 (Acc 4068 124 (1)) that Neill's and Morrison

& Gibb had signed the memorial. Both firms had originally been firmly opposed to any concessions.

49. Cf. the case reported by Macdonald, *Women in the Printing Trades*, 53, of a woman bookbinder being offered a more skilled job: 'I know my place', she replied, 'and I'm not going to take men's work from them.' Powerful loyalties were at work among women of the working class, brought up in respect for the male breadwinner. This is not the same thing as 'apathy'

50. *Scotsman*, 1 Sept. 1910.

51. *Edinburgh Evening News*, 2 Sept. 1910. See the account in the *Despatch* for the same date. Miss Symonds is quoted as saying 'the conduct that went on during the dispute in that office was something disgraceful'.

52. *Edinburgh Evening News*, 19 Aug. 1910.

53. Amelia McLean, article in *The Vote*, 10 Sept. 1910.

54. *Edinburgh Evening News*, 2 Sept. 1910, and NLS MS, Acc 4068, 124 (1). The union's full title was the National Amalgamated Society of Printers, Warehousemen and Cutters. Alfred Evans wrote to the *Scotsman* on 2 Sept. 1910, saying that there was a total of 5,000 women and girls employed in the printing trade in Edinburgh: they outnumbered men by two to one; most of these were in 'auxiliary' trades, as machine-feeders, folders, envelope-makers and so on. He said they were all, including the compositors, welcome to join his union. Thus women were regarded as a single category, united by their sex rather than defined by their work, at a time when wage and status differentials among men were jealously guarded.

55. Cockburn, *Brothers*, 157.

56. *Edinburgh Evening News*, 29 Aug. 1910.

57. *The Vote*, 10 Sept. 1910.

58. *Scotsman*, 2 Sept. 1910.

59. The 'We Women' memorial was reproduced in *STJ* (June 1910), and is also reproduced in Cockburn, *Brothers*, 156. It originally contained a clause 'recognizing' that women could not claim equal pay, since they did not have the all-round experience' of men, but this was struck out of the final version. A deputation of six women, two each from Skinner's, Murray's and Constable's presented it to the masters.

60. Interview with the *Edinburgh Despatch*, 1 Sept. 1910. Personal details about Jean Symonds from records of the Women's Section of the ETS (see Chapter 7) and about Amelia McLean from the registration records (marriages). Skinner's was one of the 17 firms which were still refusing to sign the memorial in September (44 had signed, mostly small houses, but including Neill and Morrison & Gibb). The other 16 were: Turnbull & Spears, Edinburgh Press, Castle Printing, Blackwood, Ballantyne, Lorimer & Chalmers, T. &. A. Constable, Pillans & Wilson, Mercat, Oliver & Boyd, R. & R. Clark, Bain, Armour, Mackay, Green, Paton.

61. *STJ* (Sept. 1910), 438.

62. *The Vote*, 28 May 1910.

63. Ibid., 18 June 1910. See report in *Evening News* 2 Sept. 1910, of a meeting of the women's union, at which Miss Chapman, from the Bureau for the Employment of Women, said that the move-

ment was 'the girls' own' and had not been organized by 'suffragettes'. On the deputation, see the *Despatch*, 25 Aug. 1910.
64. NLS MS, Acc 4068 124 (1), minutes of talks, 26 Aug. 1910. On the same occasion, Mr Evans claimed that the 'signatures were only obtained by intimidation of the girls and some who actually signed are now members of our society and support me'; this seems to indicate at the least, considerable competition for the 'girls'' loyalty.
65. *Edinburgh Evening News*, 1 Sept. 1910.
66. *The Vote*, 10 Sept. 1910.
67. *Edinburgh Evening News*, 2 Sept. 1910.
68. For all these meetings, see local press (*Scotsman, Evening News, Despatch*) for first week in September.
69. *The Vote*, 10 Sept. 1910.
70. *Despatch*, 15 Sept. 1910. A full recapitulative account of the whole dispute appeared in the *STJ* (Sept. 1910), 433 ff., including details of the employers' amended offer and the timetable of talks in September. The upping of the women's scale is referred to in the minutes of the talks on 26 Aug. 1910.
71. *Forward*, 24 Sept. 1910.
72. *The Socialist*, July 1910, quoted in, Eleanor Gordon, 'Women Workers and the Labour Movement in Scotland', 271.
73. *The Vote*, 24 Sept. 1910.
74. *Edinburgh Evening Despatch*, 15 Sept. 1910.
75. *Edinburgh Evening Despatch*, 1 Sept. 1910.
76. NLS MS, Acc 4068 124 (1).
77. *Edinburgh Evening Despatch*, 3 Sept. 1910.

NOTES TO CHAPTER 6

1. Edinburgh Typographical Society, *Register of Employees: Case Department*, 1911 (two edns.), 1913 (National Library of Scotland). These list all compositors, male and female, and apprentices, by name and printing office. The figure 844 represents the total of names compiled from these registers, but it may not be quite accurate, as there were some omissions and anomalies, especially concerning people with very common surnames. Among the 844 women listed, there are 15 Browns, 12 Hendersons and Thomsons, 11 Reids and Robertsons, 9 Wilsons, 8 Scotts and 7 Andersons, Walkers, Grants, Millers, Munros, Smiths and Stewarts. Since certain given names were very popular in this period, some confusion of identity may have taken place. Over half the 844 women in the sample had one of the following five first names: Margaret (95), Mary (87), Elizabeth (67), Jean (66), Isabella (55). For this reason, I had to be very prudent about identifying women in the registration records for instance.
2. ETS Deposit, National Library of Scotland, MS, Acc 4068, nos. 40–45, minute books, Society's Female Section, 1913–55; and nos. 101–2, Contribution List, Women's Section, 1911–17. Some data was also found in the employers' archives, for instance

R. & R. Clark, NLS MS, Dep. 229, NC552b, Small Fines Book, which despite its name lists names of women compositors who left the office, in most cases to get married.
3. Consulted at Register House, Edinburgh and traced by annual indexes. As these are in the public domain, permission has been granted to refer to them, but I have preferred to use initials when referring to marriages and deaths rather than full names, except where permission has been granted by the family.
4. Interviews with four surviving women compositors and the daughter of a former compositor, Edinburgh, January 1986.
5. To the 160 plus cases whose year of birth is known from the registration records, are added those whose 65th birthday is noted in the retirement records.
6. Cf. G. Gordon, 'The status areas of Edinburgh' (Ph.D., Edinburgh University, 1971).
7. Although families in all classes were larger in Edwardian times than now, 'in 1911, the general labourer had on average two more children in his family than the minister or teacher', Lynn Jamieson, 'Growing up in Scotland', in, Glasgow Women's Studies Group, *Uncharted Lives: Extracts from Scottish Women's Experiences 1850–1982* (Pressgang, Glasgow, 1983), 18.
8. City of Edinburgh Charity Organisation Society (CECOS), *Report on the Physical Condition of Fourteen Hundred Schoolchildren in the City, together with some account of their home and surroundings* (King, London, 1906). It is not easy to make comparisons, as the ages of the girls and young women mentioned range from 13 or 14 to as high as 27. But apart from the occasional shop assistant (who might earn 15s), the highest wage outside printing seems to have been 10s to 12 s for those *over* 20 years of age, such as a book-folder aged 22, a paper-worker aged 22, and envelope-maker aged 25. Teenage girls were usually earning rather less than 10s a week, such as the pantrymaid of 17 who earned 8s, the 'chocolate coverer' aged 18 who earned 8s. The girl compositor's wage varied too, but as a general rule as we have seen, an 18–20 year old would be earning 10s to 12s and could earn as much as 16s, at the time of the CECOS report.
9. Ibid., 18–19, tables on married women's employment.
10. Cf. Lynn Jamieson, 'Growing up', and 'Limited Resources and Limiting Conventions: Working-Class Mothers and Daughters in Urban Scotland c. 1890–1925', in, Jane Lewis (ed.), *Labour and Love: Women's Experience of Home and Family 1850–1940* (Blackwell, Oxford, 1986). These two articles also discuss children's games and street life at about this time.
11. CECOS, *Report*, 19–20 and cf. note 10 above. Lynn Jamieson points out that the arduous nature of housework at the time, and its symbolic role when a family was struggling to keep up appearances, made it more likely that girls' domestic labour would be more highly valued than their not very high earning power, in some families.
12. Lynn Jamieson, 'Growing up', 18, quoting census figures.
13. Board schools for both sexes were established in Scotland by the 1872 Act. Hitherto, girls' literacy had somewhat lagged behind boys', but now the bright working-class girl could at least learn to read, although the channels of social mobility through secondary education were still more or less closed to her. It seems

likely that promising girls were encouraged by teachers to think about the printing trade, and in the 1900s, the School Boards actually organized classes (in the evening?) for would-be girl compositors as the *Scottish Typographical Journal* (April 1909), 86, reported with dismay. The 'smartness and adaptability' of the Edinburgh girl compositors were apparently much valued when for instance many of them worked in the Post Office, winning the postmaster's 'golden opinion' (*STJ*, May, 1915). On the problem of public education for working-class children in Edinburgh, because of the existence of the Merchant Company Schools, see, T. C. Smout, *A Century of the Scottish People 1830–1950* (Collins, London, 1986), 221–2. It is not a problem that has gone away.

14. D. N. Paton, *A Study of the Diet of the Labouring Class in Edinburgh* (Edinburgh, n.d.), 28: the average amount spent per head per week in 'workmen's families with regular wages' was estimated at 3s 2¹/₂d.

15. 'A famous printery, R. & R. Clark's', *The British Printer* (1896), 113–18.

16. This is on the whole more likely to have been in the years between the wars when women were increasingly doing every aspect of the traditional compositor's job, if they were not working machines. See below, chapter 7.

17. Almost all the survivors had worked at some time in Clark's, which had the printing of Shaw's works. The Clark manuscripts in the National Library of Scotland contain a separately classified collection of Shaw papers.

18. *Scottish Typographical Circular* (Dec. 1904). Reports of the social evenings, dinners and picnics regularly appeared in the journal from the beginning, in the 1850s. The social evenings were usually held around New Year, the picnics either in the 'trade holidays' in July, or in early September. See, Robert Gray, *The Labour Aristocracy in Victorian Edinburgh* (OUP, Oxford, 1976) for comment on the solidarity between masters and men at these occasions.

19. Ibid., ch. 5, and regular reports in the *Circular*.

20. Only tentative conclusions can be drawn from a few isolated examples, reported moreover by observers who were not entirely objective, but in the CECOS *Report*, in several families where the oldest daughter was a compositor, there are hints that she was something of a force for respectability (families 147, 356, 383: two eldest daughters both compositors, 'very clean and neat' by contrast with rest of family; 468: similar comment; 768: 'guiding' mother from drink).

21. For reports on all these events, see the *STJ*.

22. But the absolute number of marriages seems to have increased within the group. 'Juvenus' reported in the *STJ* in August 1915 that 8 women members of one chapel were getting married that month. In September 1915, a former Edinburgh compositor serving in France sent a letter to the journal saying that despite the pretty 'Mademoiselles' it was still 'the Edinburgh case-room girls for me'.

23. *STJ* (Feb. 1915; see also Feb. 1916). The term 'patriotic work' is sometimes used, but this did not necessarily mean war work.

24. NLS MS, Acc 4068, nos 101–2, Contribution List, Women's Section of ETS.
25. Cf. Gray, *The Labour Aristocracy*, 120 ff. Gray was engaged in quantitative sampling from which he was able to conclude for instance that building labourers were increasingly marrying daughters of skilled and white-collar workers at the end of the nineteenth century, compared with the 1860s. Our sample is both smaller and more scattered over time, and is affected moreover by the upheaval of the war, so our conclusions must be tentative.
26. In fact the S. family seems to have been something of a printing dynasty, as compositors of this name (an unusual one) crop up throughout the years of this study. A John S. was in the same office as Andrew, and was probably his uncle.
27. 'Meg' in the *STJ* in March 1918.
28. NLS MS, Acc 4068, minute book Female Compositors' Section, loose sheet undated but obviously 1922.
29. Ibid., entries in 1930s.

NOTES TO CHAPTER 7
1. *Scottish Typographical Journal* (May 1911), 119. For this chapter the *Journal* and the women's section committee minute book, National Library of Scotland, Acc 4068 nos. 40–5 are the main sources as well as the Annual Reports of the Scottish Typographical Association (AR). The information given in the *Journal* is episodic and fragmentary, and that in the Minutes is incomplete, so the history of the women's section has to be pieced together, and gaps remain. It is hard for instance even to discover the rates of pay during the period 1914–24 or so, which included so many changes. Rather than attempt to reconstruct year by year activities in relation to the many complex issues facing the Scottish Typographical Association as a whole, and the Edinburgh branch in particular, I have tried simply to select the most important aspects of the women's section's history. The reader is referred to, Sarah C. Gillespie, *A Hundred Years of Progress, 1853–1952: The Record of the Scottish Typographical Associawtion* (Maclehose, Glasgow, 1953), which is, however, almost silent on the later history of the women's section There is a considerable literature on women and trade unions in Britain: see for instance Barbara Drake's still classic *Women and Trade Unions* (Labour Research Department, London, 1920); and Sarah Boston, *Women Workers and the Trade Union Movement* (Lawrence & Wishart, London, 2nd edn. 1987), which has a bibliography. A stimulating essay is Deborah Thom's 'The Bundle of Sticks: Women, Trade Unionists and Collective Organization before 1918' in, Angela John (ed.), *Unequal Opportunities: Women's Employment in England 1800–1918* (Blackwell, Oxford, 1986). On Scotland, see Eleanor Gordon's article in, Glasgow Women's Studies Group, *Uncharted Lives: Extracts from Scottish Women's Experiences 1850–1982* (Pressgang, Glasgow,

1983); and her 'Women and the Labour Movement in Scotland 1950–1914' (Ph.D. thesis, Glasgow, 1985; to be published by OUP, forthcoming).

2. *Scottish Typographical Journal* (May 1911), 138.
3. 'THP' writing in *STJ* (July 1912), 365. On the STA vote ibid.
4. The section went by various names. When founded, it was called the Edinburgh Female Compositors' Society. The *Rule Book* of 1916 says that it is officially to be known as the Edinburgh Typographical Society – Female Section, and that it is also the Female Section of the Edinburgh Case Branch of the Scottish Typographical Association. In ordinary correspondence and meetings, it was called the Female Section or the women's section and it will simply be called the women's section in this chapter.
5. Figures from minutes, women's section minute book, 20 July 1922; see also AR 1912–15, where the section is reported as 'coming along well'.
6. Figures from women's section minute book, relevant dates.
7. Margaret Rendall, the section's secretary, in her speech in July 1922, spoke most warmly of both Hampton and Juvenus: 'Especially would we mention the work of Mr W. G. Hampton, our organiser and the writing of 'Juvenus' our Journal friend. These forces *created the section* [my italics] and carried it over many difficult places. How difficult, perhaps they alone entirely know'. On Juvenus, see, Gillespie, *A Hundred Years of Progress*, 206, where she reveals that Juvenus was 'a gentleman and an active member of the STA'.
8. *STJ* (May 1911), 125–6.
9. Significantly, on this occasion (10 Oct. 1917) it was Mary Alston who took the chair (see below). The new committee, elected the very next week, had a woman president.
10. Margaret Rendall's report on the section from October 1922 to October 1923, women's section minute books, (Oct. 1923). Membership stood at about 300 at this time. In a fairly typical year during this period, 15 members had been lost during the previous 12 months, 8 to be married, 4 to go abroad, 2 from ill health and 2 because they had died.
11. *Rule Book*, ETS, women's section (Edinburgh, 1916), 9.
12. In 1917, Juvenus upbraided an early treasurer, Miss Mackenzie, for asking to 'take a rest from her labours', remarking sternly that 'only marriage' could be an excuse for giving up. Mary Alston succeeded her.
13. *STJ* (1917), 143.
14. Letter received from Mr A. Simpson, Feb. 1986.
15. Women's section minute book, 1928.
16. *STJ* (April 1915): 'a certain West End firm has ceased to be, and a certain number of girls are looking for work'. In 1915, Ballantyne's was taken over by Spottiswoode and plans to move to London affected 450 employees.
17. Cf. Gillespie, *A Hundred Years of Progress*, 147 and 209 ff.; AR for years in question.
18. *STJ* (1920) *passim*, 1921, and women's section minute book 1921; AR, 1921, 1922.
19. Women's section minute book, 1922, *passim*, esp. 20 July.
20. Gillespie, *A Hundred Years*, 214–15; women's section minute

book 1925, and ballot papers issued on the question, pasted into minute book; final report in, AR 1925, 25–34. The tone of all the documents suggests a sincerely held point of principle.
21. Women's section minute book, Apr. 1918; *STJ* (May 1918).
22. Ibid., May 1919.
23. Ibid., Mar., July and Oct. 1919; *STJ* (Aug. 1919).
24. Ibid., Oct. 1923, July 1925
25. See above 111 for full quotation.
26. *STJ* and women's section minute book, Apr. 1917.
27. Ibid., Mar. 1916.
28. Ibid., Feb. 1916, May 1918.
29. Letter from Mary Alston to committee, ibid., 1918.
30. Ibid., May 1920.
31. Ibid., 15 Mar. 1922.
32. Jane Lewis, *Women in England: Sexual Divisions and Social Change 1870–1940* (Wheatsheaf, Brighton, 1984).
33. Gillespie, *A Hundred Years*, 206.

NOTES TO CONCLUSION
1. This was by no means confirmed to Scotland: Flora Tristan, a pioneer trade-union organizer in France in the 1830s and 1840s, remembered a printer explaining to her that 'we pay women half the rate: that is only fair, because they work quicker than the men; they would earn too much if we paid them at the same rate!' F. Tristan, *Union ouvrière*, Paris, Eds. des femmes, 1986 edn., quoted in, Helen Harden Chenut, *La Construction Sociale des Métiers Masculins et Féminins dans la Bonneterie Troyenne 1900–1939* (CNRS, Paris, 1987). In many trades where women worked, speed *was* effectively skill, but rarely recognized as such.
2. Swasti Mitter, *Common Fate, Common Bond: Women in the Global Economy* (Pluto, London, 1986), a book which contains some telling references to Scotland in the 1980s.
3. J. Ramsay Macdonald (ed.), *Women in the Printing Trades: A Sociological Study* (King, London, 1904), 53.
4. Here as throughout this section, the 'class solidarity' is essentially that of a particular section of the working class in Edinburgh: that associated with Gray's 'labour aristocracy', although the language of the time implied a much broader definition.
5. Quotations from Christopher Harvie, *No Gods and Precious Few Heroes: Scotland 1914–1980* (Arnold, London, 1981) and W. Knox (ed.), *Scottish Labour Leaders* (Mainstream, Edinburgh, 1984). I do not wish to sound unduly critical; Harvie's book is much more sensitive to gender than many general histories, and Knox has made an effort to include women in his dictionary. But after so many years of neglect of women in Scotland, historians need to explore what is meant by 'subordination' rather than simply assert it.

INDEX